Gavin White is also author of:

The Queen of Heaven. A New Interpretation of the Goddess
in Ancient Near Eastern Art

Babylonian Star-lore. An Illustrated Guide to the Star-lore and Constellations of
Ancient Babylonia

Queen of the Night

Queen of the Night

The Role of the Stars in the Creation of the Child

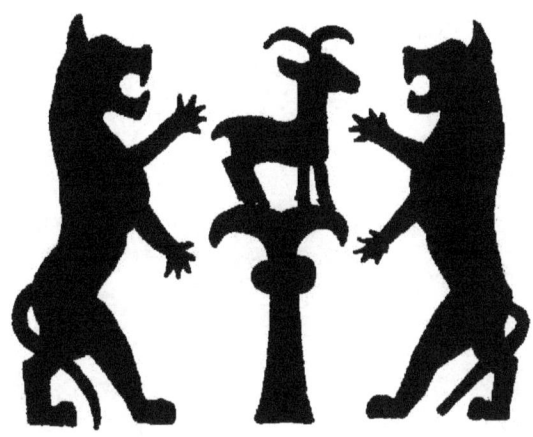

Written & Illustrated by
Gavin White

Solaria Publications
9 Sanford Walk
New Cross
London SE14 6NB

ISBN:978-0-9559037-3-1
First Published June 2014
© 2014 Gavin White

All rights reserved. No part of this publication may be reprinted, reproduced, stored in a retrieval system or transmitted in any form or by any means, electronic, mechanical, photocopying, recording or otherwise, without the prior permission of the copyright holder.

Contents

Foreword 9

PART ONE: The Cattle of the Skies

The Cattle of the Skies 13
The Lustrous Horn 25
The Cattle-pen 36
The Cross of the Stars 44

PART TWO: The Womb of Heaven

The Birth of the Child 57
The Child in the Waters 59
The Field 67
The Scorpion 73
The Serpent & Dragon 79
The Lioness 91
The Sphinx 104
Seeding Symbolism 109

PART THREE: The Animalian Powers

The Planets 119
Planetary Deities 128
The Animal Powers 136
The Lady of Babylon 150
The Ziggurat 165
Origins & Ends 173
The Lion of Death 184

Contents

Appendix – The Star-maps of Greece and Babylon	190
Bibliography	192
Symbol Index	195
Sumerian Signs	206
Indexes	209
Chronological Tables	213

Foreword

In my previous book, *The Queen of Heaven*, I tried to reconstruct the nature of the Sumerian goddess known as Inanna. By exploring ancient artworks, I endeavored to show that Inanna encompassed all of heaven, from the realm of the winds and storms all the way up to the exalted abode of the sun and stars. As goddess of the 'great above', Inanna embraced all the life-generating powers of the skies. This fundamental truth was encoded into a set of pictorial metaphors that all conveyed the same basic message that all life originated in the realm of heaven and descended from there to its birth upon earth.

The Queen of Heaven provides the foundation for the present study, which focuses on the symbolism of the stars and constellations. The origins and nature of the constellations are a perennial mystery that has vexed mankind for untold centuries. Understanding the basis upon which they were created would transform our view of prehistory. In this book, the *Queen of the Night*, I will develop the idea that the ancient star-map is informed by the very same conception of the fertile heavens. Taken as a whole, the constellation figures, and in particular the constellations that make up the zodiac, are nothing less than a depiction of the womb of the sky.

This is, I believe, an entirely new idea. And one that has significant repercussions for our understanding of the ancient world. The fundamental insight that the prehistoric heavens were intrinsically feminine in nature is an uncomfortable idea to many modern readers who are so accustomed to think of archaic spirituality in terms of 'earth mothers' and 'sky fathers'. However, once this impasse has been overcome, I hope that this alternative conception will help many readers to better understand the rationale that informs so many of the traditional arts. In particular, I hope it will shed a new light on the truly ancient origins of astrology, and further highlight its intimate relationship to the symbolism found in mythology and early religion, archaeology and the arts.

I would like to extend my thanks to Gill Zukovskis for help with proof-reading, corrections and helpful suggestions. Once again I would like to dedicate this book to Tom van Bakel for all his help and for sharing his ideas on ancient art, many of which are central to this book.

Pronunciation Guide

I have followed the common practice of rendering Sumerian terms either in bold or capital letters, and setting Akkadian terms in italics. Modern renditions of Sumerian and Akkadian use a number of alphabetic characters unfamiliar to most western readers; the four special characters below represent the following sounds:

Š – should be pronounced as "sh" as in 'shop'. It is often rendered as 'sh' in modern works.

Ṣ – should be pronounced as "ts" as in 'Tsar'. Some modern works on Assyriology choose to render this character as 'z'.

Ṭ – is a harder sound than ordinary "t".

H – should be pronounced as "ch" as in Scottish 'loch'.

In addition to these characters, Akkadian recognises three main forms of vowels – short, long and contracted, the last of which is really a combination of two vowel sounds. The respective lengths of the vowels are represented as '*a*', '*ā*' and '*â*'.

A Note on Cuneiform Signs

The sign-forms used in this book are taken from the very earliest tablets so far discovered in Mesopotamia. The reason why I have adopted these early signs is that they are much more differentiated and it is generally easier to see the pictorial basis for the signs.

PART ONE:
The Cattle of the Skies

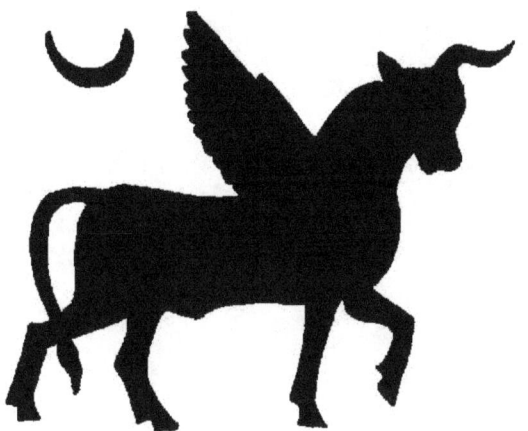

The Cattle of Heaven

From the hymns of Vedic India to the art of ancient Egypt, archaic man conceived of the heavenly realms in terms of celestial cattle. Throughout their long history, the ancient Egyptians revered the skies in the form of the cow-goddess Hathor.[1] Their cow goddess could be depicted in various forms: sometimes as a woman with bovine ears or with the head of a cow, and sometimes in a wholly animalian form as a great cow covered in stars. Most of these varied depictions show her with the sun disk set between her bovine horns:

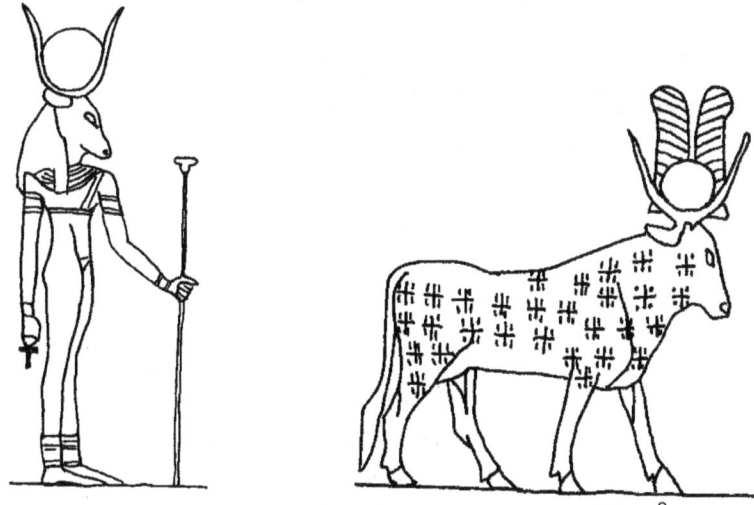

1 & 2 Images of Hathor, the Egyptian cow goddess [2]

Hathor's name, literally meaning the 'Temple of Horus', refers to her celestial nature and her role as mother of the sun-like Horus. According to Egyptian myth, every evening at sunset, Hathor devoured the sun-disk and then every morning she brought it to birth again in the form of the hawk god Horus.

The essential nature of Hathor can be deduced from later texts where she is related to the Sun god Re. Some texts regarded her as the mother of Re because she was so commonly adorned with the solar-disk. On the other hand, she was also closely associated with the stars and in this aspect she could be considered as the daughter of Re, as the sun god was often thought to be the father of the stars.[3] This contradictory evidence – that Hathor was mother and daughter of the sun god – is easy enough to reconcile: beyond the changing roles and hierarchic positions of the gods, Hathor originally represented the whole realm of heaven, which naturally incorporates the sun and all the stars.

[1] Bunson 1991, page 107.
[2] Unknown source. Found by an internet search 'Egyptian cow goddess'.
[3] Bunson 1991, page 107.

The Cattle of Heaven

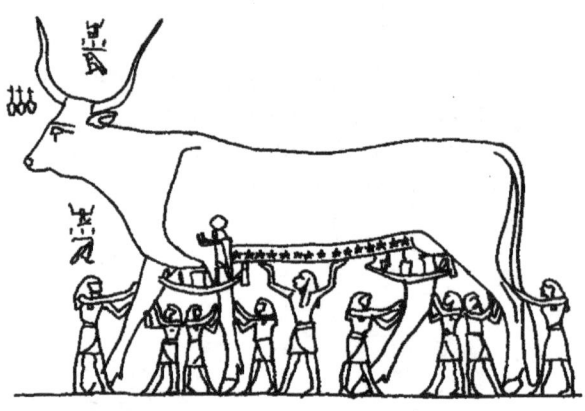

3 Hathor, the sky cow [4]

The cosmic nature of the cow goddess is most clearly seen when she is portrayed with a row of stars along her belly and the barge of the sun at her breast (*left*). From images such as this, we can conclude that Hathor embraced the dual aspects of heaven on high – both the daytime skies filled with sunlight as well as the night-time skies replete with the light of the stars.

The poets of Vedic India used the imagery of celestial cattle in a somewhat different manner. In the Vedas, as well as the great cow of the sky whose 'threefold voice' was lightning, thunder and rain,[5] we also meet herds of celestial cows that represent the rain clouds and the rays of sunlight released at the break of dawn. Although the Vedas do occasionally make mention of sky-bulls, whose semen-like rain brings abundance to the earth,[6] the repeated stress on the feminine nature of these celestial cattle all point to the same original conception of the skies as a fecund cow.

In Mesopotamia, the divine cow of heaven was sacred to the great goddess of heaven known as Inanna. Sumerian hymns to the goddess still remember her as 'the Great Cow among the gods of heaven and earth'.[8] In later times, she was integrated into the wider pantheon, firstly as the 'good wild cow of An' (the god of 'Heaven'), and then as the 'good wild cow of father Enlil', (the leader of the whole pantheon of gods).[9]

The image of Inanna's sacred cow is especially popular in the artwork of the Uruk period (4000-3000 BCE) where it is sometimes seen with Inanna's sacred standards:

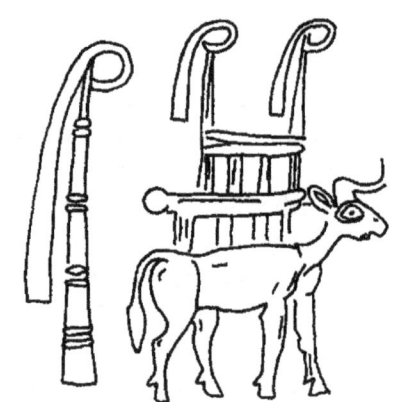

4 Inanna's cow with standards [7]

[4] Wilkinson 2003, page 174.
[5] O'Flaherty 1981, page 174.
[6] O'Flaherty 1981, page 172, mentions only three hymns are dedicated to Parjanya, the sky-bull.
[7] Amiet 1961, plate 46, fig 653.
[8] ETCSL: Inanna C, lines 182-196.
[9] ETCSL: Associated with Enlil - Inanna F, lines 14-17. Associated with An - Iddin-Dagan A, lines 20-33.

The Cattle of Heaven

Another image from the last centuries of the Uruk period provides us with a much more detailed exposition of the cow's celestial attributes:

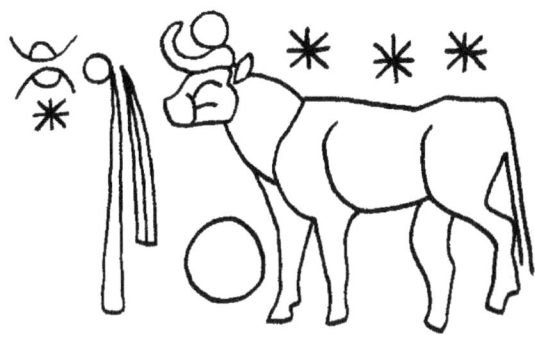

5 The Cow of Heaven [10]

From a symbolist's point of view, this image of Inanna's celestial cow is, to all intents and purposes, identical to the icons of Hathor with her star-spangled hide and the solar disk set between her horns. The various elements seen in this image of Inanna's cow can effectively be read as script as most of them have their counterparts in the cuneiform writing system. Although there is no formal grammar present, the basic concepts rendered here are perfectly clear – the left-hand part of the design can be translated as 'divine Inanna of sunrise & sunset', while the right-hand side defines the celestial cow in terms of the solar disk and the stars.

The cuneiform signs used in this illustration can be tabulated as follows:

	This combination of signs was used to write Inanna's name throughout Mesopotamian history. The initial star is acting as a determinative or classifier, which signifies the class of 'divine beings'. The second sign, known as a ring-post, was Inanna's primary emblem or standard in archaic art. It was built of bound reeds and apparently had streamers tied to its top which fluttered in the breeze.
	The next two signs are images of the rising sun (*above*) and the setting sun (*below*). The uppermost sign, representing the rising sun was invested with a set of primary solar meanings, principally – sun, day, summer, heat & fever.[11] It is widely thought to depict the sun-disk rising between two mountains. The sign of the setting sun (*below*) is simply the inverse of the normal Sun-sign. It is a rarer and much more limited sign, which, in later literature, has no direct solar meanings. Instead, its principal use was to signify the action of 'getting smaller or weaker'.[12] However, it is very likely that this meaning was derived from the image of the setting sun disappearing below the horizon.

[10] Late Uruk period cylinder seal. Glassner 2003, fig 8.9 on page 175.
[11] PSD UD [sun].
[12] PSD SIG [weak].

The Cattle of Heaven

We don't have any grammar to stick these bits of information together, but it is easy enough to understand their relationship. Just like Hathor, the goddess Inanna is defined in terms of sunrise and sunset. From these attributes we can deduce that Inanna, like Hathor, embraces the whole of the daytime heavens traversed by the disk of the sun.

The remaining motifs found in this design can be understood as follows:

	The **Mul**-sign, composed of three stars, refers to all manner of 'celestial bodies', be they stars, planets, constellations or meteors.[13] Although most examples of this sign arrange the stars in a triangular pattern, there are several examples like this one that just place the stars in a row. This way of rendering the **Mul**-sign makes it very similar to the Egyptian sign for 'star, constellation', which is made up of three pentacles set in a row.
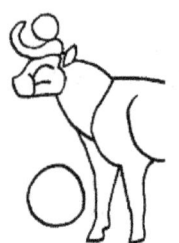	The final elements in this design are the two circles set around Inanna's cow. The large circle placed before her breast and the smaller disk set upon her horns are both presumably renditions of the sun disk. Thus, this Mesopotamian image of Inanna's sacred cow is effectively identical to the Egyptian cow of Hathor whose horns are also adorned with the solar disk or has the boat of the sun set at her breast.

In summary, we can see that both the heavenly cows of Inanna and Hathor have a close association to sunrise and sunset, both have the radiant sun-disk placed upon their shining horns, and both creatures have a set of stars strewn across their bodies. This grouping of symbols, known from the earliest times, defines the essential nature of the sacred cow in archaic art and myth. She is a symbol of the fertile heavens, which by day is brimming with the light of the sun, and by night, illuminated by the scintillating stars. All in all, this design summates the idea that the sacred cow embodies the whole of heaven filled with divine light. These characteristics identify the cow as one of the great prehistoric symbols of the heavenly goddess.

The very nature of this heaven-born light is to bring life to the worlds. Heaven is symbolised by a great cow for the fundamental reason that, like all mothers, she brings her calf to birth. And this calf is emblematic of all the earthly life that originates in the heavenly realms. This idea is most naturally expressed in ancient art by the great icon of the cow and her calf:

[13] PSD: MUL [star] & Labat 1988 #129a on page 96-97.

The Cattle of Heaven

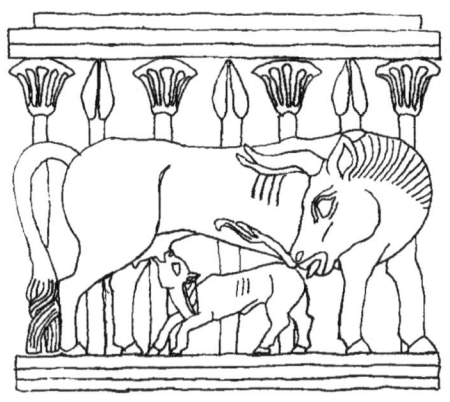

6 The cow and her calf [14]

The cow and her calf are a recurrent motif found in art, myth and religion throughout the ages. The essential nature of the icon is divulged in literate texts where it is widely used as a symbol of parental love and devotion. Obviously such a meaning goes well beyond the overtly bovine form of the icon and ultimately refers back to the underlying conception of the mother-and-her-child.

Even here, in this very naturalistic image of the cow and calf, there is a visual subtext. The ornate plant forms atop their column-like stalks are not just ornamental features. Ultimately they allude back to the sacred trees of myth, whose crowns reach unto the very heavens.[16] It is here, in the heights of heaven, that the seed of all life is first conceived and formed. This idea, of far-reaching consequences, is often expressed by the wonderfully simple icon of the cow and rosette:

7 Cows and rosettes from an Uruk sealing [15]

The narrative behind this image is that the mother beasts have each eaten from the plant of life and have assimilated its seed into their own being. This pictorial device is a common way of expressing the idea that these cows have gained their own sexual maturity and their reproductive capacity. The potential or 'seed' of their own calves is contained within the flowers set above their backs. In more modern terms, we could compare the seed within these flowers to the eggs within the female's ovaries, which according to modern science are there from birth. Whatever the mode of interpretation, archaic or modern, the essential idea is that the potential of all life resides in these heaven-born seeds.

[14] Mallowan 1978, 56 fig 65.

[15] Amiet 1961, plate 24, fig 396.

[16] The Sumerian sign AN meaning 'god' and 'heaven' also means 'crown of a tree'. PSD AN [sky].

The Cattle of Heaven

This image also demonstrates another principle of visual symbolism: the flowers that represent the cow's 'seed' are, by convention, placed outside the creature that are thought to bear it. This convention is particularly common in seal designs where there is a background environment on which to display symbols. When the same icons are rendered as sculptural forms with no background space available, the seed-bearing flowers are placed directly onto the body of the cow. This mode of displaying symbolic attributes is perfectly illustrated by the clay model of Inanna's sacred cow seen in our next illustration:

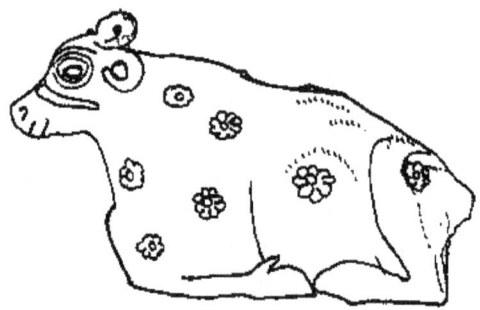

8 Clay model of a cow [17]

Now that we know a bit more about the visual language of the mother goddess we can better appreciate the symbolism of her sacred cow. Her body, covered in a multitude of rosettes, points to the fact that she is an embodiment of the fertile heavens that holds the seed of all living beings within her body.

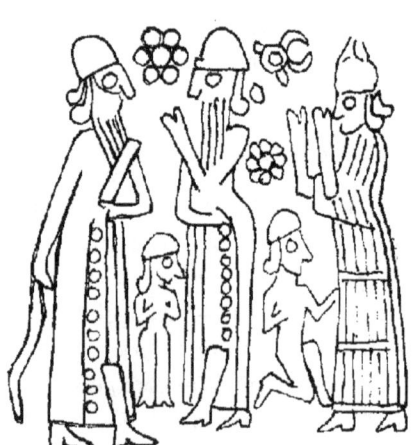

9 The heavenly rosettes and their 'seed' [18]

The nature of these flowers and their all-important seeds are revealed in images such as fig 9 (left). Here we see a Lama goddess (on the right)[19] and a nobleman praying that his Lordship (on the left) is granted the boon of children. Both petitioners raise their arms to the heavens and pray to the heavenly rosette that its 'seed' may fall to earth in the form of children – here a kneeling boy and a tiny girl. By incorporating the very human element of children this image shows beyond any doubt that humanity is at the very heart of these fertility designs.

[17] Goff 1963, fig 454.
[18] Assyrian 1500-1000 BCE. Collon 1987, detail of fig 855.
[19] The Lama goddess is an intercessor who typically prays on behalf of the Lord or who introduces him into the presence of the gods. See *The Queen of Heaven* page 14 for a more detailed description of this figure.

The Cattle of Heaven

The same basic principles are also demonstrated in figure 10 (*left*), which helpfully returns to the symbolism of celestial cattle. Here, in this simpler image, it is much easier to understand what is going on.

Again the Lama goddess raises her hands and prays to the heavens but this time in the form of the solar disk and crescent moon. The child that she prays for appears before her in the form of a child's head alongside the head of a calf. Images like this only make sense in the context of symbolising the heavens as a cow that gives birth to the child in the form of a calf. Like the seed fallen from the celestial flower they have descended through the skies to be born upon earth.

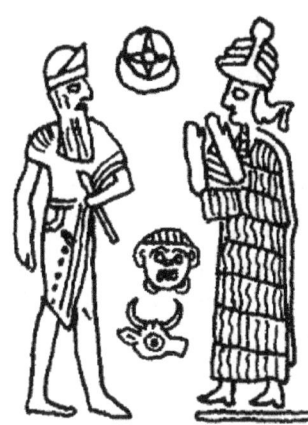

10 The bull-calf metaphor [20]

The identity of the child and calf is very helpfully proven in the cuneiform writing system where the **Amar**-sign *(right)*, which evidently depicts the head of a calf, is commonly used to signify any type of 'youngster' including the human 'child'.[21]

Two versions of the **Amar**-sign

The perfect summation of all these ideas is the Egyptian image of the heavenly cow suckling the human king *(below)*. Exactly the same idea is found in Mesopotamian traditions where Enmerkar, a predecessor to Gilgamesh on the throne of Uruk, was described as being born to the 'good cow' in the 'heart of the mountains'. The text in question further describes him as being 'given suck at the udder of the good cow', which, in the symbolic language of royal ideology, indicates that he was rightly destined for the kingship. In a very similar manner, Gilgamesh proclaimed that his mother was Ninsun – the 'Lady Wild Cow' – the patron goddess of Uruk.

11 An Egyptian prince suckles at the udder of the great sky cow [22]

[20] Colon 1987, fig 185.
[21] PSD: AMAR [calf].
[22] Internet source. Deir el-Bahri shrine.

The Cattle of Heaven

In all these instances, the mother-child relationship between the celestial cow and humanity is plain to see. What is more, the occurrence of near identical symbolism in ancient Egypt and Mesopotamia shows that there is a coherent and international system of ideas behind all this exotic imagery.

As we will see in the next chapter, much of the symbolism applied to the celestial cattle can also be applied to other horned animals like mountain goats, deer and bison. I suspect that the origins of this symbolism may be traced back to the 7th millennium BCE when mankind first undertook the domestication of wild herd animals and entered into a deeper symbiotic relationship with his livestock than hitherto known among early hunters. This era of prehistory, commencing in the Neolithic age, is what I call the First Age of myth and art. This was when the goddess alone ruled the heavens and all its fertile powers.

In the latter half of the 4th millennia BCE, however, we start to see changes afoot in the artistic record and the dawn of a new Age of art and myth. Alongside the great cow of heaven, we start to see the appearance of decidedly masculine versions of the sky beast. In the Second Age of myth and art, the symbolism of fertile bulls and Billy goats, bearded rams and randy bucks comes to the fore. We will explore the symbolism of these various horned beasts in the next chapter; for the moment we will endeavour to sketch out the nature of the great bull of the sky.

The Bull of Heaven, as he is called in Mesopotamian lore, is a magnificent beast that embodies all the powers of the fertile skies:

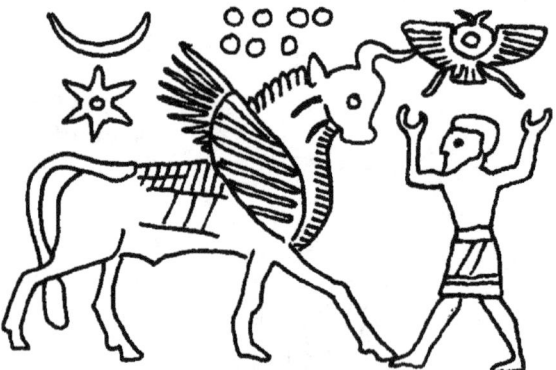

12 The winged bull of heaven from an Assyrian seal [23]

Like the celestial cow, this bull's body represents the entire realm of heaven and within this frame of reference his wings naturally refer to the ever-shifting winds and the storms that they stir up in the skies. This bull's celestial aspects are further emphasised by the sun and moon placed above his rump. In fact, there is good reason to identify this particular bull with the zodiac figure that we know today as Taurus as the seven dots

[23] Frankfort 1939, Plate XXXV, fig h.

The Cattle of Heaven

seen above his neck can be positively identified as the compact cluster of stars known as the Pleiades, which are still depicted at the shoulder of Taurus.

The nature of the heavens is summarised in the icon of the winged-disk seen above the human figure. In essence, this icon is a solar disk adorned with wings. Like the wings of the bull, these wings also allude to the winds that blow through the heavens. The rains that the winds bring are here represented by the two outflows of water that descend like legs from the body of the divine disk.

All this symbolism about the wind and rain and the celestial orbs identifies this bull as an embodiment of the skies. These symbols allow us to define the heavens as being composed of two basic realms – a lower stratum where the weather and the clouds hold sway and an upper stratum where the sun, moon and stars shine forth. Although this image maps out the physical nature of the heavens, it doesn't really describe the essential nature of the skies as the realm where all life originates. To appreciate this aspect of the great bull of the sky we need to explore some more designs.

In contrast to the motherly cow who was adorned with flowers (*see figs 7 & 8*), the fatherly breed bull was often depicted with a huge head of barley set above his back:

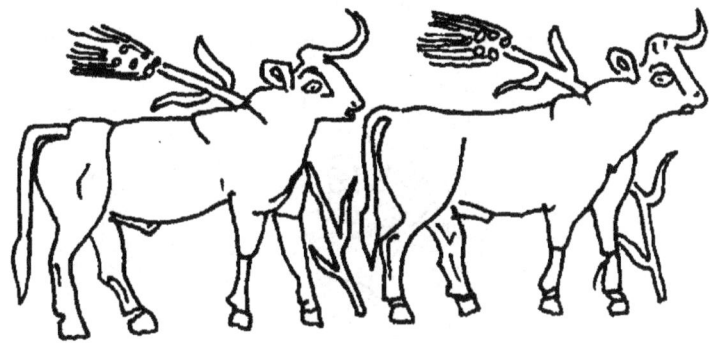

13 Bulls with barley heads [24]

Even with the change of plant-type, the meaning remains the same. Just like the flower, the barley-head represents the all-important 'seed' that is waiting to burst forth into manifestation. In Vedic literature this bull is characterised as the great breed-bull bursting with seed. His seed is the fertile rain, for he is the storm cloud that brings the steppes and foothills to life.[25]

This breed bull is the oldest and most natural symbol of the fertilising sky-father, the archetype of the generative fathers, who brought the earth to life with his semen-like rains. It was this celestial bull that came to dominate the realm of myth and religion in the Second Age of myth and art.

The fertile cattle we have met so far have assimilated the seed of a flower or the barley-head. While the symbol of the flower may well be timeless, the occurrence of

[24] Amiet 1961 plate 24, 397.
[25] O'Flaherty 1981, page 173. (Rig Veda 5.83 verses 2 & 6).

The Cattle of Heaven

cultivated barley is necessarily limited in time as it can be no earlier than the Neolithic period. I believe both these forms are developments of an earlier and truly prehistoric model which shows the sky beasts eating from the tree of life *(right)*.[26]

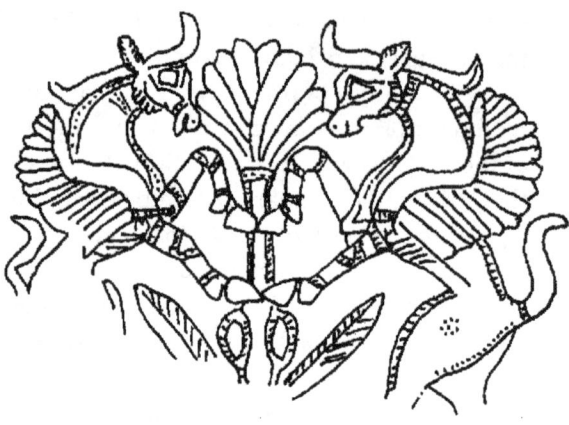

14 The sky-bulls acquire their seed [27]

Like many other horned beasts that clamber into an ornate tree, these winged bulls are intent on eating the flowers in the crown of the tree. In this design, the potency that the bulls have acquired is simply, but profoundly, represented by the flower-like pattern of seeds placed upon their thighs.

Occasionally the sky-bull is placed within a much more detailed artistic context. The following image from ancient Iran shows that he became a true counterpart to the celestial cow by absorbing many of her time-honoured symbols into his own sphere:

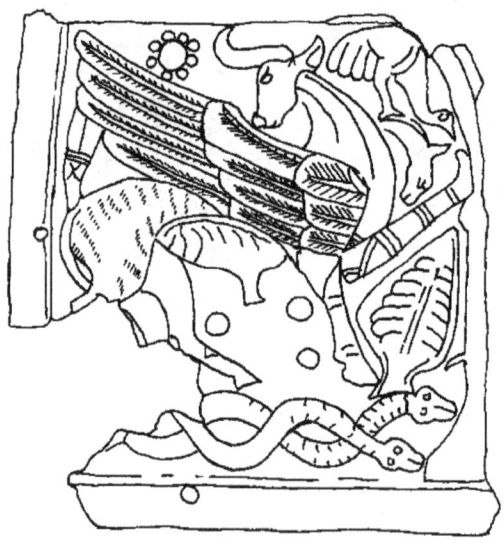

15 The fertile sky-bull from an Iranian plaque [28]

This magnificent winged bull is set among a veritable array of fertility symbols. Like previous examples, this bull has eaten from the plant of life that stands before him, and his 'seed' is again symbolised by the flower set above his wings. Other motifs

[26] See *The Queen of Heaven* pages 39-42.
[27] Porada 1965, fig 59.
[28] Godard 1965, fig 38.

The Cattle of Heaven

scattered around him include a bird with a calf head, which I believe is an abbreviated form of the heavenly bird carrying a calf down from the skies. This icon, as I have previously suggested,[29] is equivalent to the stork of European folklore that delivers babies to their mothers. These symbols of potency and fertility all express the procreative powers of the bull in an artistic and metaphorical manner. The same message is also conveyed much more directly by his prominent phallus and the circular seeds that fall from it towards the earth.

Finally, right at the bottom of the design, we have a pair of intertwined serpents. Here we are getting into much deeper symbolic waters. We will be meeting several more serpents (and a few dragons) in the course of this book, and as will become apparent there is a lot more to the symbolism of these maligned creatures than the sexual qualities that are so obviously tied to them here.

All these various elements are but a part of a grand scheme of symbolism that combines animal and plant symbolism into a unified theory that states that all earthbound life originated in the heights of heaven. This grand scheme reflects the prevailing ideas of prehistoric times, what I call the First and Second Ages of art and myth. But in the Third Age, the age-old cult of the Bull of Heaven and the motherly Cow were suppressed by the Akkadian gods and their earthly counterparts, the kings of the mid 3rd millennium BCE. The most famous account of this mythical deed is attributed to Gilgamesh who killed the Bull of Heaven in the open squares of Uruk.[31] The slaying of the great sky-bull makes an occasional appearance in ancient art. The example seen below emphasises the very human nature of the beast by giving him a human head.

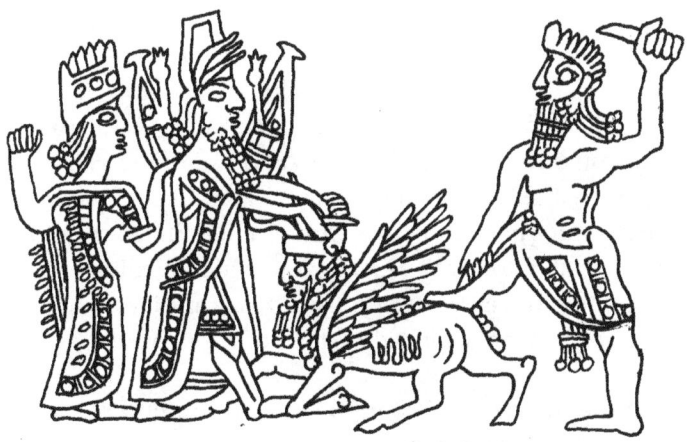

16 Gilgamesh and Enkidu slay the Bull of Heaven [30]

[29] See *The Queen of Heaven* pages 20-21.
[30] Black & Green 1992, fig 41.
[31] George 1999, pages 51-53 for the Akkadian version (Tablet VI lines 120-166); pages 166-175 for the Sumerian account.

The Cattle of Heaven

This particular design is a near perfect depiction of the latest version of the myth. On the right-hand side, Enkidu grasps the bull by its tail which allows Gilgamesh to approach the bull and deal the fatal blow: "like a butcher, brave and skilful" Gilgamesh thrusts his knife "between the yoke of the horns and the slaughter spot".[32] This version of events appears in the so-called Standard Version of the Epic that was current in the 1st and early 2nd millennia BCE.

Before this time the Sumerians had a slightly different version of events in which Gilgamesh smote the beast on its crown with his battle-axe of 7 talents.[34] Even more intriguing are some images of the slaying *(right)* which portray the bull being killed with a bow and arrow – a circumstance that is not currently known in any literary sources.

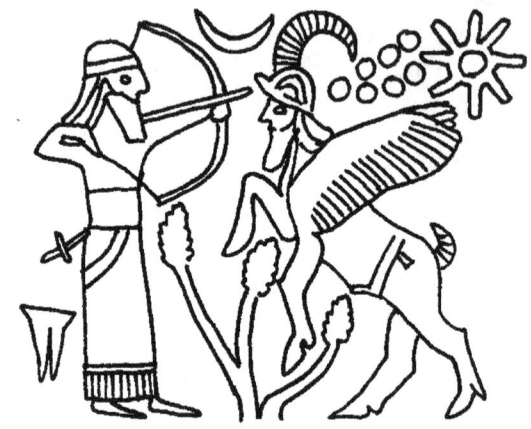

17 An alternative slaying of the bull of heaven [33]

Set among the celestial orbs and adorned with wings, this great bull combines the imagery of the celestial cattle with the fertility symbolism of the tree. He is truly a creature of the fertile skies and his human head attests to his real nature, and the nature of the seed he carries. For this bull of the skies is the progenitor of all life on earth including mankind. He is the great breed bull bursting with the seed of mankind.

Why was the bull slain? Ultimately I believe that he is a victim of cultural change. The older Sumerian idea that all life originated (and ended) in the empyrean skies didn't fit with the cultural norms of the Akkadian peoples that came to dominate Mesopotamia from the 3rd millennium onwards. For the Akkadians, the heavens were the home of a multitude of gods that ruled over the affairs of men like all-powerful kings. Heaven was no place for mankind who was now destined for a life of servitude on earth and who, after his death, was fated to dwell as a ghost in a gloom-ridden underworld. Accordingly the ancient conception of celestial cattle and their calf-like child was expunged from the religious cultus of the land. And with their fall a new, much more material, era was ushered in.

In the next chapter, we will continue our exploration of the celestial cattle through the symbolism of their shining horns.

[32] George 1999, page 52. (Tablet VI, lines 135-140).
[33] Detail from a Neo-Assyrian cylinder seal. Colon 1987, fig 880.
[34] George 1999, page 174. (Text MA line 127).

The Lustrous Horn

The sacred cattle that roam the skies of ancient myth embody the life-giving powers of the heavens, chiefly the sunlight and the rains. To emphasise the procreative powers of these cattle, they were commonly adorned with flowers or barley heads. As we will see in the course of this chapter, the fertile powers of these cattle were particularly concentrated in their magnificent horns.

In modern slang, 'getting the horn' is a well-known euphemism for lust and sexual desire. In archaic art, the horns of the wild beasts, be they mountain goats or deer, domestic cattle or wild bison, will be shown to draw on the very same ideas. The most naturalistic expression of the generative powers of the sacred horn is seen in our first design:

18 Wild goats climb the mountain and gain their sexual seed [1]

Again the basic narrative behind this design is that the mountain goats have climbed the sacred mountain and have eaten from the tree of life that grows on its peak. The 'seed' that they gain from the tree is very directly expressed in the way that their progeny spring forth from their horns. The idea of a new generation springing into existence is also encoded into the tree symbolism found in the outer areas of the design. Here, new saplings shoot up from the mountainsides showing that the family tree has, in effect, put forth new shoots.

The core element of this design – the goat-kid springing forth from its parent's horn – sometimes appears in a much more abbreviated form where the kid is represented by its head alone *(right)*:

19 The fertile horn [2]

[1] Late Uruk period. Frankfort 1939, plate IV, fig j. Also Amiet 1961, plate 34, fig 537.
[2] Mid 2nd millennium BCE sealing, Nuzi (Iraq). Stein 1993, detail from fig 2.

The Lustrous Horn

These two designs, which show the kids springing directly from the horns of the parent, can be regarded as a template for a whole series of symbolic variations.

The elegant design seen below makes the first elaboration of many on the symbolic powers of the mountain goat's horns. It shows that the fertile powers of the tree, assimilated by the goats, go straight to their horns:

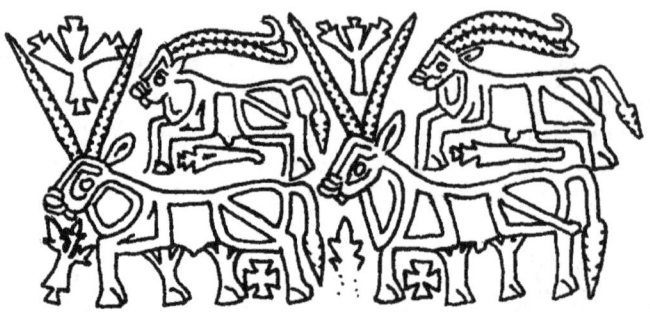

20 Horned beasts feed on the plant of life and thereby produce their young [3]

The horns of these beasts are bursting with the verdant force of the tree. Their horns have seed, and that is manifest in their kids which are seen in the upper registers of the design. Like the first image, this design utilises the symbolic language of trees to spell out the same message. In this design, the tree between the beast's horns has reproduced itself as the single branches set below the goat-kids. The very same idea is still present in the English language when we speak of an heir or descendant of a person as their 'scion' – whose primary meaning is a branch or young shoot of a tree.

The close association, even the identity, of the fertile horn and the verdant plants can be traced back to Neolithic times, as the following pair of Samarran designs show:

21 & 22 Two Samarran dishes with deer and plants [4]

[3] Collon 1987, fig 912 on page 189.
[4] Left, Huot 2004, page 57, top image. Right, Goff 1963, fig 39.

The Lustrous Horn

In both these Samarran designs, the horns of the beasts are fashioned in exactly the same way as the foliage that they browse upon. All this symbolism is neatly summed up in the Akkadian term *kisittu*, which at once refers to the 'branches' of a tree, the 'branches' of a stag's horns and the 'branches' of one's family tree – all three meanings are but different ways of referring to a person's ancestry.[5]

The images that we have explored so far provide a useful foundation for taking our study further. Now we are in a good position to approach some of the more bizarre combinations that are encountered in ancient art, such as the following design from Northern Iraq, which places a rosette and a scorpion upon the beast's curvaceous horns:

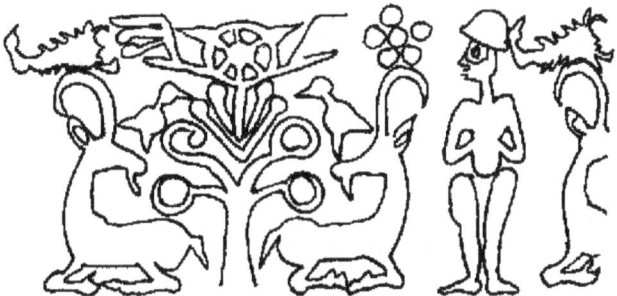

23 The nature of the horns is symbolised by a scorpion and a rosette [6]

Scorpions and rosettes are often paired together in this type of design. Obviously the flower can be treated in the same manner as the tree, since both symbols are really ciphers for the all-important seed. This explains why the flower symbol can be added to the goat's horns, but the scorpion is much more of a surprise. That the scorpion is a definite attribute of the horns is proven by our next design:

24 The ancestral herds and their living offspring [7]

[5] *Kisittu* – CDA 'branch or bough' of a tree, 'branch' of stag's horn, 'stem' of reed. The meaning has been transferred to the human sphere when it refers to the genealogical 'descent' of person, as well as referring directly to a 'descendant & offspring'.

[6] Stein 1993, fig 164.

[7] Collon 1987, fig 55.

The Lustrous Horn

The fertile powers of the horns are again expressed through the agency of scorpions and flowers, but now the association of the scorpion with the horn is emphasised even more. Here the scorpions are actually physically fused to the horns. To be more precise, the horns are merged with the scorpion's stinger. Above all else, this shows that the essential part of the scorpion, so far as fertility symbolism goes, is its upraised stinger. It is easy enough to interpret the raised stinger of the scorpion as a phallic symbol but we should not presume that this masculine meaning is intended here. Later on in this book we will also explore the feminine side of the scorpion. As we will see 'mother scorpion' is revered in ancient folklore as a paragon of motherly devotion due to the fact that she carries her tiny youngsters around on her furrowed back until such time as they can fend for themselves. Beyond attributing a general 'fertility' aspect to the scorpion here, we will have to return to this much misunderstood creature in Part Two of the book.

Getting back to the design seen in fig 24 it is plain to see that this image is utterly dominated by the symbolism of horns and horned beasts. I believe there are two types of horned beast represented here. In the upper parts of the design we see a whole series of heads belonging to different types of animals – I believe these heads represent the timeless ancestral herds. In contrast, I would argue that the three complete goats seen in the lower part of the design are their living kin upon the earth. These living beasts have attained their fertility and have channelled the ancestral powers above them into a new generation of offspring – their tiny youngsters can be seen set beneath their beards.

The motif of the fertile horn and its seed-like powers attained a rare grandeur in the hands of Iranian artists. One of the favourite themes of pottery painters working in the middle of the 4th millennium BCE was to place an image of the farmer's field within the circular frame of the beast's horns:

25-28 Design details from various Iranian funerary vases [8]

The powers inherent in these over-sized horns are still expressed through the agency of seeds, but here, within a farming metaphor, they are recast as the cereal seeds set in the fields of the barley farmers. The fields are represented by a range of graphic

[8] All mid 4th millennium BCE. 1st & 4th Lloyd 1978, The Archaeology of Mesopotamia, details from fig 48. 2nd Ayatollahi 2002, detail from fig 10. 3rd Parrot 1960, detail from fig 79 on page 61.

The Lustrous Horn

forms: in the two examples seen on the left we see a chequer-board system of fields and an irrigated field with its furrows full of flowing waters; and in the two images on the right, we see different types of field both embellished with a huge ear of barley.

The enormous horns of these beasts are the defining feature of these four designs. Their highly distinct form has even lent them to become the basis of the earliest examples of abstraction in ancient art. Divested of any body they can be portrayed as a symbol in their own right as can be seen in the following design from another Iranian bowl:

29 Abstract sets of horns from an Iranian bowl [9]

While the pairs of curving horns are easy to recognise here, I am not at all sure about the other smaller elements in this design *(right)*. Due to their number I tend to think that they are independent symbols, perhaps frogs or turtles. If that is the case, then they would symbolise the foetal forms of children produced by the horns.[10]

After surveying these diverse ways of expressing the powers of the horn it becomes a lot easier to recognise similar ideas in other designs. When I started the pictorial research for this book, the following image was one of hundreds that just presented a confusing mass of rather generic 'fertility symbols'.

30 A human child springs from the goat's horn [11]

[9] Kawami 1992, fig 8 on page 14.
[10] See *The Queen of Heaven* pages 29-30.
[11] Stein 1993, fig 439.

The Lustrous Horn

But now the whole image resolves itself around the horn of the wild goat and the human figure that springs from it. What a succinct way to express the nature of the horn's fertile powers!

Just as the animal's horn is depicted as the source of the human child, when an adult grasps the horn for himself he too attains the power to father children:

31 An adult man gains his sexual potency [12]

These last two designs show that the horn metaphor, like all the other metaphors of fertility, applies to mankind just as much as it pertains to his precious herds. In the wisdom of everyday speech, this man has acquired the 'horn' of the buck, the stag and the ram – in animal terminology this man has become a 'stud' just as much as the breed bull of the skies.

And the seeds he carries within him are as numerous as the seeds of the flowers and trees that surround him.

Some modern scholars believe that the velvet from deer horns was mixed into beer or wine and used as a magical concoction. Apparently modern studies have shown that it has aphrodisiac properties.[13]

All these horns are easy enough to understand as simple symbols of fertility that perpetuate the generations of man and beast. But in ancient art, horns are much more than this. The true nature of the beast that bears these fruitful horns is finally revealed in another Iranian design:

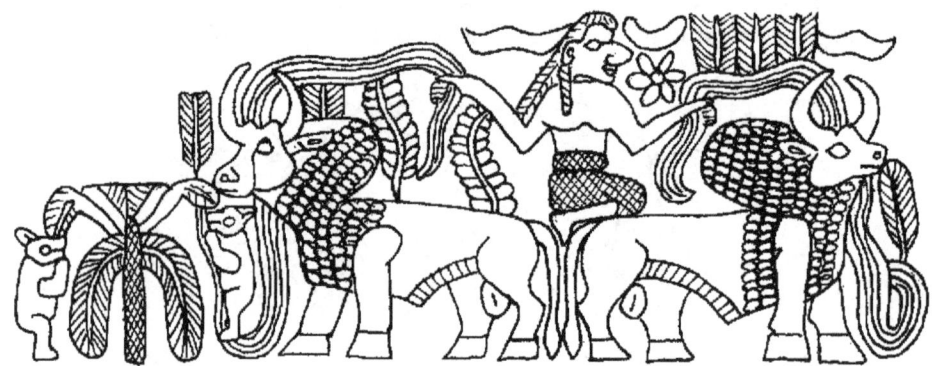
32 The celestial waters flow through the horns of the sky-bull [14]

[12] Collon 1987, fig 242.
[13] Sexualitat Article, page 415.
[14] Porada 1965, section from fig 12, on page 36.

The Lustrous Horn

These great bulls are nothing other than the breed bulls of the skies. The waters that flow through their horns are the waters of heaven, the life-bearing rains that bring abundance to the earth. This design proves that the animal horns found in ancient art represent the fertile powers of the skies.

The icon of the heavenly waters flowing from the horns of the sky beast recurs throughout Near Eastern art. The motif even appears in literary format in an incantation that seeks to bring the benevolent waters down from heaven to bless and purify the king. Here the waters are described as dripping down 'from the thick horns of the stag' and as 'flowing from the cow-shaped horn of the mouflon' (one of the wild ancestors of domestic sheep).[15]

With this new insight in mind many other images of divine bulls start to make a lot more sense. The following pair of images, hailing from the Halaf period, can now be seen to be another way of illustrating the rain-bringing bulls of heaven:

33 & 34 Two bowls decorated with bull's heads and glyphs of the heavenly rains [16]

The basic motif of the water-bearing horns can be traced back to the very origins of Mesopotamian art where they can be seen to inform the image of the Samarran deer (*right*) whose wavy horns also express the watery nature of the skies.

The rippling horns of these deer express the very essence of the waters that course through the heavens. The groups of fish that follow in the train of these deer, like all the symbolic forms that spring from the fertile horns, symbolise the life-within-the-waters.[18]

35 Samarran bowl with stags and fish [17]

[15] Van Dijk & Hussey 1985, page 34.
[16] Mellaart 1975, left & right, fig 150 on page 233. Halaf period.
[17] Mellaart 1965, fig 40 I. For a photo see Roaf 1966, page 39, lower left.
[18] See *The Queen of Heaven* pages 22-25.

The Lustrous Horn

The last few designs have started to build up a bigger picture of the fertile horn. From the calves and kids that leap into manifestation from the horns of a wild goat, to the flowers and trees that express their seed-producing capacity, to the celestial waters that flow through the horns of the sky-bull, the mighty horn is revealed as the true cornucopia of heaven, pouring forth its abundance upon the earth. All these diverse icons show that the horn of archaic art must be another way of expressing the fundamental nature of the fertile heavens.

However, one element remains – light. To be a fully functional symbol of the heavens and all its powers, the horn also needs to embody the nature of heavenly light.

We have already met with a design that fulfils this criterion (*right*). Inanna's sacred cow with a sun-disk adorning its crown is the perfect expression of the light-bringing horn.

Detail of fig 5

Similar images, drawn from other historical periods, both earlier and later, spell out the same message:

36 & 37 The light-bearing horns [19]

These two designs attribute the radiant light of the sun and the stars to the horns of the celestial cattle and mountain goats. Similar ideas can be found in literate sources. A simple word-search of Sumerian mythical texts produces several instances of cattle with shining horns.[20] For instance, the 'wealth of the land' can be symbolised by 'its mighty cows with shining horns'.[21] In the poetic language of the Temple Hymns, the temple can sometimes be compared to 'a wild cow growing horns and delighting in its shining horns'.[22] More to the point, the temple of the sun god could also be symbolised as a 'shining bull' that lifts his head to Utu in heaven; this bull's 'shining horns' are described in the hymn as 'aggressive, holy and lustrous'.[23]

[19] Left, Stein 1993, fig 11. Right, Mellaart 1975 fig 150.
[20] Search the ETCSL site for 'horns'.
[21] ETCSL: Lament for Sumer & Urim 411-319.
[22] ETCSL: Temple Hymns 147-156.
[23] ETCSL: Temple Hymns 169-177.

The Lustrous Horn

The light-bearing nature of the holy horns is remembered in Sumerian poetics, where the term **Simul**, meaning 'shining horn', is used as a by-name for the stag.[24]

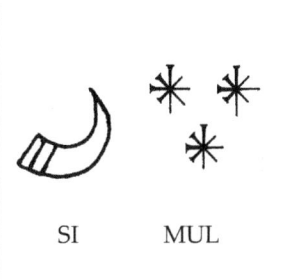

SI MUL	**Simul** is a poetic name for the stag. It has a range of possible meanings. In this context, 'sparkling horn' or 'shining horn' is probably the most appropriate, but 'branching or radiating horn' may also be implied by the term. The **Si**-sign depicts the horn of a bull or bison, and the **Mul**-sign, although commonly meaning 'star or constellation' also has the verbal meaning 'to shine or radiate'.

Both meanings of **Simul** – as radiating horn and sparkling horn – are very appropriate to the magnificent stag seen below in fig 38. The seed-bearing potential of the horns is again expressed through the agency of the goddess' heavenly flowers which, being symbols of the sunlit skies, may further lend the stag's horns a quality of glistening light.

38 Design from an Iranian plaque [25]

The light-bearing horns are also found in Greek mythology, where they belong not to a stag, but to a hind that was held sacred to Artemis. The Hind of Ceryneia was described as a huge creature, larger than a bull, with hooves of bronze and enormous golden horns that glinted in the sun.[26] Hercules was set the task of capturing it as one of his Labours.

Now we know more about the underlying symbolism of the light-bearing horns, the hind's golden horns that 'sparkle in the sunlight' become the central feature of the mythical beast. This attribute and her brazen hooves are enough to identify her with the solar horse of the Indian Vedas whose flowing mane represents the sunlight radiating through the skies. It too has the same thundering 'hooves of bronze' [27] that bring on the rains and storms. All these mythical creatures are ultimately symbols of the fertile skies. They all allude to the highly poetic image of the celestial waters being enlivened by the light of the sun and the stars.

[24] PSD: SIMUL [stag].
[25] Godard 1965, fig 11.
[26] Graves 1992, section 125a, page 472.
[27] See *Babylonian Star-lore* under the 'Horse' for more details and references.

The Lustrous Horn

While most of the images we have explored so far depict horns that belong to wild goats and cattle, on a more mythical plane, the shining horn of the sky really belongs to the great bison.

The Sumerian sun god, Utu, was himself directly symbolised as 'a bison running over the mountains'.[29] This lovely image refers to the sun running over the mountain of heaven, whose holy slopes map out the sun's rising and descending path through the skies. Before Utu was the bison in the mountains, the goddess herself played out this role. In her own densely mythical words, the goddess declares: "I (Ištar) am the bison of the mountains, who lifts up his horns".[30]

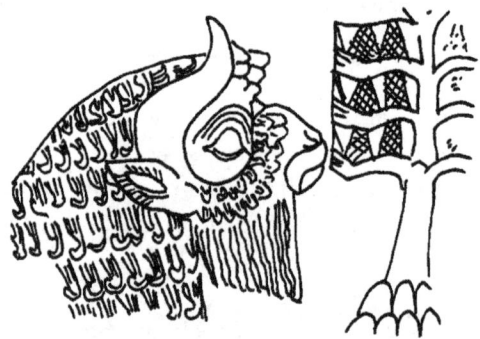

39 The bison eats of the tree of life [28]

Even the Sumerian lexicon confirms the light-bearing qualities of the goddess' horn. The Sumerian term **Simuš**,[31] which combines the horn-sign with Inanna's ring-post, defines the very nature of the goddess herself as the pure light of heaven.

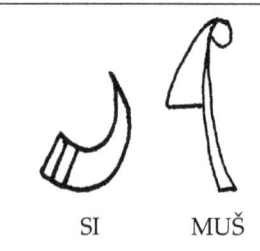

Simuš is the Sumerian term for 'brilliance, radiance' and 'ray' (of light).

Made up from a bull's horn (**Si**) and the ring-post sign of Inanna (**Muš₃**), the term can be understood as the lustrous horn of the sky goddess.

By establishing that Inanna's horn also radiates light we have finally proven that the horn is an all-embracing symbol of the abundance-bringing skies. All the powers of heaven emanate from the great horn of the sky-beast; it is a truly comprehensive symbol of the fertile skies. We can just about squeeze its manifold characteristics into a schematic diagram:

[28] Godard 1965, fig 42.
[29] ETCSL: Utu B, lines 1-6.
[30] CAD: *kusarikku*.
[31] PSD: SIMUS [brilliance].

The Lustrous Horn

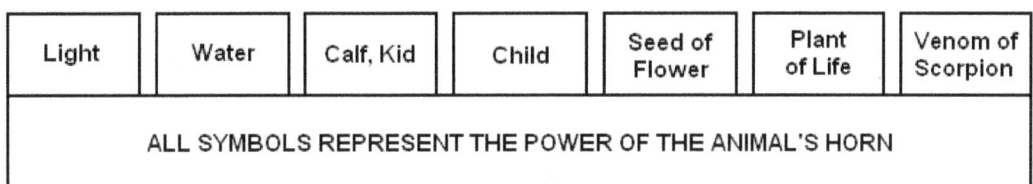

Summary of the horn's symbolic nature

This diagram shows the true nature of the animal's horn. The varied symbols attached to the horn show it to be one of the primary symbols of ancient art.

The final image in this chapter comes from the prehistoric period of high symbolism, when artists and designers expected their educated audience to add their own accumulated knowledge to the skeletal framework they provided.

40 A design from a Halaf period bowl [32]

From a symbolist's point of view, this minimalist icon expresses all the fecund powers of the heavens. Like so many ancient icons, it is a complete glyph of the light-bringing, water-bearing realms of the skies that bring the seed of all life to birth upon the earth.

[32] Goff 1963, fig 89.

The Cattle-pen

The cattle-pen is one of the most important symbols in the whole of ancient Near Eastern art. It is one of the prime symbols of the land's abundance as defined by its herds and the bounty they produce for the benefit of mankind. On many seal designs, newborn lambs and calves can be seen emerging from its doors to frolic in the fields:

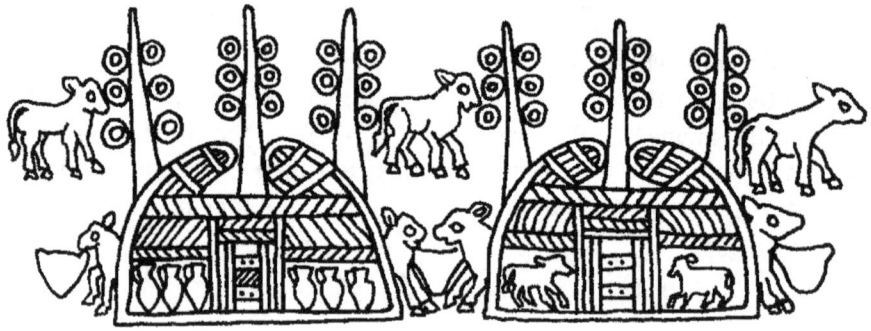

41 A cattle-pen from a Sumerian seal [1]

With the birth of their calves and kids, their mothers start to produce bounteous milk. They produced enough milk for the youngsters, which is fed to them in large bowls, but more to the point, they produced a large surplus that could be used for the benefit of man, which is why one of the pens in this design is full of milk jugs.

The cattle herds produce milk, and sheep produce fleeces, both of which have their uses in their natural state, but it is only when these natural products are developed through technology that they become significant cultural and economic assets. Milk can be made into butter, ghee and cheese, all of which have a long storage life and are easy to transport and trade; while fleeces are transformed through spinning and weaving into all manner of cloth and fabrics – one of the most important industries of Mesopotamia throughout its long history.

The buildings seen in the illustration above are entirely built from reeds. The superstructure of the pen was made from bound reed columns which were then covered with mats of woven reed. The resultant cattle-pen was a smaller but otherwise identical copy of a reed-built house. The similarity between the cattle-pen and men's houses is the first hint that there is something more to the cattle-pen than a mere animal stall.

We can get a good idea of the cattle-pen's cultural significance by looking at contemporary cattle-herding cultures in parts of West Africa. In the course of Jack Goody's book *Death, Property and the Ancestors* the author provides a wealth of evidence for the cattle-pen being used as the prime ritual arena for all the major ceremonies connected with human births, marriages and deaths.

[1] Collon 1987, detail from fig 12.

The Cattle-Pen

Beyond its mundane uses to house livestock, the cattle-pen also served the function of a birthing house and a temporary funerary parlour for the human population. The cattle byre, which was generally adjoined to the living quarters of each compound, was where the womenfolk gave birth to their children.

The first things that newborn children would see upon their birth were the roughly hewn wooden statues of the kin group's ancestors. These ancestral figurines, usually only a couple of feet in height, were permanently housed in the cattle-pen. They were also utilised in the extended ceremonies performed at the death of a clan member. Before its final burial outside the compound, the corpse was first placed in the cattle-pen, among the ancestors. In a rite that parallels the Orphic ritual of scattering seed upon the grave, the chief mourner would stand upon the roof of the adjacent building and cast grain upon the dead man and the ancestral figurines.

These West African traditions, show that the cattle-pen was regarded as the primary ritual arena of the human family. Within the safety of the cattle-pen's walls, the children of a new generation came to birth amidst the ancestral shrines, and at death the deceased returned to the potency of their ancestral kin. The cattle-byre is effectively cast as a two-way 'gateway' between the world of the living and the timeless worlds of the ancestors.[3]

42 Calves emerge from a sacred cattle-pen[2]

Turning now to Mesopotamian traditions we will presently see that the cattle-pen is also intimately associated with the idea of human birth. The best place to start our investigation is in the Sumerian writing system, where the domed structure of the cattle-pen and the ring-posts that typically surmount it can still be recognised in the cuneiform sign known as **Tur₃**:

Two versions of the **Tur₃**-sign	The **Tur₃**-sign has the basic meaning of 'animal stall' or 'courtyard' but in ominous texts it takes on the further meaning of 'halo' of light. (We will return to this significant secondary meaning in the next chapter). The ancient form of the **Tur₃**-sign is closely based on the shed-like cattle-pen with a large ring-post on top. The ring-post is an independent sign in its own right (the **Nun**-sign) which refers to a 'noble' or to a 'princely' quality.[4]

[2] Goff 1963, fig469.
[3] Goody 1962, page 78, 226 & 228 for scattering seeds on the corpse and the ancestral figurines; pages 391-2 for birth and marriage ceremonies held in the cattle-byre; and page 234 for installing the ancestral figurines in the cattle-byre.
[4] PSD: NUN [prince].

The Cattle-Pen

The core image of the cattle-pen also forms the basis for another independent cuneiform sign. By tilting the ring-post over on its side, a new variant sign called **Tu** or **Tud** is made (*right*). The purpose of creating this variant sign is to assign it a different meaning.[5]

The **Tu**-sign

Accordingly, this sign is not used to write the name of any cattle enclosure but is instead specifically used to write the verb 'to give birth' or more specifically 'to bear a child'.[5] Modern scholars agree that this sign was utilised for this purpose because the cattle-pen was used as a birthing shed where lambs, kids and calves were born into this world. This meaning refers back to the gate-like nature of the cattle-pen – just as the calf emerges from the gateway of the cattle-pen in ancient art so does the human baby emerge from the 'gateway' of its mother's womb.[6]

Thus within the writing system, the image of a cattle-pen, as well as conveying the material structure of the pen itself, also conveys an inner symbolic meaning – to give birth to a child. These same principles are reflected elsewhere in the Sumerian lexicon in various words and signs that incorporate either one of the cattle-pen signs. One of the most important such instances is seen in the name of Nintu, the birth goddess:

The name of Nintu	Nintu's name is made up from three signs. The initial star is used as a classifier or determinative, which identifies her as a 'deity or divine being'. Then the concept of 'lady or queen' is rendered by the central **Nin**-sign, which is itself a composite sign made up from the feminine vulva [7] set above a sign meaning 'noble', which may depict a seat of some sort. Together they connote a 'noble woman, lady or queen'. And finally, the variant cattle-pen sign conveys the idea of giving birth. So, according to the way her name is written, Nintu is the 'Lady who gives birth'.[8]

On a pictorial level, Nintu's name defines her as the 'noble woman of the birthing pen'. In literate sources she was identified with the Akkadian goddess *Šassurum* – 'Lady Womb', and in hymns of praise she is called the 'Mother of all the small children'. Her

[5] PSD: UTUD [bear].

[6] The concept of 'gateway' is explicit in another closely related sign called **Ku**, which also appears to depict a cattle-pen or reed-built house; it is used to write the common verb 'to enter or go in'. See Labat 1998 #58 where all three signs are treated as originally distinct but merging together, over the centuries, into a single sign with variant readings.

[7] PSD: GALA [vulva].

[8] Leick 1991, page 135 under 'Nintu/Nintur'.

The Cattle-Pen

birthing functions are touched upon in mythical texts where Nintu is described as the divine 'midwife of the land' and 'the cutter of the umbilical cord'.[9]

The close association between the cattle-pen and birth is further developed in the Sumerian word for 'womb' (Šag₄-Tur₃):[10]

Šag₄-Tur₃	The Sumerian word for womb is composed of two elements: The first sign (Šag₄) refers to the 'inner body' of a living being or the 'heart, middle or inside' of any inanimate object.[11] In origin, the sign may well depict the swollen belly of a pregnant woman. The second sign is our familiar cattle-pen sign which refers to the animal byre. Therefore, in Sumerian, the womb is understood as something like the 'interior birthing-pen' of the female body.

Regardless of which form of the sign is actually used, there is evidently an intimate connection between the idea of the cattle-pen and the womb. That connection is even stronger in another Sumerian sign known as **Šilam** (*right*). According to the lexicon, this uncommon sign simply means 'cow or bovine' [12] but its graphic form describes the cow in terms of a distinctly feminine and womblike cattle-pen.

The Šilam-sign

By combining the signs for 'cattle-pen' and 'woman, vulva' into one sign meaning 'cow' the **Šilam**-sign adds another layer of meaning to our evolving equation. We can now start to appreciate that the inter-linked concepts of cattle-pen, womb and cow seen here are merely aspects of one greater symbolic concept. Ultimately they all point to Inanna, the great cow of heaven who gives birth to humanity.

Due to the piecemeal way that symbolic equations work it will take a few more pictures to demonstrate this general proposition. The first such image (*left*) helps to identify the cattle-pen with Inanna. It does so by adorning the cattle-pen with the goddess' sacred ring-posts.

43 A cattle-pen with Inanna's ring-posts [13]

[9] Leick 1991, page 135.
[10] PSD: Šagtur [womb].
[11] PSD: ŠAG [heart].
[12] PSD: ŠILAM [cow].
[13] Detail from a Sumerian cattle-trough. Moortgat 1969, detail from plate 17.

The Cattle-Pen

This shows that the cattle-pen is not so much a symbol that is associated with Inanna but is, in fact, an aspect of the goddess herself just as much as the cow. Behind all the varied imagery is the unifying concept of the womb of the sky.

The human equivalent of the cattle-pen is the birthing house. It is typically depicted as a simple arched construction (*below*), and like most small ritual buildings it would have been made from the same ever-versatile reeds.

44 The birth house [14]

Here we see a woman entering such a birth-house; she is already holding her belly as if feeling the pangs of labour that herald the coming of her baby. The imagery around her shows that the heavens are still very much a part of the picture – their character is here expressed by the enormous rosette that dominates the design and by the goddess' all-seeing eyes that look down upon the birthing house.

The same celestial imagery is much clearer in our next design:

45 The cattle-pen as birth house of the heavenly goddess [15]

This design is dominated by the beatific face of the goddess looking down from the heavens. Her sacred rosettes are scattered along the arching vault of the firmament. The goddess' rosettes represent the life-giving potency contained in the skies – the seed of these flowers is the 'seed of humanity'. This seed-like potency is realised below, upon the earth, through the sacred womb-like gateway of the cattle-pen. This is where the calf-like child is finally born into the world.

[14] Detail of an Early Dynastic seal. Collon 1987, detail of fig 53.
[15] Amiet 1961, plate 48, fig 681. Also Goff 1963, fig 370 (photo).

The Cattle-Pen

Previously I have argued that the goddess' rosettes and her benevolent gaze are both symbols of the heavens illuminated by the life-engendering light of the sun.[16] Set within this context, these last four images (*figs 42-45*) bring to mind a seminal quote concerning the sun god's gaze bringing fertility to the world: "When you gaze upon the bulls in the cattle-pen, bulls fill the cattle-pen. When you gaze upon the sheep in the fold, sheep fill the folds. When you gaze upon the man …. ".[17] The quote is incomplete as the text is fragmented at this point, but the essential idea can be restored from the allusive symbolism found in one of Inanna's hymns: "The mistress stands alone in the pure heavens. From the midst of heaven, my lady looks with joy at all the lands and the black-headed people (the Sumerians) who are as numerous as sheep".[18]

46 A hind within a birthing house [19]

The same idea of the heavenly birth house is also expressed in designs such as that seen in fig 46 (*left*). Here we see exactly the same arched structure as appeared in fig 44 above. The hind that awaits inside its holy walls can be safely identified as a mother-to-be as the radiant sun that shines above her back shows that she carries a new life within her body.[20]

Now we can start to see the true nature of the cattle-pen. Beyond the simple metaphor that posits a mythical identity between cattle and mankind, the symbolism of the cattle-pen goes much further as it also explicitly embraces the symbolism of the heavenly mother and her celestial womb that brings all life into being. This is why the cattle-pen is so often adorned with ring-posts – they identify the sacred birthing pen as an aspect of Inanna, the goddess of the fertile skies.

The imagery of the cattle-pen is sometimes combined with other major symbols of the life-giving sky goddess. Previously we saw how the flying bird carrying its calf (*right*) could also be identified as another aspect of Inanna bringing her child to birth. Just like the stork that delivers a baby to its mother, the flying bird descends from the skies bringing its charge to be born upon earth.

As the next design shows, the very same long-legged bird can also deliver its charges via the agency of the womb-like cattle-pen.

47 The flying bird & calf [21]

[16] See *The Queen of Heaven* pages 94-96 for the gaze of the sun, pages 116-127 for the rosette.
[17] ETCSL: Utu E, lines 60-66.
[18] ETCSL: Iddin-Dagan A, lines 82-87.
[19] Early 3rd millennium BCE seal. Amiet1961, plate 59, detail of fig 801.
[20] See *The Queen of Heaven* pages 97-104 for a series of similar images.
[21] Collon 1975, detail of fig 60.

The Cattle-Pen

48 The heavenly bird brings the calves to birth via the cattle-pen [22]

By combining the cattle-pen with the heavenly bird, the artist has built up a purely symbolic picture of the birth goddess; it is her womb, the birthing-pen, which brings all earthly life to birth. In terms of its meaning, this image is identical to the icon of the winged goddess flying through the skies to deliver her calves and children to their mothers upon earth (*below*).

49 The Winged Goddess carries her children down from the skies [23]

The arguments and interpretations put forward in this chapter have so far concentrated on the pictorial evidence. Fortunately, some significant literary sources help to confirm our basic thesis. This additional source material is found in the annals of royal ideology where the birth of the king is often set within the mythical context of the celestial pen.

We have already met with Enmerkar, an early king of Uruk, who was born to the good cow in the shining mountains. Several centuries later, king Šulgi, a late 3rd millennium ruler of Ur, gave a very similar account of his own birth. In the royal hymns dedicated to this king we actually find three different variations of the 'born from the heavenly cattle' theme.

Firstly, just like Enmerkar, Šulgi described himself as a 'calf of the white cow'.[24] This effectively identifies him as a child of the feminine heavens. We can get some idea of the white cow's nature by the way her name is formulated in the written script:

[22] Early Dynastic Seal design, Amiet 1961, plate 58, fig 796.
[23] Detail from Louvre collection AO 7296. Winter 1987, Abb 379.
[24] Cunningham 1997, page 73.

The Cattle-Pen

'White Cow' (**Ab₂ Babbar**)	The first sign depicts the face of a cow (**Ab₂**) with its long downward-pointing ears; it is placed over the term for 'white' which was written with two **Ud**-signs depicting the rising sun. This double sun sign is read in Sumerian as **Babbar₂** – 'white'.[25] Intentionally or not, the way that 'white cow' is written appears to allude back to the various images of the great cow of heaven that are adorned with the disk of sun (*see fig1-3 & 5*).

Alongside this, Šulgi also claimed that he was the offspring of the sky-father when he proclaimed himself as 'the true seed of the breeding bull'.[26] More significant however, is the third variant of the born-from-a-cow theme in which Šulgi declares that he was 'born in the cow pen'.[27] In the most explicit account of his birth Šulgi declared: "I am a king born from a cow. I am the calf of a thick-necked white cow, reared in the cow-pen".[28]

The power and longevity of these ideas are remarkable. Even now, over 4000 years since Šulgi sat upon the throne of Ur, they are still alive in the Christian story of Jesus being born in the manger among the lowly animals. Like Šulgi 2000 years before him, Jesus also proclaimed himself the son of heaven and, as such, the rightful king of his people.

In the next chapter we will continue our exploration of the cattle-pen and will see that it is a truly wonderful conceptual model of the archaic heavens.

[25] PSD BABBAR [white].
[26] Cunningham 1997, page 72-3.
[27] Cunningham 1997, page 72.
[28] ETCSL: Šulgi C 1-17.

The Cross of the Stars

Just like the kings of ancient Sumer, the ordinary mass of humanity also had their ultimate origins in the holy cattle-pen. The basic tenets of this belief system are very clearly articulated in a group of magical incantations that were designed to aid an expectant mother to bring forth her child in safety. One of these birth incantations gives us a very succinct summary of the cosmic origins of the child. It runs as follows: "The cow is pregnant, the cow is giving birth in the cattle-pen of the Sun, in the sheepfold of Šakkan".[1] The rather dense poetic language needs to be unravelled a bit in order for it to yield its meanings. The 'cattle-pen of the sun' and the 'sheepfold of Šakkan' are the pivotal terms as they both have a very specific relevance to the heavenly realms.

The first term – the Cattle-pen of the Sun – leaves us in no doubt concerning the celestial locale of the cattle-pen. But to get to the real relevance of this poetic term we need to turn to an astrological text that explores some of the esoteric aspects of celestial terminology; I shall quote the passage in full and then explain its significance for our study:

> The Road of the Sun at the foot of the Cattle-pen is the Path of Ea.
> The Road of the Sun at the middle of the Cattle-pen is the Path of Anu.
> The Road of the Sun at the head of the Cattle-pen is the Path of Enlil.[2]

Naturally the 'Road of the Sun' refers to what modern astronomers call the 'ecliptic' – it is the path, give or take approximately 8 degrees, that all the celestial bodies (sun, moon and visible planets) travel through the stars. It is part of the fixed superstructure of the heavens and a fundamental part of ancient astronomy because this path incorporates all the zodiac constellations that we still recognise today.

The so-called 'Paths' of Enlil, Anu and Ea – who are the three principal gods of the pantheon from the early 2nd millennium BCE onwards – are another integral part of Babylonian astronomy as they refer to three broad divisions of the celestial sphere. The Path of Enlil includes the most northerly zodiac constellations, which rise in the summer months, and all the circumpolar stars. The Path of Anu is made up from the equatorial stars and includes roughly half the zodiac constellations. The Path of Ea is composed of the most southerly stars which includes the zodiac constellations that rise during the winter months.

Thus, according to the text, the 'Road of the Sun' traverses the three principal regions of heaven which are referred to as the 'head, middle and foot' of the cattle-pen. This text therefore identifies the whole of the visible heavens as the celestial cattle-pen. This is where humanity has its ultimate origins.

Our second poetic term –'the Sheepfold of Šakkan' – leads us to the same conclusion but by a slightly different route. According to modern sources, Šakkan was the son of the sun god, and the protector of all wild herd animals, being especially concerned with their

[1] Cunningham 1997, pages 107-108.
[2] BPO2, text III, line 24b.

The Cross of the Stars

fertility.[3] However, a quote from the *Erra Epic* reveals that there was much more to Šakkan's herds than the wild beasts that grazed the steppes and plains of the earth. The poem in question explicitly describes the Fox-star (a star in Ursa Major, the Great Bear) as being 'among Šakkan's cattle'. This means that Šakkan's cattle are nothing less than the 'astral images' of the stars and constellations that grace the night-time skies.[4]

Now we can understand the true significance of our birth charm – the calf-like child is ultimately thought to have its origins among the heavens that are illuminated by the light of the sun and the stars. As I hope to show during the course of this book, we can expand this paradigm to include the light of the moon and the planetary orbs that also travel the same Road of the Sun through the empyrean skies.

50 Cattle breed under the fertile skies [5]

Before extending the scope of our study I'd like to explore another brief passage from the same esoteric astrology text that I quoted on the previous page. Although this passage is only composed of three or four lines, they very neatly summarise and confirm our emergent thesis about the birthing pen of the skies.

The first line of our text, which is only partially understood, explicitly defines the celestial cattle-pen (**Mul E₂-Tur₃**) as a symbolic name for 'the entire sky' along with all 'the creatures of the sky'.[6] The 'creatures of the sky' refer to the astral images of the stars and constellations; they are an obvious precursor to our modern term 'zodiac', which refers to the ecliptic constellations as the 'circle of little animals'.[7]

The text continues with two pivotal lines that describe the essential nature of the heavenly cattle-pen:

The star of the womb is for … cattle ….

The star of the woman with the womb is for the fall (birth) of cattle.

[3] Black & Green 1992, page 172 under 'Šakkan'.
[4] Dalley 1989, page 296 (Tablet II).
[5] Ornan 2005, fig 213. Also Frankfort 1939, plate XXXV, fig g.
[6] BPO2, text III, lines 22-22a on page 43.
[7] The word 'zodiac' comes via Latin from the Greek term *zōidiakos*. Online Etymology Dictionary.

45

The Cross of the Stars

(Comment) 'Fall' equals '*miqtu*'.[8]

Even though parts of the text are impossible to translate, it self-evidently defines the abiding nature of the heavens in terms of the woman's womb and the birthing metaphor of the 'descending calf'.

The identity of the 'woman with the womb' can be none other than Inanna – this is proven by her name. Even though the goddess' name was always written with her ring-post sign (the **Muš₃**-sign), this way of writing her name obscures its real meaning and derivation. Ultimately she is (deity) NIN-ANA, the 'Lady or Queen of Heaven' (*right*). She is the celestial 'woman with the womb' that rules all heaven, who brings to birth the host of her star-born children.

Going back to our original quote about the Road of the Sun we can now appreciate the way that the pictorial nature of the cuneiform writing system can open up new vistas of understanding.

The very imagematic terms 'head, middle and foot' (*left*) that were used to describe the parts of the cattle-pen naturally form the basic outline of a human figure in the mind's eye. And as the sign used for 'middle' is the very same sign seen earlier that probably depicts a woman's pregnant belly, the human form that emerges from the text is that of a pregnant woman. This is the heavenly woman whose fertile womb is a symbol of the starry firmament.

The implications of this thesis concerning the womb-like heavens are manifold and highly significant for the early history of myth and religion. Later on in the book, we will explore the idea that the planets, as well as the sun and moon, were regarded as the

[8] My translation of the text: BPO2, text III, lines 21-24a. The text is difficult and like many symbolic texts written in cuneiform has in-built ambiguities. The last two lines in particular, illustrate the difficulties faced by any translator of cuneiform. The modern editors of the text translate them as follows: 'The star of the woman with the ... womb ...U ŠI ... cattle', with the comment: 'U ŠI = epidemic (among cattle)'.

The central issue is the word 'fall' (Akkadian *miqtu*, derived from *maqātu* – 'to fall'). In the broader lexicon, the verb *maqātu* has mostly negative connotations – to 'fall' in battle, to 'fall' ill, as well as a more general sense of 'to collapse, drop or die'. Applied to livestock it means their 'death', which is often made more specific as death from 'epidemic'. This is how the modern editors translate it here and in the many astrology omens that predict the 'death or fall of cattle'.

Contrary to this interpretation, I would advocate that the intended sense of the word 'fall' (*miqtu*) is the same as we have already seen in the birth incantations (see Queen of Heaven page ...and page of the present book), where the poetic term 'fall of cattle' refers to their birth. An example of an astrological omen may help here: 'If the She-Goat (Venus) reaches the Wolf (Mars): in that year epidemic among cattle' (Gossmann 1960, section 145 III A 4). Beyond the deadly narrative of goats confronting wolves, this omen also embraces a fertility theme where the conjunction of Mars and Venus, the archetypal male and female, leads to the 'fall' or birth of cattle.

The Cross of the Stars

principal agents in the formative process that brought the child to birth. But before that, we will have to take another look at the archaic constellations, particularly those found along the Road of the Sun. According to our theory, the rationale that informed the creation of these star figures should be this self-same idea of the fertile womb of the skies.

By the historical periods the Babylonians recognised about 50 large-scale constellations.[9] Taken as a whole, they constitute one of the most complex icons inherited from the ancient world. We do not have the time or space to explore the symbolism of all 50 constellations. Instead we will limit our enquiry to the primary animal symbols found in our seal designs. Foremost amongst these creatures are the lions and sphinxes, the herd animals with their shining horns, the fish, the scorpion and the flying bird. These are the primary animal symbols of the sky goddess, and they are all found among the imagery of the constellations.

When we look at the Babylonian star-map we find that several of these creatures are found along the Road of the Sun. It is easy to see that the lion and scorpion dominate the ancient quadrants that marked the summer and autumn months. And further round the course of the sun we also find that the ancient wintertime stars were dominated by the imagery of flowing waters and a number of fish, while the quadrant of spring was characterised by images of cattle and sheep. Anyone interested in the history of astrology will quickly recognise that these four constellations – known today under the names of Leo, Scorpio, Aquarius and Taurus – are fundamental to our enquiry. Together they constitute what modern astrologers call the 'fixed' signs of the zodiac. Their significance for our study is that they marked the solstices and equinoxes in prehistoric times. Way back in the 4th and 5th millennia, these four constellations were set out like a grand cross that divided the visible heavens. It is fair to say that they are among the oldest and most important constellations that grace the night-time skies.

It should come as no surprise that these four creatures hold a certain primacy among the stars and among the imagery of our birth related seals. After all, the star-map and the symbolic artwork we have been exploring were created and used by the very same groups of ancient peoples. While much of the surviving artwork uses these animal symbols in a seemingly chaotic and disorganised manner, the exactitude of the star-map with its underlying principles of spatial and temporal order allows a much more orderly application of our symbolic imagery. The star-map is key to developing our understanding of the imagery used in ancient art.

The following diagram is a schematic representation of this great cross of the skies, it represents the era when Leo, the celestial lion, marked the summer solstice and the spring equinox was heralded by the rising of Taurus:

[9] See Appendix 1 for a reconstruction of the Babylonian star-map.

The Cross of the Stars

A schematic diagram of the archaic skies

My colleague, Tom, was the first to recognise the basic outline of the scheme. One of his early theories was that many of our seal designs embodied a very simple calendrical code through their animal symbols. One aspect of Tom's theory was that the lions often represented the constellation of Leo and thus alluded to the time of the summer solstice. This, according to Tom, was the time that a sacred marriage was consummated and the child conceived. Then, some 9 months later, the birth of the child was heralded by the annual rising of Taurus and Aries in the springtime skies.

Tom's theory can be described as a 'normative pattern' of the ideal birth process using Leo and Taurus to mark the beginning and end of the process. During the process of researching this book I also discovered that the same calendrical pattern appears in the mythical lore associated with Juno, the Roman goddess of childbirth and midwifery.

The sacred festival of Juno, which celebrated her motherhood (the Matronalia), was timed to coincide with the first or calends of March. This festival honoured the birth of her son Mars, who was accordingly a true springtime child.[10] Juno's name provides us with a clue as to when her child was originally conceived. It comes as a surprise to many people that the solsticial month of June is actually named after her. The implied pregnancy term of the goddess thus runs from June to March, which is, of course, a very human nine months.

[10] Grimal 1990, page 231 under Juno.

The Cross of the Stars

The lore of Juno and Tom's calendrical theory are mapping out exactly the same territory. Mankind and nature both bring forth their offspring in the springtime months when the climate and food resources maximise their chances of survival. Given a springtime birth it is only a simple matter of counting back 9 months to the month of June to derive the normative month of conception.

At this point it is useful to map out the calendrical scheme of the ideal pregnancy onto the cross of the constellations. In the diagram below, I have also added in the characteristic features of the 3 Trimesters which constitute the modern terms of a human pregnancy.

1, LEO

THE BIRTH SECTOR
The final sector of the cross marks the birth season. The typical period of a human pregnancy (38-42 weeks) is marked out in the shaded area

FIRST TRIMESTER
The embryo goes through its animal-like phases. The time of most miscarriages

4, TAURUS

2, SCORPIO

THIRD TRIMESTER
The fully formed foetus grows to full size

SECOND TRIMESTER
The tiny foetus takes on fully human form

3, AQUARIUS

Schematic diagram of the Trimesters superimposed on the constellation cross

As you can see, the temporal pattern of a human pregnancy does fit the cross of the stars remarkably well. The average term of a human pregnancy is given as 40 weeks or 9 months plus a week, while the stellar cross of the year reckons on a rounded 9 months.

This diagram furthermore suggests that there may well be more to the basic outline mapped out in Tom's theory and Juno's lore. It suggests that other ecliptic constellations like the Scorpion, Fish and Water-bearer may also be part of the same scheme. If this is indeed the case, then we can formulate a provisional theory that the constellation cross, and therefore much of the zodiac, was originally created to demark the temporal pattern of a human pregnancy. This gives us a very specific interpretative framework to apply and test.

The Cross of the Stars

Before exploring the major star figures found upon the constellation cross I'd like to go back to the midsummer inception point when the human child was originally conceived. I believe this summertime starting point relates to one of the great philosophical systems known in the ancient world.

In his famous *Commentary on the Dream of Scipio*,[11] the Roman writer Macrobius, sets out a unique philosophy. He relates that the souls of mankind have their true home among the stars of the Milky Way. They start their epic descent to earth by passing through a cosmic gateway called 'the Gate of Men' that was located in the constellation of the Crab. These god-like souls then descended through the planetary spheres, where they gained ever more corporeal bodies, before finally descending to earth and their birth among mankind.

The arcane philosophy that Macrobius records bears some remarkable similarities to the narrative we have built up. Firstly, both narratives declare that man's soul originates in the highest heavens, and secondly, both systems state that the conception process commences in high summer. That Macrobius further locates the Gate of Men among the zodiac constellations surely points to the Mesopotamian origins of his ideas. The age of this philosophy may be gauged by the fact that Macrobius gives Cancer, the Crab, as the location of this spatial-temporal gateway, whereas in the archaic era, which we are most interested in, it was the Lion of heaven that was accorded this honour. As this book unfolds we will periodically return to these and other ideas related by Macrobius.

So far we have talked about the role of the sun and the stars in the creation of the child but the moon is also very much a part of the same picture. According to one group of birth charms, the calf-like child was fathered by a celestial bull that was actually the moon god in disguise.[13] The story tells how the moon fell in love with a beautiful cow called Geme-Sin, who was 'decorated with ornaments and tempting of shape'. Unseen by the herd-boys, the moon secretly mated with her; in the words of the charm 'he lifted her tail'.

Nine months later, as the appointed time arrived, the calf-like child was born. According to the birth charm 'the calf fell down on the ground like a gazelle's young'. The term 'fell down' is again derived from the same Akkadian word *maqatū* which referred to the 'fall of cattle' in our earlier esoteric astrology text (*see page* 46).

51 The cow gives birth under the stars [12]

[11] The standard English edition of this work is by W.H. Stahl 1952.
[12] Ornan 2005, fig 215.
[13] Veldhuis 1991, page 9.

The Cross of the Stars

The overriding purpose of the incantation is made plain right at the very end of the charm when it states: "Just as Geme-Sin gave birth normally, may also this girl in labour give birth. Let the midwife not tarry, let the pregnant one be all right". Incantations like this place the celestial cattle and the cattle-pen in their proper context – they symbolise the heavenly powers that form each and every child that is eventually born upon the earth.

The moon, which is invariably a masculine god in Near Eastern mythology, measures out the months of the mother's pregnancy and brings her child safely to birth. In this role, the moon is also considered as a source of fertile light. This seminal feature is expounded in a number of astrological omens that make predictions about the outcome of the pregnancy; a typical example runs as follows: "*If the Moon has a halo in Month 2 (Ajjaru) and its gate opens to the south: in this month women will repel their embryos (they will miscarry)*".[14]

As is often the case, this astrological omen features a learned subtext. The 'halo' of the moon is the all-important concept here. As I mentioned earlier, the term 'halo' is commonly written with the sign for 'cattle-pen' (**Tur₃**). If we now review the various cuneiform signs that incorporate the image of the cattle-pen, we can now start to connect their disparate meanings:

TUR₃	TU	ŠILAM
Cattle-pen Open courtyard Halo of light	To give birth to a child	Cow, cattle

Taken together these signs are a subtle key to the symbolic material we are exploring, as they implicitly draw into a single integrated chain of associations, the seemingly diverse concepts of cattle and cattle-pens, celestial light and bringing new life to birth. The informing idea behind all these signs is the heavenly birthing pen that overflows with the light of the sun, moon and stars.

As well as referring to the shed-like animal pens seen in our earlier images (*figs 41-43*) the **Tur₃**-sign also refers to an open area or courtyard that is surrounded by a fence. Just such a livestock pen is seen in our next illustration:

[14] Gossmann 1950, section 3, 1, 5, C (on page 144).

The Cross of the Stars

52 A rustic animal pen with calves [15]

This rustic cattle-pen is probably made of reed fencing or thorn bushes; and it is very appropriately shown sheltering a pair of newly-born calves. Its perfectly circular form helps to explain why the **Tur**$_3$-sign is also used to designate a halo of light, such as seen around the sun or moon.

This halo of light can surround the all types of celestial body but it is particularly used in relation to the moon in astrology texts. There is a special class of lunar omens that place certain stars and constellations within the halo of the moon.[16] Among this relatively large class of omens there is a smaller sub-group that make predictions concerning the birth and conception of human children. There are just three surviving examples of this sub-group; they read as follows:

"If the Moon is surrounded by a halo and the King Star stands in it: in that year women will give birth to male children".[17]

"If the Moon is surrounded by a halo and the Scorpion stands in it: the Entu-priestess will be made pregnant".[18]

"If the Moon is surrounded by a halo and the Star Cluster stands in it: in that year women will give birth to male children".[19]

These are the only known examples of this little sub-genre of astrological omens. At first sight, they are of obvious interest as they describe the fertile aspects of the heavens in terms of celestial light. Via the pivotal concept of the cattle-pen (or halo) they describe the process of human conception and procreation in terms of the light of the stars and constellations combined with the luminous halo of the moon.

What is even more remarkable about this little set of omens is that they mark out three of the four arms of our constellation cross. The celestial lion is represented by the King Star, (our Regulus) which stands at the breast of the Lion. The Scorpion is rightly

[15] Collon 1987, fig 20ii on page 146.
[16] See Gossmann 1950 pages 143-147.
[17] SAA8: report 41.
[18] SAA8: report 147, lines r2-4.
[19] SAA8: report 273 & 376.

The Cross of the Stars

associated with pregnancy and the Star Cluster is the Babylonian name for the Pleiades, which stand at the shoulder of Taurus. It can be no coincidence that this little group of omens, taken as a whole, actually contains the indelible outlines of our constellation cross:

Perhaps the series will be completed one day by the discovery of a similar omen concerning Aquarius (either Gula or the Fish) being seen in the lunar halo.

In light of the preceding discussions we can now understand the core meaning of our final seal design:

53 The fertile skies [20]

It is only when we realise that this design is a portrayal of the fertile heavens that we start to get the measure of its imagery. To be honest, I can't tell if the central bovine figure is meant to be a cow or a bull or their calf but that isn't so important. We know that it is either the heavenly progenitor or the child itself incarnate in its bovine form. In either case, this design is a symbolic depiction of the fertile heavens generating new life within its cosmic womb.

The equal-armed cross set above the creature's back is commonly included in scenes of animal fertility,[21] but it isn't a simple 'fertility symbol' in the conventional sense. In the

[20] A 1st millennium seal design, Iran. Collon 1987, fig 410 on page 88.
[21] See figs 96 & 97 in *The Queen of Heaven*.

The Cross of the Stars

final analysis, it refers back to the annual rotation of the sun around the starry heavens. The solar cross spins out the ever-repeating cycles of the seasons and this is what brings generation upon generation to birth upon the earth.

In the next part of the book we shall explore the symbolism of the constellations that mark out the three trimesters in greater detail. Starting with the birth of the child and working backwards, we shall endeavour to trace out the origins of the child to its heavenly source.

PART TWO:
The Womb of Heaven

The Birth of the Child

As the expectant mother counts down the months, and the time of birth approaches, the midwives assemble. In the skies, the springtime season of birth is announced by the rising of Taurus (the Bull of Heaven) and Aries (the Hired Man).[1] By the historical period, both these constellations were fashioned as adult male creatures – the Bull of Taurus and the Ram of Aries, but in earlier periods, they were very likely figured as a newborn calf and lamb.

54 The springtime constellations of Taurus and Aries

In ancient times, Taurus alone marked the time of the spring equinox and was very likely figured as the Golden Calf of biblical fame. Rising before the sun, the stars of Taurus heralded the season when all nature bears it young. The calves, kids and lambs born at this time have the greatest chance of survival as the pastures are verdant with grasses born of the springtime rains. Likewise, human children also faced the greatest chance of survival if they were born in the mild climes of springtime. In the archaic philosophy, humanity was just as much a part of nature and its seasonal rhythms as the herd animals.

55 The season of birth [2]

[1] See *Babylonian Star-lore* for more information on these springtime constellations.
[2] Tell Brak, Northern Syria. Amiet 1961, plate 8, fig 170.

The Birth of the Child

As the time of birth approaches, the mother's contractions start as she goes into labour. According to one birth incantation: 'It was indeed the time of birth, the woman crouched down. Her cry approached heaven, her cry approached the underworld'.[3]

Another incantation relates that the moon god heard the screams of the woman in labour and sent the two Daughters of Heaven to aid her. One of Heaven's daughters carried 'oil-of-the-jar' with which the mother's forehead was anointed; while the other brought down 'water-of-labour' which was sprinkled over the mother's whole body. Only on the third application of the magical salves was the child finally released.[4]

Other birth charms describe the birth in terms relating to the sunlit skies: the 'little one who lived in the house of darkness', where 'the eye of the sun does not bring light',[5] has indeed 'come out and seen the light of the sun'.[6] And after the safe delivery of the child, Gula, the goddess of medicine and childbirth, was petitioned to 'cut the umbilical cord' and 'determine the destiny (of the child)'.[7]

The great cow of heaven has finally given birth to her calf. The cow is the great goddess herself, the heavenly mother of all humanity and her calf is the human child fashioned in her own divine likeness. Together they form one of the most beautiful and oft-repeated icons known in ancient art:

56 The cow and her new-born calf [8]

[3] Cunningham page 71, lines 9-10.
[4] Veldhuis 1991, page 9.
[5] Cunningham 1991, page 110.
[6] Cunningham 1991, page 109.
[7] Cunningham 1991, page 72, lines 49-50.
[8] Louvre collection AO 11452. Arshlan Tepe, Northern Syria.

The Waters of Life

The Third Trimester

The seventh month of the pregnancy marks the start of the third and final trimester. Within the mother's womb, the unborn baby is actually fully formed with all its sensory and life-support systems operational. Even though it is very small, typically only 12 inches from head to toe, it can potentially survive if it is born before its proper term. As the time for birth approaches, the baby turns its head downwards and the mother sometimes gets the sensation that it is about to fall out of her womb.

Before its birth, the foetus dwells within the safety of its mother's womb, where it is supplied with nutriment and oxygenated blood through the umbilical cord and placenta. The foetus, ensconced within the amniotic sac, is essentially an aquatic creature. This is why it is represented by the symbol of the fish. When I started to explore all this symbolic material, I thought that the fish only represented the very earliest stages of foetal development when it had pronounced fish-like characteristics such as a tail and gills. But by setting it within the framework of the constellation calendar, the fish symbol must also refer to the later stages of the foetus' life when it dwells within the amniotic waters.

The amniotic fluids, which in the mythical language of the ancients were called 'the waters of life', have their celestial correlate in the wintertime skies which are rightly called 'the Waters' in Greek astral traditions. The symbolism of these life-engendering waters are manifest in all the constellations that rise over the course of the winter months. Chief amongst these constellations is the figure of 'the Great One', our Aquarius, whose overflowing streams are embellished with the astral symbol of the Fish:

57 The wintertime constellations that mark the start of the Third Trimester

The Waters of Life

On the Greek star-map, Aquarius, the Water-bearer, is typically represented as a bearded man with an overflowing vase in one or both of his hands. The origins of this figure can be found in the Babylonian constellation known as the Great One (Gula). In the literate sources this constellation is identified with the water god of Babylonian tradition known as Enki or Ea, who is sometimes simply known as 'the Great One, Ea, the Lord of Springs'. The water god with his vases is a popular subject in ancient art:

58 Enki, the god of the celestial and terrestrial waters [1]

Standing high above the mountains, this water god is rendered on a cosmic scale. He is portrayed as a god of the skies who dispenses the living waters of heaven upon the earth. Here the rains are depicted as descending torrents that fall into another set of vases set upon the earth. These earthly vases symbolise the reservoir of sweet waters that lie below the surface of the earth, which the Sumerians called the Abyss (**Abzu**). All the rivers and springs that flow upon the earth draw their waters from this underground source.

This masculine conception of the Water-Bearer is naturally associated with the idea that the fish which swims in his overflowing waters represents the seed of the unborn child. In other words, the seed of the child is contained in the male's seminal fluids.

In the era before the male water god Enki-Ea took charge of the heavenly waters they were shared between the male and female powers. This conception is manifest on the façade to Inanna's temple at Uruk (*below*), where we see alternating pairs of male and female figures each holding overflowing vases set all along the length of the temple wall. Between them, their waters merge and descend towards the earth in graceful spiralling streams:

[1] 14th century BCE cylinder seal, discovered in Thebes, Greece. Detail from Collon 1987, fig 240.

The Waters of Life

59 The male & female waters [2]

The coming together of the male and female waters was the predominant sexual metaphor in art and design in the late 4th and early 3rd millennia, what I call the Second Age of myth and art. This concept also appears in literate sources: according to the words of one Sumerian myth the child is brought about by the male pouring 'ejaculated seed into a woman's womb', which then combines with the feminine seed, so that 'the woman will give birth to the seed of her womb'.[4] In this theory of the celestial waters, the female egg and the male sperm come together to form the human embryo, the 'seed of humanity'.

The conception of the male-and-female waters no doubt informs the design seen in fig 60 (*right*), where the child can be seen emerging from the downward-flowing waters. The coiling streams with their twin fish would then represent the male and female waters coming together to create the nascent child.

60 The metaphor of the celestial waters [3]

[2] Façade from the Inanna temple at Uruk. Ornan 2005, fig 1.
[3] Babylonian seal, 1500-1000 BCE. Collon 1987, fig 236 on page 59.
[4] ETCSL Enki and Ninmah, lines 83-91.

The Waters of Life

In the earliest periods, however, in what I call the First Age of myth, the celestial waters were entirely feminine in nature. These creative waters were thought to embody the 'wisdom of the womb' that governs the formation and development of the foetal child. Ultimately the waters of skies are equated with the amniotic waters of the mother's womb and the seed-like potency that resides within them is the embryonic child. In this conception, the fish represents the life-within-the-waters – the foetal child swimming in the amniotic fluids of its mother's womb.

The archaic feminine form of the heavenly waters is seen in figure 61 (*left*), where a Sumerian goddess can be seen holding a pair of vases. The fertile nature of the waters is conveyed by the disk-like rosettes that seem to descend from the heavens. These flowers, as I have previously endeavoured to prove,[6] represent the sunlit heavens and their innumerable seeds are, of course, the celestial 'seed of humanity' that travels down to earth with the descending waters.

61 A Sumerian goddess with vases [5]

The living potency contained within the goddess' waters is more clearly conveyed in fig 62 (*right*). Here the heavenly streams that flow from her vase are full of fish and their fertile nature is further emphasised by the plant motif that springs from her sacred vase.

In later artistic traditions these water-bearing goddesses are generally treated as minor deities who bring abundance and good fortune to the land. However, I believe they are a remembrance of the distant past, when the goddesses ruled the skies and all their fertile powers.

62 The living waters of heaven [7]

[5] Leick 1991, fig 29.
[6] See *The Queen of Heaven* pages 42-43 & 116-127.
[7] 2nd millennium wall painting. Moortgat 1969, detail from fig 49a, reconstructed in the area of her face.

The Waters of Life

Indeed, there are a number of later artworks that still explicitly portray the constellation figure of Gula (our Aquarius) as a goddess (*below*).

63 A female version of Aquarius [8]

This image is redrawn from an entitlement stone.[9] These are stone monuments typically decorated with the symbols of the astral gods and goddesses. In ancient times, this particular stone was removed from Babylonia and taken to the Elamite city of Susa to the east, where it was discovered by modern archaeologists thousands of years later.

It was in Susa that many of the symbols were engraved with the names of their associated gods and goddesses. Accordingly, our lady's throne is here labelled with the name of 'Gula' – the Great One – a well-known title for the goddess of health, healing and midwifery who was known and worshipped under many local names.[10]

In our next illustration (right) we see the same Aquarian goddess, enthroned upon the goatfish, with her ever-flowing waters full of symbolic life.

The life-bearing nature of the waters is conveyed by the embryonic frog or turtle that swims in its streams and, more pertinently, by the upside-down figure of a child. This last motif, which I call the 'descending child', represents the unborn child turned around within the womb and ready for its headfirst descent into the world. More than any other image of the water-bearing goddess, this design conveys the nature of the life-engendering waters that the goddess disburses.

64 The goddess of the fertile waters [11]

[8] Detail from an entitlement stone, Ornan 2005, fig 16; and Black & Green 1992, fig 7.
[9] Entitlement stones typically commemorate various legal agreements especially grants of land and special prebends and privileges granted to certain individuals. See Slanski 2003.
[10] Black & Green 1992, page 101 under 'Gula'.
[11] Detail of an early 2nd millennium seal. Collon 1987, fig 4 on page 6.

The Waters of Life

The sacred fish that swims in the amniotic waters is seen in our next design (*below*).

Even though the design is incomplete, it can still relay much of its message. Two naked women in the centre pray to a radiant star for twin sons. The children will descend from heaven, travelling through the celestial waters in the form of fishes and will eventually take up their place within the woman's womb, bringing life to her internal waters.

65 The fish as symbol of progeny [12]

The journey of the fish-like embryo is thus described as a journey from the celestial womb of the goddess to the womb of the earthly mother.

As a prelude to the immanent birth of her child, the amniotic sac of the mother breaks open and her waters are released. This symbolism is rightly set within the context of the heaven-born waters in the wording of another birth incantation. Here, at the time of birth, the child is petitioned to come forth 'like rain from heaven, like water from a drain-pipe on a high roof, like a river pouring into a lagoon'.[13]

In modern works on Mesopotamia it is widely held that the watery Abyss, the **Abzu**, refers solely to the underground reservoir of freshwater that emerges from the earth to feed rivers and springs. It is conceived of as a cosmological realm in its own right, located below the earth but above the underworld, that is home to many gods, goddesses and mythical beings. As I hope to show in the following discussion, the waters of the Abyss and the Abyss itself also have a celestial aspect. Our earlier image of the water god Enki (*fig 58*) certainly helps us here, as his waters clearly have their origin in the skies. But to get to the heart of the matter we first need to review the geographical setting of Mesopotamia.

In the higher ground surrounding Mesopotamia, which constituted the 'fertile crescent' where farming originated, there is enough rainfall to support agriculture but in the valleys of Mesopotamia proper there is nowhere near enough rainfall to support intensive cereal cultivation. The earliest farmers in Sumeria overcame this problem by developing an extensive system of manmade canals, levies and dykes that supplied the fields with water drawn from the Tigris and Euphrates rivers. Thus irrigation agriculture was invented.

The difference in climate and rainfall patterns between the fertile crescent and the river valleys of Mesopotamia has some quite dramatic repercussions for native

[12] 2000-1500 BCE, Alalakh. Collon 1975, fig 94.
[13] Cunningham 1997, page 72, lines 42-44.

The Waters of Life

mythology and cosmology. In the first place, it explains why the chief fertility gods of the fertile crescent were often storm deities like Adad, but in Mesopotamia it was gods like Enki with his river waters that were regarded as the bringers of life.

However, the dichotomy between the waters of the sky and the subterranian waters of the earth is not so strict. As we can see from fig 66 (*right*) the sweet waters that flow upon the face of the earth have their ultimate origin in the skies. This is why I would argue that in Mesopotamia the waters of the Abyss retain a dual nature – they refer to the underground waters that feed rivers and they also have a celestial aspect where

66 The Lord prays to the fertile heavens [14]

they refer to the vast reservoir of freshwater that is contained in the heaven-born clouds. The dual nature of the Abyss is apparent in the cuneiform sign known as the **Engur**-sign:

The **Engur**-sign	According to modern lexicons this sign has two principal meanings. Its most frequent use is to write 'Abyss' as referring to the subterranean waters, but its less common meaning, when read as **Zikum**, is as a name for 'the heavens', which proves that the waters also belong to the skies above.[15]

The **Engur**-sign is used in combination with other signs to spell out some fundamental water-related concepts in Mesopotamian thought. First of all, it is combined with the water-sign (**A**) to produce the sign for 'river, watercourse and canal' (*left*). This combination sign, known as the **Id₇**-sign, clearly relates to the subterranean Abyss, as the whole sign can be understood as a river or stream flowing forth from its underground source.

The Id₇-sign meaning 'river'

The **Engur**-sign, when preceded with the star-like sign of divinity, is also used to write the name of the goddess known as Nammu (*right*). In the mythical traditions of Sumeria, this great goddess ruled the sweet waters of the Abyss before Enki adopted them as his special abode. Nammu was considered a primordial

The goddess Nammu

[14] Collon 1975, detail from fig 25.
[15] PSD: ENGUR [waters] and ZIKUM [heavens]. See also Labat 1988, #484 on page 214-5.

The Waters of Life

mother goddess who gave birth to many of the ancient gods. Her role as one of the mother goddesses may well be suggested by the striking resemblance that holds between the **Engur**-sign and the **Ama**-sign meaning 'mother' (*right*).

I have previously suggested that the star set within the mother-sign represented the star-born child within its mother's womb.[16] It is thus entirely appropriate that the goddess of the great Abyss should be described in the same symbolic terms. Nammu's most important child was Enki, which again indicates that she was the abiding deity of the Abyss before her son, the water god of later times, usurped her time-honoured place.

The **Ama**-sign meaning 'mother'

According to some mythical sources, Nammu was also regarded as the mother of heaven and earth.[17] This mythical detail again indicates that her waters were not limited to the underground reservoir but had a far greater scope and extent. Indeed, if Nammu, as presiding divinity of the Abyss, is considered to be the mother of heaven and earth then her 'waters' must surely refer back to the primeval waters of creation – the original chaos from which the whole world-order was born.

Behind all these mythical and lexical facets, the nature of the great water goddess shines through – she is the mother of the gods, the child and the whole world-order. This is the cosmological frame within which each and every child is created.

[16] See *The Queen of Heaven* pages 102-104.
[17] Black & Green 1992, page 134.

The Field

Long before people settled down into fixed agricultural communities, early humans harvested wild cereals as a part of their varied diet. It was only with the Neolithic revolution that true farming, which entails preparing the land and deliberately sowing seed by hand, started to become the mainstay of food production. Over the course of untold centuries, selective harvesting and sowing, combined with cross-breeding different species of wild grasses, led to the first domesticated cereals that are ancestral to the varieties we know today. Since these far-distant times, farming, its tools and methods, have entered into the rich arena of human culture and the arts.

Pictorial evidence for farming and cereal crops is found in Neolithic artwork from the 6th millennium onwards, which was when irrigation farming was first introduced to Mesopotamia. The evidence consists of numerous pottery vessels with long strands of vegetation painted upon them:

67 & 68 Hassunah period pottery with vegetation motifs, probably barley heads [1]

These vessels may well have acted as storage bins for threshed grain or ground flour. Even though the plant strands are overly long they certainly resemble early versions of the barley-sign (Še):

69 Early versions of the Še-sign depicting barley heads [2]

It is currently believed that the simple soil-breaking plough or ard was invented sometime during the 7th millennium BCE.[3] Then, as in later times, the hoe was considered to be the most versatile and frequently used tool of the fields.

[1] Left, Goff 1963, part of collection seen in fig 1. Right, Goff 1963, part of collection seen in fig 3.
[2] Redrawn from Falkenstein 1936, sign number 111.

The Field

One of the very few early images of agricultural activity is seen in the sealing illustrated in figure 70 (*left*). It shows a large group of workers using hoes or adzes to work the soil. This labour-intensive scene harkens back to the most primitive stages of agriculture where hand-held tools are predominantly used in cultivation. It comes as something of a surprise to learn that depictions of the well-known agricultural activities – the symbolically rich activity of ploughing and the economically important act of harvesting – seem to be entirely absent from the art record of the earliest periods.

70 Workers toil in the fields [4]

It is only from the mid 3rd millennium BCE onwards that the seed-plough appears on seal designs (*below*).

71 A Bison-man drives a seed-plough drawn by a pair of lions [5]

The highly ritualistic nature of this scene is indicated by the pair of lions that pull the plough. Here, and in a number of other designs that we will meet later, the activity of implanting the seed into the furrow is in the hands of predominantly male gods and the ancestral powers like the bison-man who drives this particular plough. This shows that the seed-plough is here being treated as a symbol of male fertility which implants the male seed into the feminine furrow.

The overtly masculine nature of this image points to a significant change in the culture of farming. Anthropological sources tell us that 'primitive' farming was originally in the domain of women.[6] It grew out of the so-called 'hunter-gatherer' phase of human culture, where men predominantly took the role of hunter and fighter,

[3] Roaf 1966, page 8.
[4] Amiet 1961, plate 16, fig 276. See also Collon 1987, fig 20i on page 146 for a detail of this design.
[5] Early Dynastic seal design. Collon 1987, fig 615 & Frankfort 1939, plate XI, fig j.
[6] Harrison 1962, page 272. Maquet 1972 under 'Civilisations of the Clearings'.

The Field

while the women were primarily concerned with the gathering of local produce, especially plant-based foods, and the endless drudge of obtaining drinkable water.

Even though the masculine powers took over the symbolism of ploughing, farming never became an exclusively male preserve. The fact that the start of the farming year, when the fields were seeded, is still demarked by the annual rising of Virgo shows that the fundamental farming activities were always considered to be within the symbolic sphere of the female powers.

In Babylonia, the figure we know today as Virgo was represented among the stars as the goddess Šala (*right*). She was married to the storm god Adad, who fertilised her fields with his potent rains, and just like the modern image of Virgo she held an oversize ear of barley in her hands.

The metaphor of the farmer's field plays a significant role in ancient art, myth and magic. Even in modern times, the symbolism of ploughing the furrow and seeding it has overt sexual connotations, and as we will see in the remainder of this chapter, such ideas harken back many thousands of years.

72 Šala with her barley stalk [7]

Going back to figure 57 we can see that the Babylonian constellation called the Field is set at the very heart of the wintertime skies in the region above Aquarius. In exoteric terms, it represents the barley fields of central Mesopotamia burgeoning with their growing crops that are irrigated with the waters of the Tigris and Euphrates.

The zigzag lines that are seen within the rectangular borders of the Field represent the irrigation ditches and channels delivering their precious waters to the crops. Something of a similar nature is seen in the cuneiform sign for 'field' (*left*). This sign, known as the **Gan₂**-sign, is used to write 'cultivated field or terrain'. It shows a similar rectangular plot of land crossed by a set of irrigated furrows. The whole plot is surrounded by an irrigation ditch that acts like a boundary to the field and which is fed by a more substantial waterway – the extended line seen on the left-hand side of the sign-form.[8]

The Gan₂-sign

The sexual symbolism associated with the farmer's fields takes us into the esoteric arena where the field and its furrows serve as a metaphor for the mother's womb. These ideas inform a surviving myth about the origins of mankind.

The Sumerian poem known as the Song of the Hoe,[9] like many magical incantations, starts with an account of how the world-order was created. It describes how Enlil, the god of farmers and leader of the pantheon of gods, created the realms of

[7] Detail from an astronomic tablet from Uruk. Reiner 1995, page 10. Black & Green 1992, fig 147.
[8] PSD: GANA [field] & IKU [unit]; see also CDA *ikû* [field] & *īku* [dyke, ditch].
[9] ETCSL: Song of the Hoe, lines 1-7 for Enlil using the hoe to prop apart heaven & earth; lines 18-27 for the creation of mankind.

The Field

the sky by using his sacred hoe like a cosmic pillar, to prop apart heaven and earth. The king of the gods then turned his attention to the creation of the first human beings.

Taking up his sacred hoe once more, Enlil placed the first models of mankind into a brick-mould. This metaphor of shaping the formless clay into the form of humanity is an obvious allusion to the birth goddesses shaping the child's body from clay in the Akkadian myths of man's origins.[10] This act appears to represent some kind of basic design stage before mankind's full emergence from the matrix of the earth. I believe that it refers to the creation of the seed-like embryo that is implanted within the womb-like furrow, as the story continues with Enlil using his hoe to plant these seeds into the fields. After they have taken root and grown within the earth to their full term, the very first men – the 'black-headed people' as the Sumerians called themselves – finally sprout through the soil. The myth states that they emerged from 'the place where flesh grows forth'. This is how the ancestors of mankind are born from the furrows in the farming metaphor.

The idea that the irrigated field is understood as a fertile womb full of seed is implicit in another Sumerian term for field – **Ašag** – that is much commoner than the **Gan₂**-sign that we have just encountered:

AŠAG	The Sumerian term **Ašag**, also meaning 'cultivated field', is made up from two independent signs. The first element is the **A**-sign, which is made up of two wavy lines that either depict the parallel banks of a river or the basic nature of flowing water. In the lexicon it primarily signifies 'water' but, as we have seen before, it also refers to the very human concepts of 'semen and progeny'.[11]
	The **Šag₄**-sign, probably depicting the swollen belly of a pregnant woman, is widely used to write 'inner body, heart, insides' but its meaning also extends to 'internal organs' and more significantly to 'womb'.[12]
An older form of the **Šag₄**-sign	The angular aspect of this sign is characteristic of later periods when cuneiform was written with a straight-edged reed. In the earliest periods, when the signs were written with a stylus, the rounded nature of the sign is easier to recognize as a bulging abdomen (*left*).

The term for 'irrigated field' can therefore be understood on an esoteric level either as the mother's womb with the seed of humanity growing within it or, in terms of the masculine ideology that dominated later times, as the womb impregnated with the father's watery semen. The very same ideas are embedded within another

[10] See *The Queen of Heaven* pages 158-160.
[11] PSD: A [water] See also *The Queen of Heaven* pages 22-23.
[12] PSD: ŠAG [heart] and for the meaning 'internal organs' and 'womb' see CDA under its Akkadian equivalent *libbu*.

The Field

Sumerian birth incantation whose conventional English translation runs as follows: 'The just breeding bull (**Ninda₂**) has mounted this woman in the cattle-pen, the pure fold, (he) has poured the just seed (**Numun**) of mankind into the womb (**Šag₄**)'.[13]

At face value this incantation is describing human conception in the symbolic terms of cattle mating in the celestial cattle-pen. But due to the multiple meanings attached to the pivotal cuneiform signs, this passage can also be understood as a farming metaphor.

There are three essential terms in the passage quoted above that effectively have a double meaning. They can be tabulated as follows:

NINDA₂	In Sumerian, the **Ninda₂**-sign has two distinct meanings. In our incantation it refers to the 'breed bull' that is the father of the child, but the sign itself clearly doesn't depict a bull. The concept of the fertile breed bull is derived from this sign's commoner meaning of 'seed-funnel' which is what the sign-form actually depicts. This implement was part of the seed-plough (*see fig 145*) that deposited cereal seed directly into the furrow. The dual meaning of the sign is now easy to understand as the bull and the seed funnel both plant their seed into the womb or the field.[14]
NUMUN	The **Numun**-sign, presumably depicts a sprouting cereal seed, which is its everyday meaning. But the concept of 'seed', just as in English, also has a distinctly human connotation as seen in its less common meanings of 'semen and descendants'.[15]
ŠAG₄	As we have just seen the Sumerian term **Ašag**, meaning 'cultivated field' contains within it the **Šag₄**-sign, which refers to the 'interior organs' of the body as well as the female 'womb'.

When the double meanings attributed to these three signs are brought into the equation the incantation produces an alternative narrative. Parallel to the 'breed bull

[13] Cunningham 1997, page 70-71, lines 2-3.
[14] PSD: NINDA [seed-funnel] and NINDA [bull].
[15] PSD: NUMUN [seed] & CDA: *zeru*.

The Field

pouring his semen into the woman's womb' you can also formulate the Sumerian text as 'the seed funnel (of the plough) pours cereal seed into the field'.

From a symbolic perspective, these two statements are identical – both describe the process of human conception in terms of our stereotypical fertility metaphors. This incantation is really a dual simile that expresses the conception of the child in terms of the cattle of heaven and the farming metaphor at one and the same time. Just as artists and designers combined motifs drawn from different visual metaphors, certain common signs in the Sumerian writing system are also allotted diverse meanings drawn from the self-same metaphors.

This was the incantation that was instrumental in my own understanding of all this birth-related material. Reading it and simultaneously understanding it in two different ways was the spark that ignited my own intuition. In an instant, it seemed as if an accumulated, and rather chaotic, mass of information was suddenly restructured into the well-defined patterns of the birth metaphors. And the bigger picture behind it all – the Babylonian star-map – was also redefined as a tapestry of interwoven metaphors that described the evolution of the human foetus from its mystical conception among the stars all the way to its earthly birth.

In my earlier book, 'Babylonian Star-lore', I had said that the star-map constituted a complex set of symbols concerning man and the world around him. But I hadn't understood that the concept of the child was utterly central to the overall composition of the star-map. At that time, I didn't understand that the heavens were the cosmic womb of the sky goddess that gestated the seed of humanity and brought it to birth upon earth. Ultimately, I have to thank Tom for fostering this fundamental insight in me through kindly sharing his theories on ancient art over many an email.

The dual meanings seen in certain cuneiform signs are instrumental in reconstructing the world-view of ancient times. They are a vital key that can unlock the thought processes and associative chains of meaning attached to the visual symbols found in ancient art.

With these insights in mind, the magical amulet seen in figure 73 (*left*) reveals its inner meaning – this lady is pregnant with the seed of humanity. Her womb, like the fertile field, is full of divine seed.

These ideas, originally conceived in the Neolithic age, are still embedded in many latter-day mystical traditions such as the Eleusinian mysteries where the sacred child was displayed to the initiates in a winnowing basket.

73 A fertility amulet [16]

We will return to further aspects of the farming metaphor in a future chapter, but before that we will explore the fertility symbolism of the scorpion and the serpent.

[16] Beaulieu from 'Asherah, supreme goddess of the ancient Levant' on the Matrifocus website.

The Scorpion

The Second Trimester
During the second trimester, the foetus passes out of its protean animal forms and takes on fully humanoid characteristics; it is now a tiny replica of a human being only 3 or 4 inches long. As early as the 4th month the mother can feel her baby kicking inside her. The mother starts to put on weight and by the 5th month of her pregnancy a distinctive bulge is seen on her belly.

The constellation cross keeps on turning through the skies and, come autumn, the annual rising of the Scorpion heralds the start of the Second Trimester. On the star-map, the autumn months are dominated by the figure of the celestial Scorpion and beside it a serpent-legged figure called the Sitting Gods:

74 The constellations of the autumnal 2nd trimester

We will explore the symbolism of the serpent-man in the next chapter, for now we will focus on the scorpion. The scorpion has been a sacred symbol in Mesopotamia from the earliest times. While later astrology texts stress its war-like qualities and particularly associate it with the martial powers of the king,[2] in the artwork of the ordinary people the scorpion most commonly appears amidst scenes of human procreation (*right*).

75 A scorpion with human lovers [1]

[1] Amiet 1961, plate 63, fig 849.
[2] See *Babylonian Star-lore* under the 'Scorpion'.

The Scorpion

In later literate traditions, the scorpion was held sacred to the great goddess known as Išhara.[3] She was worshipped throughout the ancient world and was very popular among women, many of whom took her name. She was particularly associated with the nuptial bed of newly wed couples, and appropriately one of her chief epithets was the 'Lady of Love'.[4] In the *Gilgamesh Epic* it is said that the marriage bed was made for Išhara;[5] and that association is borne out in ancient art where the scorpion can sometimes be seen under the ceremonial marriage bed:

76 The marriage bed with a scorpion [6]

Another literary work, the *Atrahasis Epic*, gives us a little more detail concerning the wedding ceremonies and their association to Išhara. In this early 2nd millennium BCE text, the goddess is said to preside over all the wedding celebrations that lasted nine days and more specifically she is said to 'rejoice' in the union of the couple.[7] This gives us our first tangible evidence for the symbolic nature of the goddess' scorpion – it was concerned with the union of man and wife. This is made much clearer in the remarkable design seen below:

77 A later version of the nuptial bed with a scorpion [8]

[3] Before Išhara was associated with the scorpion her sacred beast was the *Bašmu*-serpent, which we will meet later. Black & Green 1992, page 110 under 'Išhara'.

[4] Leick 1991, page 94-5.

[5] Dalley 1989, page 60. George 1999 page 16 translates the line 'goddess of weddings' (Tablet II line 109).

[6] Amiet 1961, plate 91 fig 1203.

[7] Dalley 1989, pages 17-18, middle of section vi.

[8] Winter 1987, Abb 366, dated to the 15th century BCE.

The Scorpion

The presence of the benedictory priest and the goddess' scorpion under the bed are best understood as magical devices that are intended to ensure a fertile union with many children. Those future children are represented by the familiar symbols of the fish and goat kid set above the couple – they have descended from the skies to enter the womb of their mother.

The successful union of male and female, brought about by Išhara's scorpion, has left the woman impregnated with the seed of her child. This union and the fruit it will bear is at the heart of the scorpion's symbolic character. This would explain why a love-charm of Ištar, shaped in the form of a scorpion, was called 'the son or darling of Ištar.[9] However, a successful conception is only the start of the pregnancy; many complications can still arise, and the involvement of the goddess' scorpion continues right through the whole term of the mother's pregnancy.

Our next illustration (*below*) demonstrates this truth as it places a naked woman, presumably about to give birth, between two enormous scorpions:

78 A woman about to give birth alongside scorpions [10]

Now that the principal subject of the design is the pregnant mother herself, it is much easier to understand that the symbolism of the scorpion is not really about sex but about the woman becoming impregnated and bearing a child. This is the real function of Išhara's scorpion and the ultimate meaning of being stung – the woman conceives.

The ancients knew, as well as we do, that couples can mate hundreds of times but never actually conceive a child. This is what Išhara's scorpion is all about – by being stung by the goddess' scorpion, the woman is successfully implanted with the seed of humanity and her belly will start to swell just as if it had been stung by a scorpion. And the proof of this is the continuation of the sting analogy. For the pain of being stung by mother scorpion, and the risk of death, are delayed until the time of birth.

Even if the pregnancy comes to full term, injuries and fatalities to both mother and child were all too common and the only help at hand was the accumulated knowledge and experience of the midwives. Just such a scene is portrayed in our next design:

[9] Sexualitat Article, page 414.
[10] Amiet 1961, plate 63, fig 847.

The Scorpion

79 A mother gives birth upon her couch [11]

This design has been interpreted as a pregnant woman in the throes of labour being attended by a kneeling midwife who waits expectantly for the child to appear. The image would not be complete without the watchful presence of mother scorpion below the bed. Thus from a feminine perspective the scorpion governs the whole cycle of female fertility, from conception, all the way through the term of the pregnancy, to a successful birth.

These images of the goddess' scorpion evidently share in the same nature as the mother scorpion of Near Eastern folklore. According to these traditions, the female scorpion was considered to be a paragon of motherly love and dedication because she carried her tiny youngsters around upon her furrowed back until such time as they could fend for themselves. Her brood of youngsters, tiny but perfect replicas of herself, are true microcosms of their heavenly mother. They represent the tiny human foetuses of the Second Trimester, which have taken on fully human form. Such loving dedication earned the female scorpion the honour of being one of the birth goddess' most enduring symbols.

The Scorpion-man

Like so many of the animal symbols of the goddess, the scorpion also appears in a distinctly masculine form. The first such creatures appear in the artwork of the Akkadian period (2390-2210 BCE). Although they are typically called 'scorpion-men' they are actually made up from the various parts of a bird, man and scorpion.

In figure 80 (*right*) the scorpion-man is seen in his fully phallic form receiving the fertile waters of heaven from the winged disk above him. Around his erect tail can be seen two mysterious symbols, one perhaps

80 Phallic scorpion-man [12]

[11] A detail from a cylinder seal, mid 3rd millennium BCE. From the website of Chicago University, Teaching the Middle East, fig 15.

[12] Ornan 2005, slightly reorganised detail from fig 162. For a photo see Collon 1987, fig 883, on page 184.

The Scorpion

womb-like or seed-like in nature,[13] and the other unknown. Even if we don't know their purport, the fact that they are set around his tail again suggests that the stinger is the essential part of the scorpion as far as our fertility-related designs are concerned.

From a masculine perspective, the fact that the stinger is raised erect when the scorpion is aroused has led it to be associated with the male's penis. The thrusting action of the stinger and its discharge of venom made it an obvious symbol for the male sex organ. This idea is confirmed in magical incantations designed to aid in male fertility, where both the symbols of the stag's horn and the scorpion's stinger could be utilised to restore male potency.[14] Given these circumstances, it easy to draw the conclusion that the stinger of the scorpion-man is here being used as a phallic symbol associated with the male's seed.

Our next illustration (*below*) develops this masculine strain of thought even further. Here the scorpion-men appear to be the powers that grant the boon, be that a child or perhaps the restoration of potency, to the man that supplicates them.

81 A man propitiates two winged scorpion-men [15]

The human at the centre of this design propitiates two scorpion-men by respectfully touching their beards. What he wishes for has to be deduced from the other symbols set around the design. While the goatfish and bird may be ambiguous in this context, the two tiny monkeys are almost certainly referring to the human child.[16] From this we may draw the conclusion that the man is asking the scorpion-men to either grant him a child or to increase his seed-bearing potency.

The two tiny fish-men seen at the bottom of the design typically appear in scenes of blessing and purification. They are sprinkling holy water upon the man, but it is uncertain whether this ritual act is meant to heal or purify the man. Nevertheless, we can be sure that their holy waters were thought to increase or restore the man's innate powers of fertility.

[13] Please refer to the Symbol Index and compare the symbols I call the Falling Seeds and Lozenge.

[14] For the stag's horn see Sexualitat article page 415. For a scorpion's tail see Cunningham 1997, page 21.

[15] 1st millennium BCE seal. Collon 1987, fig 356 on page 79. Ornan 2005, fig 161.

[16] See figs 19-22 in *The Queen of Heaven* and the accompanying discussion.

The Scorpion

Even though the scorpion-man came to the fore from the middle of the 3rd millennium BCE, the older feminine form of the scorpion held sway in earlier periods. The older material shows that the scorpion was one of the primary symbols of the birth goddess who governed the whole process of human conception, gestation and birth. Its specific role in the fertility designs we have encountered in this chapter was to bless the union of man and woman, and to implant the seed of humanity within the mother's womb. We will explore these ideas further on in the book, in the chapter entitled 'Seeding Symbolism'.

In the next chapter we will look at the symbolism of serpents and their allies, the dragons. Both creatures have much in common with the scorpion, but through their imagery we can penetrate deeper in the mysteries of human procreation.

Serpents & Dragons

On the Greek star-map,[2] the figure of Ophiuchus (*below*) wrestling with a huge serpent is set alongside the celestial Scorpion to mark the autumn months. This enigmatic figure was identified with all manner of personages drawn from Greek mythology. To some he was Heracles or Phorbas who both fought against monstrous serpents; to many others he was Aesclepius, the Greek god of medicine with his serpent of healing. According to other stories he could also be identified with arrogant kings who treated the grain goddess Ceres (Demeter) with disrespect, and who were punished by the goddess after their deaths by having a huge serpent set upon them.[3] The diverse attributions point to the rather obvious fact that the Greeks had actually inherited this mysterious constellation-figure from a foreign source and were trying to assimilate it into their own traditions by identifying him well-known figures from their own mythology.

82 An Arabic image of *Ophiuchus*, the Serpent-Bearer [1]

In my previous investigations into the Babylonian star-map,[4] I suggested that the source of Ophiuchus and his serpent could be found in Babylonia in the form of the constellation known as the Sitting Gods. While the Greek constellation may depict a hero contending with a huge serpent, to judge from surviving artworks, the Babylonian figure undoubtedly represented a snake-man, whose body terminated in a snake rather than human legs. Several such beings are found in early Near Eastern art. The following illustrations map out their different forms:

[1] Carey 2001, volume 2, plate 34 A. Image reversed left to right; I have reconfigured the design removing the split caused by the projection used on the original.
[2] See Appendix 1 for an image of the Greek star-map.
[3] Condos 1997, pages 141-144.
[4] See *Babylonian Star-lore* under the 'Sitting Gods'.

Serpents & Dragons

83-85 Different types of snake-man from Akkadian art [5]

These strange humanoid beings are all fused with the body of a coiling serpent. In one example (*right*) the man simply has a serpent body and tail but in the other two examples the serpents also have their own independent heads. The way that one of the snake-men grasps the neck of his serpent is so similar to the way that Opiuchus is configured that a Babylonian origin for the Greek constellation must be certain.

As I have said before, the serpent shares much of its symbolism with the scorpion. In early artworks they can even be treated as interchangeable elements as the next pair of designs demonstrate:

86 & 87 Serpents in scenes of human procreation [6]

Just like the scorpion, these snakes appear in scenes of human reproduction. The example in fig 87 (*above right*) even appears alongside a couple who sit upon a bed just like the scorpion of Išhara that sat under the marriage bed (*figs 76 & 77*).

This pair of images give us a basic starting point as they tell us that the snake is concerned with aspects of human procreation but neither example can tell us much more. To get to closer to the nature of the snake we will have to change track a little and explore some designs that set serpents alongside horned beasts rather than humans:

[5] Left & centre, Black & Green 1992, fig 137. Right, Bibliotheque Nationale, Cylindres Orientaux no 78.
[6] Left, Amiet 1961, plate 63, fig 849. Right, Amiet 1961, plate 2, fig 45.

Serpents & Dragons

88 & 89 The serpent among pairs of horned beasts [7]

The first example (*left*) shows a coiling snake approaching a pair of goats; the way they cross their necks is arguably a sign that they are a breeding couple.[8] The second example gives us a little more information as it seems to show the serpent between a horned male and an unhorned female. From these images we can start to infer that the serpent blesses the union of the beasts with many a bleating youngster just as Išhara's scorpion blessed the union of the human couple.

Beyond their role in ensuring a fertile union, snakes are also set in contexts of an adult horned beast gaining its sexual maturity and its all-important seed:

90 & 91 Two images of the serpent with mountain goats [9]

The tiny crescents dotted around these designs must be plants, and that allows us to understand that these two designs, which show an enormous snakes encircling a wild goat, are based on the familiar theme of the horned beast eating the plant of fertility and gaining its own sexual seed.[10] Our next pair of designs (*below*) takes the story further by showing the outcome of the animals gaining their serpent power:

[7] Left, Amiet 1961 plate 2, fig 58. Right, Amiet 1961, plate 5, fig 108.

[8] One of Tom's propositions for which he has collected many pertinent examples. Email correspondence.

[9] Left, Amiet 1961, plate 4, fig 98. Right, Amiet 1961 plate 4, fig 95.

[10] See *The Queen of Heaven*, pages 35-37, for a more detailed exploration of this metaphor.

Serpents & Dragons

92 & 93 The fertile serpent from an Iranian stamp seal [11]

These two designs were engraved on the opposite sides of the same stamp seal, which is good reason to think that they are intimately connected. Taken as a pair, I believe their narrative can be recreated as follows. On the left-hand side is the male animal with a long tail; he has eaten the plant of life (the small crescent below him) and has gained its potency for himself, and that potency is symbolised by the serpent above him.

The potency of the serpent is realised on the other side of the seal in the form of the calf or kid suckling at its mother's teats. In this context then, the serpent appears to originate with the male and slither its way to the female. An obvious solution to this set of characteristics would be to interpret the serpent as the male's sperm. This neatly fits in with the popular conception that the serpent is a phallic symbol. We can now return to a human-based series of images.

As far as the ancient Near East goes, the idea of symbolising masculine potency by the serpent appears to have originated in Iran. In several seal designs dating back to the 5th Millennium BCE, we see the serpentine powers wielded by the figure of a horned man:

94 & 95 Two horned men with serpents, 5th millennium BCE Iran [12]

Many previous commentators have identified this type of horned man with the figure of the shaman as he is obviously involved with the animal powers but I would argue, on the pictorial evidence examined so far in this chapter, that he is really the

[11] Root 2005, fig 80a & b.
[12] Left, Amiet 1961, plate 7, fig 150. Right, Amiet 1961, plate 7, fig 149.

Serpents & Dragons

'fertile-man' – the potent father with the seed of the ancestral fathers coursing through him.

Proof of this assertion is seen in the designs seen below which portrays an ordinary man, not adorned with horns, in the company of writhing serpents. Rather than being a shaman, he is 'everyman' who has attained the power to create generations of men.

96 & 97 Ordinary men attaining the serpent powers [13]

A couple of thousand years later, the serpents have been passed on to other mythological creatures like the bison-man who appears so frequently in our birth-related designs:

98 & 99 The bison-man with fertile serpents [14]

The first example, on the left, is more instructive. The pair of serpents that this bison-man holds even appear to be fashioned with phallic heads, and all around them can be seen the manifold seed that the serpent generates. The horned bison-man is never considered to be a shamanic figure. On the contrary, he is another common symbol associated with the fertile fathers; the fact that he now wields the serpentine powers suggests that the snake must embody the generative powers of the ancestors.

[13] Left, Amiet 1961, plate 7, fig 151. Right, Amiet 1961, plate 95, fig 1247 A.

[14] Left, an ornate Iranian pinhead, Godard 1965, fig 25. Right, Amiet 1961, plate 95, fig 1251.

Serpents & Dragons

This leads us directly to a unique and remarkable artefact, described as an ancestral shrine, which places dragons and serpent-men within the context of a human family.[15] The shrine is decorated on both sides – one side dedicated to the parents and ancestors, and the other side to children. It allows us a precious glimpse into how the animalian powers were thought to be involved in human reproduction.

The first side is dedicated to the parents and the ancestral powers:

100 The first side of the ancestral shrine [16]

At the centre of the first side, a strange snake-like man covered in scales appears to embrace an adult couple, and standing on either side of them are a pair of reverend men in exactly the same domed hats as the serpent-man – they are undoubtedly depictions of the ancestors or 'fathers'. They and the serpent-man are the real object of veneration on this side of the shrine.

The 'fathers' certainly incorporate the recently deceased forebears of the family, the grandfathers and great grandfathers, but there is usually a limit to the generations counted. Beyond half a dozen generations, memory starts to fade and the perceived familial bonds fade with them. The more ancient dead start to merge into a greater, more impersonal, collective often called the host of the dead.

The nature of the fathers, and their relevance here, becomes clearer in light of human families. In large families, where one couple may have a dozen or more children, you can't help but notice that the children bear differing degrees of similarity to their parents. Some offspring may be close in appearance to one particular parent, some may combine features of both but others will bear little or even no obvious similarity to either parent. Many such children will however resemble one of the parent's other relatives, their cousin, grandfather etc. The inevitable conclusion to be drawn from these common occurrences is that children are not the simple product of combining male and female parent. On the contrary, many children seem to be gaining their appearance and character from a broader familial collective which draws its input from the wider ancestral background of the parents. In other words, the children

[15] Wiggermann 1997, page 36.
[16] Wiggermann 1997, fig 2b on page 51.

Serpents & Dragons

within a particular family are the product of a multi-generational kin-collective – this, under a predominantly male guise, is what I would define as the 'fathers'.

Getting back to the shrine again and the serpent-man at its centre; like the serpents we have previously met in scenes of animal and human procreation, this serpent-man is likely to be blessing the union of the mother and father and bringing them a healthy brood of youngsters. The fact that the serpent-man wears the same hat as the fathers further suggests that he represents the procreative potential of the parents' multi-generational kin groups. It is this which acts as the real progenitor of their children. This throws a whole new light on the symbol of the serpent. When seen in the context of humanity and the family, these serpentine beings take on a truly trans-generational character linking the child to its ancestral kin.

The masculine serpents we have explored so far only give us part of the picture. Most of these designs, except the ancestral shrine, come from sites in the mountainous regions of Iran, not Mesopotamia proper. In the great river valleys that lay to the west of Iran, the mythical serpent was a very different creature.

The earliest serpents seen in Mesopotamian art can be found on small shards of painted pottery. Several such fragments have been discovered (*left*) of a viper-like snake whose body is often covered in a multitude of spots. Unfortunately these serpents appear in almost complete isolation so it is impossible to judge their character.

101 A spotted serpent [17]

The nature of the Mesopotamian serpent only becomes clearer in Akkadian artwork, well over two thousand years later. And even then, we only know of it through images of its destruction:

102 The serpent of the goddess is attacked by a warrior god [18]

[17] Halaf period. Goff 1963, fig 76.
[18] Ornan 2005, fig143.

Serpents & Dragons

Modern scholars have been able to identify this creature as a *Bašmu*-serpent. It is really a dragon with two legs and horns upon its head. Its very destruction at the hands of a warrior god, helps us understand it as another creature of the goddess, that was slain by the gods of the Akkadian age.[19]

The name of the *Bašmu*-serpent is even more instructive; one modern scholar translates it as the 'birth-goddess snake'.[20] Like so many mythical monsters, the great dragon is female and associated with birth. The term *Bašmu* is an Akkadian word derived from Sumerian **Ušum** – 'dragon'; in cuneiform writing its name is written **Muš Šatur**, that is, the 'serpent with a womb' or perhaps the 'serpent of the womb'.[21] If we remember that 'womb' is written in Sumerian as the 'interior cattle-pen' we can understand that the goddess' dragon is again related to the fertile powers of the skies.

The same message is conveyed by the horns of fertility that adorn its head and the womb-like symbol over its back. This last detail, *(see also fig 147)* positively identifies this horned serpent as a *Bašmu* – the birth snake of the womb.

It may come as a surprise to meet the female form of the great serpent given that the modern world, by and large, regards the serpent as a masculine symbol. In ancient Mesopotamia, at least, the mythical serpent was no phallic symbol but an embodiment of the goddess' womb! A little later I will suggest that the female serpent is really a symbol of the umbilical cord, which miraculously brings the child into being.

While the serpent-man appears to represent the potential of human progeny, the female serpents and dragons are more concerned with birth and children. This is the subject of the second side of the ancestral shrine we started to explore earlier:

103 The second side of the ancestral shrine [22]

Given that the dragon-like *Bašmu* is decidedly female in nature and that the other side of the shrine is dedicated to the ancestral powers in a predominantly masculine

[19] See *The Queen of Heaven* pages 131-143.
[20] See Wiggermann 1992, page 168 where *bašmu* is translated as 'Birth-goddess Snake'.
[21] PSD: MUŠŠATUR [snake].
[22] Wiggermann 1997, fig 2a on page 51.

Serpents & Dragons

guise, there is every reason to think this dragon is another icon of the great mother who gives birth to all humanity. The small serpent set beneath it certainly suggests that this dragon is akin to the birth snakes of Mesopotamia.

The way that one child respectfully raises his hand towards the dragon's chin confirms a benevolent, even parental, relationship between them as similar images place children in the same respectful attitude towards other mythical creatures like the bird-man (*right*).

There are many mythical serpents and dragons mentioned in literate sources. Most of their names are based upon just two cuneiform signs known as **Muš** and **Ušum** (*below*).

104 The bird-man and his children [23]

The signs for serpent and dragon

First we have the **Muš**-sign, which obviously depicts a horned serpent; it is used to refer to the broad class of serpents and reptiles, both real and mythological. Then we have the **Ušum**-sign, of unknown origin, that specifically refers to mythical 'dragons'. Even though the two signs are very different in appearance, when referring to mythical creatures, their usage tends to overlap.

To get any further with the concept of the dragon we need to go back to literate sources. While the *Bašmu* is most often encountered in magical contexts as a mythical monster, the 'dragon' (**Ušum**) mostly appears in hymns as an honorific title applied to deities and kings.

A majority of such references to the dragon depict it as a ferocious beast. The term is most commonly used in royal hymns, where the king likens himself to a mighty dragon fighting against the enemies of the land. The same conception is applied to the gods of war. Ninurta, can be called 'a fearsome dragon brandishing a terrible torch'[25] and Inanna in her warrior aspect is a 'dragon who speaks hostile words'[26] and the dragon who has deposited 'venom on the foreign lands'.[27]

This dragon is a killer, a destroyer, spewing venom upon the foe. Even Nergal, the fear-inspiring god of death and the underworld was likened to a dragon devouring gore and blood.[28]

[23] Boehmer 1965, Tafel XXIX, fig 340. Amiet 1961, plate 96, fig 1264.
[25] ETCSL: Šu-Suen D lines 44-62.
[26] ETCSL: Temple Hymns 321-2.
[27] ETCSL: Inanna B, line 9.
[28] ETCSL: Šu-ilīšu A, lines 13-16.

Serpents & Dragons

The awesome power of the dragon also led it to become an august name for the mightiest gods. Both Enlil and Enki were referred to as 'dragons'; in one hymn Enki is proclaimed as 'the supreme dragon who determines the fates'.[29]

Beyond these awesome dragons of war and fate, Sumerian poets also mentioned dragons of the abyss, and dragons that dwelt in the skies. In the heavens, the moon god was likened to a 'powerful dragon' shedding its light on the people from the high mountains.[30] Inanna too, was called a dragon 'who shines in brightness'.[31] These references suggest that the dragons were at home in the heavens and that one of their salient qualities was to shine forth light. And that leads us onto the final class of dragons that represent the goddesses of motherhood and birth.

The goddess Aruru, whose name is a title for the great mother goddess,[32] is likened to 'a great dragon (**Ušum-gal**) emerging in glory'.[33] The connection is made more secure in hymns that describe the mother goddess' temple. One such hymn states that Ninhursag 'sits within (the temple) like a great dragon'. And alongside her, 'Nintu the great mother assists at births'.[34] This places the great dragon among the birth goddesses as does our final reference which describes Inanna as 'the Queen of Heaven' and 'the dragon of the Nigin₃-garra shrine …'.[35]

105 A horned dragon [36]

The Nigin₃-garra or Nigar shrine is sometimes found in the temples of Inanna and Ninisina. Its name is derived from the Sumerian term for 'stillborn child' or 'miscarriage'. Given that 'the (stillborn or) premature child' was 'not buried in a

[29] ETCSL: Išme Dagan D, lines 1-4.
[30] ETCSL: Ibbi-Suen D, line 2.
[31] ETCSL: Temple Hymns, lines 321-2
[32] Black & Green 1992, page 133. Leick 1991, page 121.
[33] ETCSL: Hymn to Nisaba lines 7-13.
[34] ETCSL: Keš Temple Hymn, line 78.
[35] ETCSL: Temple Hymns, line 206.
[36] Oates 1986, page 170.

Serpents & Dragons

grave',[37] one modern scholar has suggested that the shrine served as a cemetery for still-born or premature babies and as a depository for afterbirths.[38]

The Nigin₃-garra shrine is also mentioned in a Hymn to Ninsiana, a goddess of medicine and midwifery. At this shrine, Ninisina 'deals rightly with the afterbirth, she cuts the (umbilical) cord with a reed, and she determines the fate' (of the child). This passage clearly identifies the shrine as the place where mothers bore their children among the midwives. Echoing the symbolism of doors and gateways seen in the symbolism of the cattle-pen, Ninisina is described putting 'her hand on the door of the Nigar', by which act 'she makes the malformed birth come out(?)'.[39]

So our reference to Inanna being 'the dragon of the Nigin₃-garra shrine' shows that the goddess and her dragon rule over the safe delivery and aftercare of the newborn child and its mother. The special attention given to the umbilical cord and afterbirth point to the essence of the female serpent – she is a symbol of the umbilical cord and placenta that nourishes and sustains the foetal child within its mother's womb. This means that the *Bašmu*-serpent, rather than being the 'snake with a womb', is actually the 'snake of the womb'. It is this umbilical snake that brings the child to its birth.

I would argue that such creatures are portrayed in our next set of designs that all hail back to the end of the 4th millennium BCE. Our first illustration (*below*) shows two men making offerings to the dragons. The way that they coil their necks around each other is characteristic of these serpentine beasts; we will meet this feature again in a later chapter.

106 A man makes offerings to a pair of dragons[40]

In our next illustration (*below*) similar pairs of dragons appear with another creature of the goddess, the *Anzu*-bird:

[37] CAD: *kūbu* section A.
[38] Stol 2000, page 29.
[39] Stol 2000, page 29.
[40] Late Uruk period. Amiet 1961, plate 13 bis, fig L.

Serpents & Dragons

107 Lion-headed dragons and Anzu [41]

The key to understanding these dragons is found in our final design (*right*). Although it is only a tiny fragment, it is enough to show that a descending calf has been placed between the coiling necks of the dragons. This, and the presence of the *Anzu*-bird in the last design, are sufficient to show that these dragons with their twisting necks rule over the birth of mankind.

108 A calf between the dragon's necks [42]

By way of summary, the proposed affinity between the snake and umbilical cord forces us to look at the Greek figure of Ophiuchus and the serpentine gods of Babylonia in a new light. As mature male figures they are moulded to represent the ancestral fathers who held sway in the Second Age of myth. But behind this façade it is easy to imagine the form of the crouching child with its snake-like umbilical cord.

This foetal form is the seed of humanity that has been implanted into the womb. It is the image of the foetus in the Second Trimester that has developed into a human-like form.

The planting of this seed within the mother's womb is the subject of another chapter that focuses on the symbolism of seeding the fields. Before that, however, we will explore the symbolism of the great lion of the skies.

[41] Late Uruk period. Amiet 1961, plate 26 fig 424. Also Goff 1963, fig 388 (photo).
[42] Late Uruk period. Amiet 1961, plate 12, fig 209.

The Lioness

The lion is such a diverse symbol in ancient art that it would be possible to devote an entire book to this creature alone. Apart from being a symbol of war and wanton destruction, the lion can also represent the martial prowess of the king and various warrior gods. In the final chapter of this book, we will also meet the lion of death.

Beyond these ferocious and deadly qualities, the lion and lioness also function as symbols of the fertile skies and the radiant sunlight that enlivens the earth. It is these lions of the skies that are the subject of the present chapter.

109 Inanna, the goddess of heavenly light [1]

Inanna is the 'Queen of Heaven' and the great lioness upon which she rides is a creature of the solar heavens. The face of her lioness is an icon of the sun-disk and its radiant mane represents the light of the sun flooding through the skies.

This image portrays the lion goddess as the heavens overflowing with light. For this reason, Inanna is called the 'great light, the heavenly lioness'.[2] In the same symbolic vein, hymns to the goddess sometimes directly identify her as sunlight. References such as this help to define the ultimate nature of Inanna as the whole of heaven filled with radiant light. It is this lion of heavenly light that brings life to the world.

In Macrobius' era, the Gate of Men was guarded by the Crab, but in former times Leo, the lion of the zodiac, would have marked this portal through which the souls of men descended from the stars. In another part of his book, Macrobius actually gives us a precious glimpse of the older scheme. Instead of using Cancer and Capricorn, the latter-

[1] Ornan 2005, fig 124.
[2] ETCSL: Inana D, lines 1-8.

The Lioness

day markers of the two solstices, Macrobius says that the first semblance of humanity was accrued to the descending souls while the sun was in the constellation of the Lion and that the rites of the dead were celebrated when the sun rose in Aquarius.[3] With this aeonic revision in mind, our next image of an Iranian 'fertility goddess' (*right*) takes on a much more meaningful aspect.

If these lions do indeed reference the summertime constellation of Leo, and the luscious clusters of dates contain the seeds of humanity forming high up in the heavenly vault, then this design could be very plausibly interpreted as a depiction of the Gates of Men, where the massed ranks of human souls commence their journey towards their embodiment and birth. In light of Macrobius' statement about Leo, it is a plausible enough interpretation of the symbolism but to make the matter much more certain, we will need to explore many more images of the goddess' sacred lion.

110 An Iranian lion goddess [4]

111 An ornate goblet decorated with a lion [5]

The nature of this fertile lioness of heaven is perfectly expressed in the ornate goblet seen in fig 111 (*left*). Here the essential nature of the fertile heavens are expressed through the pair of rotating crosses emblazoned on the lion's face and thigh. The curving-armed cross on her face naturally represents the radiant sunlight while the cross on her thigh undoubtedly points to her procreative powers.[6]

Just to complete the picture, the two tiny stars at the lioness' breast show that her body represents the heavenly vault – a detail that aptly confirms the cosmic scale of this marvellous beast.

[3] Stahl 1952, page 134.
[4] Godard 1965, fig 47.
[5] Porada 1965, fig 61, on page 94.
[6] For more on the cross and swastika in ancient art see *The Queen of Heaven* pages 99-100 & 109-110.

The Lioness

It is this lioness of life that appears in our next illustration that returns to the format of our template designs:

112 A Lama goddess prays to a lion [7]

I have previously argued that this type of design is best understood as a Lama goddess (*on the right*) praying to the gods in heaven to grant his lordship a child.[8] While most designs of this type represent the heavens with an obvious celestial symbol like a sun disk or radiant star (*see fig 124*), the heavens are here represented by the figure of a sitting lion or lioness. Given the layout and context of this design, this heavenly creature can only be our lioness of the fertile skies. And given the lioness' age-old association to Inanna and the goddesses, it is entirely fitting that the child granted to his lordship should here be portrayed as a girl.

Later on in the book we will meet what I call 'the lion of death', so for ease of reference, I will refer to this life-giving creature as the 'fertile lioness' or some similar name. By doing so I hope to stress her feminine life-giving powers. This feminine side of the lion is remembered in older star-lists and omen-lore which sometimes use the term 'Exalted Lioness' (**Munus Ur-Mah** – the 'female exalted lion') for the lioness and the constellation that graces the summertime skies.

Given that the concept of a life-giving lion is so alien and unusual to the modern world, it may help if we review a written myth concerning the lion goddess. According to the *Etana Epic*, Etana, an ancient king of Kiš, was bereft at being childless. After praying to the sun god, he sought out the magical 'plant of birth' that would procure him a son and heir. After a fruitless search for the plant, Etana eventually flew to heaven on an eagle's back (*right*) and visited the birth goddess Ištar in the highest heaven.

113 Etana and the eagle [9]

[7] Frankfort 1939, detail from text fig 43.
[8] See *The Queen of Heaven* pages 13-16 for a discussion of this type of design.
[9] Boehmer 1965, Tafel LVIII, fig 693.

The Lioness

The heavenly form of the goddess that Etana saw is very revealing: she was described as a young girl, fair of face, adorned with a crown, and the throne she sat upon was guarded by crouching lions, of snarling visage.[10]

114 Inanna on her lion throne [11]

Even though she may be named Ištar in this Akkadian myth, the birth goddess Etana visited in the highest heavens was really Inanna. As the context of the myth shows, this heavenly goddess set upon her lion throne is the heavenly goddess who has the power to grant children to mankind. The attribution of a lion to the birth goddess only makes sense when the lion is regarded as a symbol of the radiant skies. For the same reason, Nintu, the goddess of childbirth, is described as having the 'awe-inspiring visage of a lion'.[12]

Even though the end of the *Etana Epic* is lost, we can rest assured that the goddess granted the king a son as, according to the Sumerian King List, Etana was succeeded on the throne of Kiš by his son, Balih.[13]

Fortunately, the story of Etana was also a favourite theme of visual artists. Several seals have been discovered which depict the principal episodes of his story. Naturally the image of Etana flying to heaven on the eagle's back is the most popular and easy to recognise motif, but the design seen below also adds a mythical tree, which depicts in symbolic form the delivery of the son that Etana so desperately sought.

115 The story of Etana carried to heaven by the eagle and gaining his son [14]

[10] Dalley page 199. Myth of Etana, Tablet III.
[11] Frankfort 1939, plate XXXIII fig e.
[12] ETCSL: Nintur A, lines 20-35.
[13] ETCSL: The Sumerian King List lines 68-70.
[14] Boehmer 1965, Tafel LVIII, fig 701. Also Colon 1987 fig 851.

The Lioness

Framing scenes of sheep herding and what looks like a group of men accounting for the produce of the land, we see the pivotal events of Etana's story. Over on the right-hand side, Etana flies into the heavens on his eagle, and on the left-hand side of the design we see the tree of life with the familiar symbolism of the flying bird delivering its calf. The goddess has evidently consented to send Etana a son, and in her eagle form she carries the child and delivers it to the king's family tree.

If that is the case, then we have to ask: What are the goddess' sacred lions doing milling around at the base of the tree? If we didn't already know that lions were the beasts of the mother goddess, it would be easy to regard them as being inimical creatures – perhaps blocking the birth of the child or even threatening its life.

These lions are best explained after looking at some more images. The charming design seen in fig 116 (*right*) is composed of the same basic elements (minus the bird) all set out in a similar pattern.

I believe that this design also depicts the descent of the child from heaven. To judge from its placement in the crown of the tree, the goat kid is here being compared to the seeds

116 A pair of lions capture a goat kid [15]

developing within the tree's fruit and flowers. This symbolism shows that the unborn child is still developing in the heights of heaven. To be born upon the earth, the child has to descend its metaphorical tree.

117 A baby is born from the trunk of a tree [16]

The final step of the child's cosmic journey is seen in fig 117 (*left*) where the divine child can be seen emerging from the trunk of the tree. Like so many of the goddess' creatures, this sacred tree that bears the child was destroyed by the gods and kings of the mid 3rd millennium BCE. The male deity seen on the left of this design is in the act of trampling the tree down like an enemy and hacking it to pieces with his axe.

[15] Collon 1987, fig 283.
[16] Boehmer 1965, Tafel LVII, detail of fig 683; and Collon 1987, fig 845.

The Lioness

I would argue that the lions seen in these images are acting as emissaries of the goddess and just like her sacred bird, they deliver the calf-like child to its mother on earth. These lions are best compared to similar leonine creatures such as the lion-headed *Anzu*-bird (*right*), who typically carries a pair of kids down from the skies.

Like the lion, the *Anzu*-bird is a symbol of the fertile skies; it is the storm-bird that brings the fertile rains and with its lion's head it fills all heaven with its fertile sunlight. These are the lions of the heavenly goddess that bring forth life from the skies.

118 The Anzu-bird carries its kids [17]

While it may be easy to appreciate the mother-child relationship between the winged goddess and the charges she carries (*left*), it requires a bit more imagination to realise the same relationship holds true for the lion-headed *Anzu*-bird and its 'kids'. The constant touchstone of our icons, what gives them their real meaning, is the realisation that the calves and kids seen in these designs represent human children being carried down from the skies.

119 The winged goddess and her kids [18]

If we bear this last image of *Anzu* in mind and regard it as a winged lion of the skies, then the following images present us with some more enlightening icons of the goddess' great lioness.

120 The lioness delivers a calf to its parents [19]

[17] Amiet 1961, plate 87, detail of fig 1147.
[18] Ornan 2005, detail of fig 33.
[19] Proto-Elamite seal design, Iran. Amiet 1961, plate 33, fig 530.

The Lioness

The narrative of this image can be reconstructed along familiar lines. The adult cattle have eaten the plant of life and they thereby assimilate its 'seed'. That seed, the progeny they will bring into life, is as always symbolised by the kid above them. But now, instead of being delivered by the *Anzu*-bird or the winged goddess, their calf is carried by a lion. Without knowing about the other carriers of the calf-child, this image would be impossible to understand. But if we keep in mind that the lion is a symbol of the sky goddess and its nature is that of the life-bringing light of the sun, then the imagery does makes perfect sense.

This design, like so many others, places an equal-armed cross alongside images of the regenerating herds. The cross is another symbol of the heavens full of sunlight and of the rotating year with its natural seasons of conception and birth. This helps to put the icon of the celestial lioness in its proper context as a bringer of life. Our next image presents a near identical scene:

121 A lioness carries a kid to its parents [20]

Beyond highlighting the sexual maturity of the cattle by emphasising their curling beards and lappets, this image is laid out on very much the same model as our previous design. Here the connection between the lion and kid is seen to be even closer, as the great carnivore gently carries the newly conceived calf to its parents on earth. While the bird-like figures of the goddess and *Anzu*-bird carry their kids in their hands or talons, lions have to make do with carrying their charges in their mouths as if they were their own cubs. I believe that this convention, drawn from the natural world, is at the heart of these designs.

When you understand its meaning, the icon of the heavenly lioness carrying its newly born kid is one of the most enchanting motifs hailing from the ancient world. One of the earliest and most beautiful examples I have come across is found on a fragment of pottery from prehistoric Iran. Its simple and understated appearance belies the profound truth that it conveys:

[20] Amiet 1961, plate 38 bis, fig G.

The Lioness

122 Panthers carrying goat-kids from a 4th millennium vase [21]

This elegant design presents the paradoxical image of the rapacious beast gently carrying a wild goat-kid as it would its own cub. The anti-intuitive nature of this icon is what really gives the design its power and lends it a certain fascination. It shows that ancient artists, many centuries before the invention of writing, developed a sophisticated visual language that reveled in the use of metaphor, double meaning and paradox.

This basic icon, in which the lion or panther carries her charge in her mouth, is but one of a series of carnivore-and-kid motifs that are endlessly repeated and elaborated upon in ancient art. Our next design (*right*) features another variant of the lion and kid motif in which a pair of lions are set alongside a single kid.

This design, very helpfully, places the icon in a much broader context. The lion and calf motif occupies the upper 'heavenly' register of this design, and below them we see two acrobatic youths, who descend from the skies towards their cow-like mother on earth. Thus do the fertile heavens impregnate the parent beast. To show the impregnated state of the motherly cow the artist has placed an ankh – a symbol of the physical life of the child –upon her back to show that her heaven-born children have entered into her womb.

123 The lions of the sky [22]

The same combination of acrobatic twins and a lion-and-calf motif occurs in our next design. Here the lionesses of birth appear in the unexpected context of a god's sacred emblem:

[21] Godard 1965, fig 4.
[22] Collon 1987, detail of fig 708.

The Lioness

124 An Assyrian seal [23]

This design depicts two very different versions of the same basic fertility narrative – the gods granting children to men. On the left-hand side we have the familiar scene of the Lama-goddess praying to the heavenly powers that the Lord be granted a child, here another daughter. In the other half of the design, we see an alternative conception of the same idea where the male gods have assumed jurisdiction over proceedings. The precise identifications of these two gods are not important – one, with a thunderbolt, is clearly a storm-god who strides over the mountains, the other, perhaps Marduk or Nabu (due to his dragons), is probably the more important figure as he is seated upon a throne. According to the logic of this design, these gods also have the power to grant his Lordship children, seen here in the form of the twin boys in acrobatic poses that stand before them.

The sacred emblem (*right*) that the seated god holds is the crucial part of the whole design as it should express something of this god's divinely ordained powers. When enlarged, it is clearly composed of two rampant lions either side of a descending bull-calf – no less than the celestial child brought down from the heavens by the emissaries of the goddess.

125 Lions with lineage figures [24]

We can now understand another enigmatic image (*left*) which places a group of our lineage-figures between the celestial lions. The interwoven forms of four of our virile men can be seen between the lions. Two are upright in posture and two are upside-down (one of their heads is completely destroyed) – this represents another form of the descending child motif comparable to fig 123. So here, once

[23] Frankfort 1939, text fig 40.
[24] A seal design from Alalakh, detail from Collon 1975, fig 112.

The Lioness

more, there is every reason to believe that the lions are acting as agents of the mother goddess.

Our final variation of the carnivore-and-kid icon replaces the figure of the lion with a truly extraordinary beast (*left*).

Here we have a monstrous winged demon with twin lion-like heads. But it too, despite its dramatic and seemingly demonic form, also holds a pair of kids by their back legs. This bizarre figure has to be part of the same broad series of winged beings that bring the nascent child down from the skies.

The identity between the winged goddesses, the *Anzu*-bird and this demonic figure is founded on a three-fold principle: that all such figures share a common function (carrying calves or children), they also share common symbolic features (bird's wings) and finally they are all closely related to lions. Despite its fearsome and otherworldly appearance, this lion-headed figure is a creature of the fertile skies as much as any goddess.

126 A lion-demon carrying kids [25]

This bizarre figure would typically be classified as a 'demon' in modern literature as it combines a human torso with elements drawn from the animal kingdoms. However, this term is so completely loaded with inappropriate meanings that an alternative needs to be sought. I prefer to refer to these semi-human figures as 'animalian beings' or more succinctly the 'animal powers' of the goddess.

This rather coarse depiction seen in fig 126 was perhaps inspired by one of the masterpieces of ancient Iranian art (*right*):

127 A panther-demon from an Iranian goblet [26]

[25] Collon 1975, detail of fig 218.

[26] Godard 1965, plate 34, and Porada 1965, plate 22b. The design is on a cylindrical goblet, I have readjusted the perspective slightly to take account of the curvature of the goblet.

The Lioness

Once you get familiarised with the format of the design you can see that it is composed of the variegated parts of an eagle and a spotted panther. Its twisted legs are another reference to the sky goddess as they are a characteristic feature of the personified South Wind (*right*). This detail provides a timely confirmation that this ferocious beast is indeed another aspect of the sky goddess.

Behind the striking appearance of the panther design, the basic format of the beast has changed a little. Although it is posed in the standing position, so characteristic of 'demons', this beast doesn't appear to contain any human element, so strictly speaking, this figure is not a 'demon' at all. It just goes to show that

128 The South Wind [27]

the modern designations and definitions of mythical creatures are way too limited and are very often completely misleading. We will explore the imagery of several similar beasts in Part Three of this book.

The different types of creature that carry the calf span the whole mythological spectrum. From winged goddesses in their horned headdresses, to demons of the skies, and in between these extremes, the calf is also carried by the mythical creatures of the winds like *Anzu* and the tempestuous South Wind. Above all else we have to get behind the phantasmagorical imagery of the designs and understand that they all depict the sky goddess with her heaven-born children. Even though some have the form of lions or panthers, the invariable elements in these very diverse figures remain the outstretched wings and the function of carrying the calf through the skies. The common elements within these diverse images indicate that they are all essentially identical.

I have already argued that the lioness represents the heavens full of fertile sunlight – what then of the spotted panther? The famous panther fresco from Catal Huyuk gives us a resounding answer.

129 The panther fresco from Catal Huyuk [28]

[27] Walters Art Museum, fig 29, Accession number 42.671.
[28] Mellaart 1975, fig 61 on page 111. See also Roaf 1966, page 45 for a photo.

The Lioness

These panthers certainly embrace the expanse of heaven but they are creatures of the night, as the spots that cover their hides are clearly formed as radiant stars. In the archaic philosophy, the night-time heavens, full of starlight, are just as much the progenitor of the child as the diurnal solar powers.

In ancient art, the heavenly panther is a much rarer and more archaic creature than the lion. However, we can be sure that they share much in common as the early stamp seal seen in fig 130 (*right*) depicts a spotted panther alongside the same rotating crosses seen in one of our previous designs (*fig 111*). Like the lioness, this elegant creature, surrounded by icons of the fertile skies, symbolises the life-generating powers of the great goddess of heaven.

The dual powers of day and night expressed by the goddess' lion and panther might just lend an explanation as to why the lion-demon and similar figures have two heads – it my be a conscious reference

130 The panther of the skies [29]

to the dual role of sunlight and starlight, day and night, in the creation of the child. This may well explain why the lion and panther are sometimes paired together in ancient designs:

131 An Early Dynastic seal design [30]

Reading the image from the left-hand side, I would suggest that the man who triumphs over the lion has conquered death. The dagger before him alludes to the evil

[29] Amiet 1961, plate 5, fig 110. Susa I, 4000-3800 BCE.
[30] Amiet 1961, plate 81, fig 1077.

The Lioness

nature of this lion (*see fig 237 and the associated discussion*). He overcomes death by siring children so that his ancestral line continues. The creation of his progeny is symbolised in the rest of the design. Over on the right-hand side we see the star-child descending on the wings of a bird. And in the centre, in the form of the lion, panther and kid, we have a glyph of the child being brought down from heaven by the powers of day and night, or more precisely, we see the embryonic form of the child being brought towards its birth by the agency of the light that radiates from the sun and the stars.

Now that we are better informed about the basic significance of the lion and panther in ancient art we can approach one of the better-known figures of the archaic goddess:

132 The birth goddess from Catal Huyuk [31]

Dating to the 7th millennium, way back in the Neolithic era, the famous Catal Huyuk goddess is explicitly portrayed in the act of bearing a child – the baby's emergent head may be seen between the goddess' feet.[32]

The pair of panthers that act as a throne for the goddess make her a prehistoric precursor to Nintu, the Sumerian goddess of birth who has the 'hair-raising fearsomeness of a lion' and to Inanna, the 'heavenly lioness', the 'leopard … full of pride'.[33] The roar of the goddess' lioness that resounds through the skies is the roar of a woman in childbirth.[34]

[31] This image is derived from various photos of the original. The head was entirely missing when discovered and has been reconstructed. See Mellaart 1965, fig 73. Roaf 1966, page 44.
[32] Roaf 1966, caption on page 44; also Mellaart 1965, caption to fig 73.
[33] ETCSL: Inana (C), lines 73-79.
[34] George 1999, page 92. Tablet XI, line 117.

The Sphinx

Even though the sphinx is not found among the stars and constellations, this enigmatic figure does appear time and again in our birth-related designs. Sphinxes come in all shapes and sizes, and to judge by their human heads, they appear in both male and female forms. The male form usually wears a domed hat and often has a distinct beard, while female sphinxes usually have free flowing hair. The typical sphinx is formed by adding a human head to the body of a winged lion, but to add a bit of confusion, many examples actually have the head of a crested bird rather than a human face.

The following set of illustrations delineates the different types of sphinx found in our designs:

Different types of sphinxes found in ancient art

133 Detail from a seal design [1]

Sphinxes and lions are among the commonest motifs found in ancient art, where they appear in the background of innumerable seal designs. Both creatures often appear in symmetrical pairs, which gives them a somewhat heraldic appearance (*left*). They are commonly found together on the same designs, and it has to be presumed that this recurrent feature is a purposeful device intended to either contrast or compare their respective natures.

By the time that this book draws to its conclusion we will see that both the lion and sphinx are creatures of the great goddess and that means both animals have a distinctly dualistic nature. Both creatures are bringers of life and harbingers of death. We will consider the deathly aspects of both creatures in the final chapter of the book, but for the present we will concentrate on the life-engendering aspects of the sphinx.

[1] Collon 1987, detail of fig 546.

The Sphinx

The image rendered in fig 134 (*right*) is one of many that sets a lion and a bird-headed sphinx in seemingly identical roles.

The fertility context of the overall design is set by the kneeling lineage figures that grasp a very stylised tree. In the background a lion and a sphinx, in almost exact parallel to each other, appear to capture a wild

134 A sphinx and lion in similar poses [2]

goat. By portraying the creatures in such similar roles, the artist is certainly playing with the similarities between them. To plumb the mysteries of the sphinx we will have to explore its association to the tree of life, alongside which it constantly appears.

The bounteous tree seen in our next design (*left*) is replete with ornate flowers and a crown full of developing seeds. It is surrounded by horned beasts and guarded by two attendant sphinxes.

The role of the sphinxes and the nature of the horned beasts in scenes such as this only becomes clearer in other designs that incorporate the same basic imagery. Only then will the function of the sphinx in the grand scheme of things start to become clearer.

135 Sphinxes guard the tree of life [3]

The relationship between these various creatures and the sacred tree is provided by the design seen in figure 136 (*right*). This image includes the same range of symbols as the last design but here they are arranged into two separate fields. This is very helpful as we can now identify the mountain goats at the bottom of these images as the parent beasts upon the verdant earth. They have eaten from the tree and gained its fertility.

136 A pair of sphinxes capture a goat kid [4]

[2] Stein 1993, fig 778.

[3] Frankfort 1939, detail from text fig 90.

[4] Frankfort 1939, plate XLII, fig o.

The Sphinx

Above them we see the realms of heaven where the child is conceived. This scene shows the crouching kid being carried down from the skies by a pair of sphinxes and a flying bird, who together act as the heavenly agents of the birth goddess.

A similar grouping of symbols also appears in our next design (*left*), which is centred upon the image of the good shepherd feeding the flocks.

Here the parent beasts are feeding on a pair of rosettes, and again the sphinxes bring down their future offspring from the skies. The key to understanding these designs, like many other images of similar purport, is being able to distinguish between the parent beasts and their kid.

137 The good shepherd feeds his flocks [5]

The imagery of another closely related design (*right*) brings us closer to the inherent nature of the sphinx as it substitutes the heaven-born kid with the motif of the child's head. By doing so, it is plain that this motif, like all our basic animal and plant icons, are really about the conception of human children. Now it is much easier to understand that the sphinxes are acting as celestial wards and guardians of the unborn child.

In one way or another, all these images are about the seed and flowers that grow upon the tree of life. The concept is very elegantly illustrated by our next design seen below:

138 Sphinxes with a child's head [6]

139 The winged goddess with sphinxes [7]

Rather than attending the tree, these bird-headed sphinxes stand either side of the goddess' sacred rosette. The seed of this flower contains the germ of life, a theme I believe, that is also conveyed by the row of circular disks across the top of the image.

Here the flower and its seed are all set within the heavenly realms of the winged goddess. Accordingly, we can now identify the sphinxes as guardians of the seed of mankind.

[5] Collon 1975, fig 189.
[6] Frankfort 1939, detail of text fig 44.
[7] Stein 1993, fig 446.

The Sphinx

The same idea can also be seen to inform figure 140 (*right*), which places the sphinx behind the figure of a naked goddess.

Here a single sphinx is set upon another row of circular seeds that stands above the familiar scene of the parents eating from the sacred tree. A single seed is also placed above the horn of the standing goat. I have previously interpreted this goat as a symbol of the virile male, who has attained the sexual seed that resides in the animal's horn.[9]

140 A template scene with a naked goddess [8]

The special association seen between the goddess and the sphinx in these last two images reflects the true nature of the mythical beast. It is another creature of the birth goddess, and like all her other animalian symbols, it was originally female in nature. Just such a beast is seen on a Hittite stone-relief (*below*), which reveals the sphinx to be an alternative form of the lion goddess:

141 The female sphinx [10]

This image, which beautifully combines the forms of the goddess, lion and bird so often seen in the symbolism of our seals, shows above all else that the animalian icons of the goddess were part of a unified code of symbols, all expressing the creative powers of the feminine heavens.

[8] Stein 1993, fig 395.
[9] See *The Queen of Heaven*, pages 38-39.
[10] Harcourt-Smith 1928, plate 36.

The Sphinx

Like so many of the goddess' creatures, the sphinx was often recast as a male figure in later ages. In the design seen below, drawn from an Iranian casket, we see a bearded sphinx standing proud in his horned headdress. Around him are strewn the same fertile flowers that rightly belong to the goddess of life:

142 The male sphinx [11]

The riddle of the sphinx is not yet unraveled. We will return to this elusive beast in the final chapter of the book where we will meet it again in the guise of a creature of death.

[11] Design from an ivory box, Iran. Porada 1965, fig 46.

Seeding Symbolism

So far we have explored the principal constellations that map out the evolution and development of the unborn child. The creation of the human child starts in the summertime months when the sun is at the height of its powers. According to Macrobius, this is the time when the star-born soul enters into the solar sphere through the fabled Gate of Men. As it starts its descent towards the earth the child's soul, envisioned as a goat-kid, is carried through the skies by Inanna's lion of light – an image which bespeaks the resplendent god-like nature of the human soul.

Descending to the earth, we saw how the child was then likened to the barley seed that was planted into the furrow of its mother's womb in the autumnal quarter of the skies. This juncture, where the soul of the child takes up permanent residence in its mother-to-be, was marked the constellations of the Scorpion and Serpent-man. The story continued with the watery symbolism of Aquarius when the foetal child dwelt within the waters of the womb before its final emergence into the world of men. Thus does the soul of the child travel down from heaven towards its birth.

The cosmic journey described above focuses on the annual progress of the sun around the skies and the constellations marked out by the great cross of the stars. In addition to this account of the child's origins there is another, much more obtuse, narrative embedded in the imagery of the stars. This narrative centres upon the constellation known in Babylonia as the Serpent, which is the prototype of the Greek Hydra. The sinuous form of this constellation occupies the whole quadrant that corresponds to the First Trimester. More than any other constellation figure, an examination of the Serpent's symbolism allows us a precious glimpse of the celestial origins of mankind.

This grand vision of humanity's origins is set out on the star-map in the summertime constellations:

143 The summertime constellations

Seeding Symbolism

During the First Trimester I believe that the soul of the child was still thought to reside in the skies and not be physically bound to its mother. The soul was still likened to a bird as it descended through the skies. Because the bonds between the child and its future mother were not yet fixed, they could easily be broken. This is why most miscarriages take place in the First Trimester. It is only with the start of the Second Trimester that the child actually comes to earth, that is, it permanently enters the womb of its mother-to-be. This, as I have already stated, is symbolised by the implantation of the seed of humanity into the furrow-like womb of its mother.

In this chapter we will explore the pivotal symbolism of seeding the fields. This sacred act represents the descent of the star-born soul into materiality. In the rustic year, the seeding of the fields was celebrated in the autumnal rites of the barley seeding festival,[1] which were heralded by the annual rising of Virgo and the Scorpion. In ancient art, various aspects of the rites were illustrated in a series of designs that centre around the seed-plough and the precious seed that will be laid in the furrow:

144 The blessing of the seed box & seed-plough [2]

Here we see a group of agricultural gods approaching the seated figure of the barley goddess, who raises her hand to bless them. One god presents a seed-plough to the goddess, and two more follow on behind, carrying a seed-box between them. The only animal symbol in the whole design is the scorpion set beneath the seed-box; this symbolic device marks the seed out as the centre of attention, even if it is not directly depicted in the design.

From this image alone, we cannot be sure of the scorpion's function – it may represent the potential contained in the seed or, as a creature of the birth goddess, it may be there to ensure that the seed is successfully implanted in the furrow. Personally, I would favour the latter suggestion, as the same scorpion is also present at the ritual ploughing that is depicted in our next design:

[1] Cohen 1993, page 331.
[2] Boehmer 1965, Tafel XLVI, fig 541. Collon 1987, fig 106 on page 34.

Seeding Symbolism

145 The gods drive the seed-plough [3]

Here we see the culmination of the autumnal farming rites when the gods themselves drive the seed-plough through the fields. Even though the gods may drive the plough, it is a goddess that actually places the seeds into the furrow. She is the central figure who is seen placing the seeds into the seed-funnel of the plough. This tubular implement deposits the seed right into the heart of the furrow at the correct depth and spacing.

The heavenly nature of the rites is indicted by the nature of the beasts that draw the plough. Harnessed to a snarling lion and a bull with a bird perched upon its back, this plough is definitely not of this earth. Instead these beasts point to the mythical creatures that reside among the stars and constellations. The same point is made in an even more forceful manner in our next design, which shows a lion and a *Bašmu*-serpent drawing the seed-plough:

146 A lion and *Bašmu*-serpent pull the seed plough of the gods [4]

In fact this *Bašmu*-serpent, adorned with a horned headdress, actually forms the plough rather than simply pulling it. The meaning of this unusual configuration can only be to stress that the serpent actually sets the seeds into the furrow.

[3] Collon 1987, fig 617. Boehmer 1965, fig 715a, plate LX.
[4] Frankfort 1939, plate XX fig a.

Seeding Symbolism

Another image of the horned serpent helps to confirm its close association to barley farming:

147 A *Bašmu*-serpent is attacked by a warrior god [5]

Once again, the 'serpent with a womb' is attacked by a warrior god, while the goddess looks on. By placing two ears of barley at the end of the snake's tail, the artist is again drawing on the same symbolism as the ploughing scene. This design confirms that the snake is very much concerned with the seed and its implantation into the furrow. The significance of these last two seal designs is that they match the calendrical sequence of stars that runs from the rising of the summertime Serpent to the autumnal appearance of Virgo with her barley stalk.

The proof that all this arcane symbolism relates to the stars is found in the Babylonian star-map where the summertime skies are dominated by a winged lion and a *Bašmu*-serpent, which is also adorned with wings to show its celestial character:

148 Composite image of the Babylonian constellations [6]

This arcane symbolism can only be understood by referring back to one of our previous designs (*overleaf*) which places the same actions within a very human frame of reference.

[5] Ornan 2005, fig 142.

[6] This image is a composite made up from two illustrated tablets dating to the Seleucid era. The Lion & Serpent: Reiner 1995, page 10. Weidner 1967, table V, between pages 78 & 79. The Raven & Šala: Reiner 1995, page 10. Black & Green 1992, fig 159. Weidner 1967, table V, between pages 78 & 79.

Seeding Symbolism

Parallel to the winged goddess descending from the skies with a boy-child in each hand, we also see an alternative narrative, which describes the same process through the agency of a horned serpent. This snake seems to deliver a radiant star to the human couple that are making love on earth below. The only scenario that makes sense of this bizarre symbolism is that the snake is delivering the star-like souls of the children to their future parents.

The horned serpent is evidently the connecting link between heaven where the souls of mankind originate, and the earth where they are cast into their mother's wombs, to be gestated and born.

149 A horned serpent delivers a star-like child to its future parents [7]

These images establish that the horned serpent lays its star-like seeds within the womb of the mothers-to-be. This naturally leads to the question: Where does the serpent get this seed? The answer to this question is found in our last set of designs:

150 A pair of spotted serpents rise into the skies towards a rosette [8]

Over on the left-hand side of this design we have a fascinating scene involving a pair of inter-twined serpents. They are rising into the skies towards the solar rosette full as it is with the stellar seeds of humanity. The serpents will presumably eat or otherwise assimilate the rosette's seeds and this probably explains why these serpents are spotted – the spots are the sacred seeds that the birth serpent will later sow into the furrow.

[7] Detail from Louvre collection AO 7296. Winter 1987 Abb 379.
[8] A late Uruk period seal (Jemdet Nasr period); Amiet 1961, plate 25, fig 410. Frankfort 1939, plate III, fig b (photo).

Seeding Symbolism

I would argue that the following pair of illustrations also depict the same arcane process whereby the seed of humanity descends from the sunlit skies:

151 & 152 Serpents and scorpions with rosettes [9]

The pair of serpents coiling around three rosettes continues the theme of the earlier design. Here the snakes have attained the heavens where life begins and are coiling themselves around the sacred flowers. In a similar way, the scorpion, in the second image, raises its stinger into the skies towards another rosette. It appears to knock a seed from the flower, and this very specific detail helps to clarify the underlying meaning of the imagery. The serpents and scorpion all appear to stretch into the skies in order to bring down the all-precious seed. Whichever animal agent effects the act, it appears to be initiating the descent of the embryonic seed from the heavenly spheres towards earth and on to their implantation within the mother's womb.

This finally allows us to place the serpent and scorpion in their proper roles as agents of the birth goddess – in essence they bring the celestial soul of the child down to earth. The different animal forms used to convey this cosmic narrative can sometimes confuse the underlying message they transmit, but behind the varied imagery there is the same unitary theme of mankind's descent from the sunlit skies and the implantation of the seed of humanity within the womb of its future mother.

We can now state that the basic function of the serpent is to bring the seed of humanity down from the heavens. But we will have to come back to this enigmatic creature in the final part of the book to ascertain its essential nature.

We are now in a position to draw the symbolism of the constellations together and to map out the cosmic journey that the human soul was thought to undertake before its birth. The resultant diagram is reproduced overleaf:

[9] Left, Collon 1987, fig 24 on page 17. See also Amiet 1961, plate 14 bis, fig E. Right, Amiet 1961, plate 30, fig 483.

Seeding Symbolism

SUMMER SOLSTICE
The soul enters the Path of the Sun via the Gate of Men

FIRST TRIMESTER
The heaven-born soul is free & dwells in the skies. It descends via the Serpent towards earth.

BIRTH

THIRD TRIMESTER
The foetus continues to grow to full-size until its birth in the spring

SECOND TRIMESTER
In the symbolic form of barley seed the soul is implanted into the furrow-like womb of its mother-to-be.

WINTER SOLSTICE
The soul is fully involved and bound to the body of the foetus

The journey of the soul's involution toward birth

PART THREE:
The Animalian Powers

The Planets

In ancient seal designs the heavenly realms were most often represented by a combination of the sun and moon. Only occasionally, in relatively late seals, does a constellation such as the Pleiades turn up. This famous cluster of stars, once held as the lead-star of heaven,[2] was typically represented by seven small dots, as can be seen in our first design:

153 A ploughing scene with astral symbols [1]

This seal gives us a basic schema of celestial objects – the sun appears as a circular disk here emitting its fiery rays; the moon is depicted as a graceful crescent with its horns pointing upwards which indicates a new moon; and finally, the stars and constellations are represented by groups of smaller dots.

During the course of writing this book I have been on the lookout for any early designs that could be interpreted as depicting the planets. I must admit that I haven't found any that are particularly convincing. Nevertheless, four examples do stand out. At the very least they force us to ask some questions; the first example is rendered below:

154 An Anzu-bird descends from the realm of the stars [3]

[1] Assyrian seal, 1st millennium BCE. Collon 1987, fig 618.
[2] The lead-star of heaven refers to which stars or constellations rise just before dawn at the time of the spring equinox. Over the course of several thousand years this has changed from Taurus, to the Pleiades, to Aries and Pisces. In the modern era we now await the dawning of the Age of Aquarius.
[3] Amiet 1961, plate 94, fig 1239.

The Planets

In this design we have a crescent moon and a disk-like sun at the top of the astral grouping, and surrounding them in an arc there are six smaller circles. While these smaller dots may just represent ordinary stars, they could also point to the larger, brighter and more colourful planets. One suggestive detail is the fact that the dots are of markedly different sizes, but it is impossible to tell if this is intentional and, if it is, whether it is meaningful. Our second design is equally intriguing, but presents other difficulties of interpretation:

155 The heavenly bird among the stars [4]

Here we have two large dots alongside the radiant sun. But what do they signify? The very size of these dots makes it unlikely that they represent ordinary stars, but once again it is impossible to tell what they are intended to depict. This particular design is also unusual in that it doesn't include the moon, which just adds more uncertainty to any interpretation put forward.

A different set of problems are encountered with our next design, which shows the sun nested inside a huge crescent moon, and surrounded by seven or eight star-like dots:

156 Another astral scene from an early seal [5]

Here it is easy enough to identify the sun and moon but the cluster of starry dots set around them are much more difficult. Beyond the sun and moon, there are only 5

[4] Amiet 1961, plate 96, fig 1256.
[5] Amiet 1961, plate 95, fig 1249.

The Planets

planets that can be seen with the naked eye. So the fact that this image shows 7 or 8 dots in addition to the sun and moon must surely prevent these dots from being identified as the planets.

Regardless of the problems of the last design, where the dots are unlikely to be planets, our fourth and final image is a bit more persuasive, as its astral section is so neatly organised:

157 A highly organised set of celestial bodies on an early seal [6]

Here it is only possible to identify the crescent moon with absolute certainty. The sun could either be the small dot set within the lunar crescent like previous examples, or more likely, it may be represented by the cross-like form set below the moon. What then of the four small dots arranged so symmetrically around the cross? Personally, I would advocate that the 5 naked-eye planets are the best and most obvious solution, but in all fairness it is still a very weak and inconclusive argument.

Among all the early designs I have surveyed, these four examples present the best evidence for depictions of the planets. I'm sure there are a great many other designs that show a similar potential but the question of how to demonstrate that these designs incorporate images of the planets remains an insoluble problem. Simply put, arrays of tiny star-like dots on seal designs, even if they are placed next to images of the sun and moon, are inherently indeterminate in nature.

Perhaps a depiction of Saturn with some kind of ring-structure, or Jupiter with its smaller satellite moons – both of which some modern observers claim to see with the naked eye – would provide sufficient proof to take the argument beyond any doubt, but such images, arranged in a sufficiently coherent manner, remain elusive.

The difficulty is perfectly illustrated by the next pair of designs, which both feature what modern scholars call a two-rayed star:

[6] Amiet 1961, plate 78, fig 1029.

The Planets

158 & 159 Two 2nd millennium designs featuring a two-rayed star [7]

You could argue that both these two-rayed stars could depict Saturn with its prominent ring structure. It is certainly possible, but like previous cases the argument can neither be proven or disproven.

The whole question is made even more difficult as the literate cultures of the Ancient Near East do not appear to differentiate between different classes of 'celestial object'. All such objects – stars, meteors, planets and constellations – were categorised together under the cuneiform sign known as **Mul** (*right*).

The **Mul**-sign

Obviously there are insurmountable problems with any theory that tries to pin a specific identify on these star-like objects. Like it or not, the pictorial evidence for the ancient recognition of the planets is inconclusive and is likely to remain so.

Nevertheless, a counter-argument has to be made. Any sky-watching culture that made and used constellation figures would of necessity know about the planets. Anyone taking up even a cursory interest in the night-time sky gets to know the brighter ones – Venus, Jupiter and Mars – in no time at all because they are so much brighter than the fixed stars. Even more remarkable are their constant and sometimes complex movements among the fixed stars. This special feature distinguishes them from the fixed stars and is arguably the basis upon which they were considered to be god-like powers of the heavens, each with their own independent will.

To make any progress we need to move way from the inherently inconclusive pictorial material and instead review the earliest written evidence for the planets. The first astrology texts start appearing in the early to mid 2nd millennium BCE, and it is only then that specific names and qualities can be ascribed to the planets. Like the Romano-Greek traditions, Babylonian astrologers of the 1st and 2nd millennia BCE associated various deities and specific qualities with the five naked-eye planets. These attributions can be tabulated as follows:

[7] Left, Stein 1993, fig 451. Right, Stein 1993, fig 413.

The Planets

Saturn (Cronos)	Ninurta. The warrior god, closely allied to the king, who slays the enemies of the land. In some astrology texts Ninurta is also identified with Mercury. In omen lore, Saturn was thought to have a restrictive quality and its omens sometimes predict famine.
Jupiter (Zeus)	Marduk. The great god of Babylon, who attained prominence in the 2nd millennium BCE. Before this, Jupiter may have been associated with Šulpae, a little known god associated with the animals of the high plains. In astrology, Jupiter is often associated with the king and his regal powers.
Mars (Ares)	Nergal & Erra. Two fearsome gods that are closely identified with each other. They ruled the destructive aspects of war, death and wild fire. Nergal is best known as the lord of the dead and the underworld. Mars has an astrological quality of destruction and counter-productivity that devours the wealth of the land; he is often the archetypal male.
Venus (Aphrodite)	Ištar. The goddess of love and sexual attraction. The only female among the traditional planets. Venus has a wide range of astrological attributes ranging from animal and human fertility to the life of the king and controlling the weather.
Mercury (Hermes)	Nabu. The scribe of the gods, lord of wisdom and knowledge, and son of Marduk. In astrology Mercury was often thought to bring rain and a change of weather.

As can be seen from this table, the nature of the Babylonian planets and their ruling gods has many parallels with the Greek lore associated with the planets. In both systems, Mercury is regarded as a god of wisdom and knowledge, Mars is seen as a destructive power and Venus is portrayed as the archetypal female. The broad domains which the planets were thought to rule over are not of any great value to our present study. Instead we need to focus on the much more specific arena of childbirth.

In Babylonian astrology the patronage of pregnant mothers and their unborn children primarily falls under the providence of Venus and the Moon. We have already encountered a small selection of lunar omens that made prognostications concerning the birth of human children when certain stars were seen within the lunar halo (*see page …*). However, the majority of surviving omens show that Venus was the principal planet that ruled over the affairs of mothers and their children: *'If Venus wears a black crown: pregnant women will give birth to boys'.*[8] This omen is one of the few positive examples of this type to survive. In astrological parlance 'wearing a black crown' points to the presence of Saturn or Mercury, which are both regarded as the 'black planet' in commentary texts.

Contrary to this positive example, the vast majority of celestial omens concerning childbirth forecast doom for the mother and her child: *'If Venus wears two crowns: women*

[8] BPO3, page 93, omen 18.

The Planets

will die with their child in the womb'.[9] This omen is saying that if two planets (the crowns) are located close to Venus, then dire consequences will follow. The ill-omened forecast attached to this omen may rely on the three-way conjunction of planets, which like many conjunctions is taken to be a bad sign. Another ominous sign from the gods is if the planets are dull-lighted: *'If Venus at her rising is dim: misfortune, women will have difficulty in giving birth, variant: women will die.*[10]

The same calamitous results are predicted if Venus is seen in the area of the Great Twins, our Gemini; in such circumstances she is said to 'carry a hatchet' [11] or 'wear two crowns' and that also foretells that *'women will die with their child in their womb'*. The paradigm even extends to the creatures of the goddess: *'If the Panther is very red in appearance: pregnant women and the children they bear will die'*.[12] This intriguing omen appears to bring the goddess' storm-griffin (in the form of the Panther-constellation – 'the storm demon with a gaping mouth') [13] into play her role.

This ominous material shows that Venus, above all other planets, was considered to be the planet of all things female, and to have a special jurisdiction over pregnant women and their unborn children. Then again, this should not come as a surprise, as Venus was the only planet characterized as being female in mainstream astrology.

The foregoing comments and examples are only pertinent to the 'classical' traditions of Babylonian astrology, which came to dominate the astral arts from the 2nd millennium BCE onwards. To understand the nature of the planets in much earlier periods, we will have to change track and approach this problematic subject from another angle.

Before omens such as these were written down, literate sources on the astrological arts are limited to simple lexical listings of star and planet names. This evidence – nothing more than a list of names – is so limited that no specific conclusions can be drawn from it, other than that certain names were definitely used in certain periods. But even this material of limited utility does provide a different way of approaching the elusive planets. The most important piece of information that these early star-lists provide is that the Babylonian planets were known under the collective name of the 'Wild Sheep'.

The Wild Sheep

Like the Greek name for the planets – the 'Wanderers' – the Babylonian name of the 'Wild Sheep' points to their erratic courses. Roughly speaking, all the visible planets follow the same Path of the Sun around the skies but their motions and orbits deviate considerably from the very regular and predictable passage of the sun. In

[9] BPO3 page 65, omen 11.
[10] BPO3 page 141, lines 29-30.
[11] The Great Twins were depicted as armed warriors, the rear Twin held a 'sickle-axe' in one of his hands.
[12] Gossmann 1950, section 144 III B 3b (on page 59).
[13] See *Babylonian Star-lore* under the 'Panther'.

The Planets

contrast to the sun that sticks to the precise course of the ecliptic, the planets' motions are very changeable – sometimes they are seen sailing several degrees above the Path of the Sun, and sometimes an equal measure below. Add to this their changeable rates of motion and the phenomenon of retrograde motion where the outer planets – Mars, Jupiter and Saturn – all appear to turn around in the sky once a year and travel backwards before resuming their normal motion, and you see why the name 'Wild Sheep' is eminently appropriate. Their name really highlights their aberrant and unpredictable natures compared to the regular behaviour of the fixed stars that are known as the 'Cattle of Šakkan'.

In Sumerian the term 'Wild Sheep' is written 'Mul Udu Idim':

Mul Udu Idim	The **Mul**-sign denotes the class of 'celestial objects' that includes stars, constellations and planets. The **Udu**-sign, which represents a sheep, was originally a quartered circle as pictured here. In later texts, this sign was rendered as a square with a cross inscribed within it (*see below*). Unlike the signs for bull, cow and calf, which depict the head of their respective beasts, the **Udu**-sign bears no obvious resemblance to a sheep in any period. The Sumerian term **Idim** means 'to be wild, raving or rabid'. So altogether the name describes the planets as the 'celestial Wild Sheep'. The title 'Wild Sheep' can be traced back to the earliest lists of star names that date to the Old Babylonian period (1950-1651 BCE).[14]

The symbolic name of the Wild Sheep is obviously related to the concept of the celestial sheepfold that we have already met in one of our birth incantations, where the 'sheepfold' of the stars was mentioned alongside the 'cattle-pen' of the sun. The terms of this magical charm indicate that the 'sheepfold' was regarded as a poetic name for the heavens just as much as the cattle-pen. The same conclusion can also be drawn from ancient artworks, where the sheep-fold is closely modeled on the cattle-pen as the following example with its sacred ring-posts clearly shows:

160 A sheep pen adorned with Inanna's sacred standards [15]

[14] See *Babylonian Star-lore*, appendix 4 under 'Old Babylonian star-lists'.
[15] Amiet 1961, plate 42, fig 623. Also Goff 1963, fig 470 (photo).

The Planets

The crossed circle that constituted the earliest form of the **Udu**-sign was replaced in later times by a square version of the sign (*right*). This angular form of the sign appears in another closely related sign, known as the **Amaš**-sign, that refers to a 'sheepfold'.[16] The three examples depicted below would then have to be understood on a pictorial level as a number of sheep entering or leaving the pen:

The later form of the **Udu**-sign

Early forms of the sign for 'sheepfold' (**Amaš**)

The planets, figured as Wild Sheep, have their natural home in the high plains of heaven alongside the cattle of Šakkan, which represent the fixed stars and constellations. This, combined with the fact that the cattle-pen is a poetic name for the heavens, allows us to understand the **Amaš**-sign in a similar framework. Within an astronomic setting the **Amaš**-sign can be interpreted as another glyph of the heavens with the planetary 'sheep' wandering around the 'sheepfold', which can now be more precisely defined as the Path of the Sun around which the sun, moon and planets circle the skies. The idea of the sheep entering and leaving the sheepfold is a thus metaphor for the constant movement of the planets through the heavens.[17]

The upshot of identifying the heavens with the cattle-pen and sheepfold amounts to saying that the concepts of celestial cattle and sheep are essentially the same. This leads us to the conclusion that if the planets were present in more archaic material they would probably be known under the rubric of the 'Wild Cattle'.

Such creatures do actually occur in the annals of mythology. Among the archaic beings slain and captured by the warrior god Ninurta, there were a group of 'captured wild bulls'. These enigmatic creatures are only mentioned in one listing of the Slain Heroes, where they appear alongside an equally mysterious 'captured cow'. This cow

[16] PSD: AMAŠ [sheepfold]. Esotericists may also appreciate that the *Gilgamesh Epic* frequently uses this term to describe the city of Uruk, Gilgamesh's domain as 'Uruk, the sheep-fold'.

[17] Within the context of 1st and 2nd millennium BCE planetary theory, the stellar cross may also underpin the Exaltation system, which places the major beneficent positions of the planets around the stations of the solstices and equinoxes. Elements of the Exaltation system can be seen in Babylonian texts from the 1st millennium and can arguably be traced through the 2nd millennium back to the Old Babylonian period. See my online article 'The Babylonian Exaltation System' hosted on the Skyscript web-site.

The Planets

can be identified as a form of the heavenly cow goddess through the **Šilam**-sign that is sometimes used to write her name (*right*).[18]

From all this we can infer that the captured wild bulls (**Am**) were probably male in gender and given they were listed among the Slain Heroes, we could also infer that they represented some type of divine beings. But without knowing anything more about them – such as their numbers or symbolic attributions – it is again impossible to establish if they had any form of association with the planets. Nevertheless we have learnt that the planets were known as the Wild Sheep and possibly as Wild Cattle, and that will prove very helpful for our present study.

The signs for 'wild bull' (**Am**) & 'cattle' (**Šilam**)

The imagery of celestial cattle is at the very heart of the symbolic traditions concerning the nature of the heavens. Beyond the great cow of Inanna that represented the entirety of the heavenly realms, cattle symbolism was also applied to all levels of heavenly phenomena. In particular, the constellations could be called the 'cattle of Šakkan' and even more intriguing, the visible planets were known as the Wild Sheep. I believe that all these symbolic cattle were regarded as the celestial progenitors of the human child, who was rightly symbolised as their divine calf.

In Mesopotamia, the idea that the planetary powers were involved in the formation of the human child is only made explicit in textual material dating to the 1st millennium BCE. The idea is most saliently expressed in the royal proclamations of Assurbanipal, a Neo-Assyrian king, who described himself as being 'fashioned into the image of a lord' by the mother goddess while still in his mother's womb. He then goes on to enumerate the qualities imparted to him by the planetary gods.

The moon god, Sin, caused him to see good omens so that he might exercise sovereignty. The gods of sun and storm, Šamaš & Adad, entrusted to him the never-failing craft of divination. Marduk, god of Jupiter, the sage of the gods, gave him the gift of great intelligence and broad understanding. The mercurial Nabu, the universal scribe, made him a present of the precepts of his wisdom. Finally, the gods of Saturn and Mars, Ninurta & Nergal, endowed his body with heroic strength and unmatched physical vigour.[19]

All this symbolic material defines the mother's womb as the conduit of all the powers of heaven. The calf she bears is man, whose inner nature is defined by the stars and planets within the greater realm of the light-bearing skies. Together the stars and planets regulate the functioning of the goddess' heavenly womb. It is their collective qualities that are integrated into the evolving foetus and that sets its destiny at the time of birth.

[18] ETCSL: The Return of Ninurta, lines 51-63. See also Annus 2002, page 111.
[19] Tigay 1971, page 161.

Planetary Deities

If the planets were indeed well known in the prehistoric periods, as I certainly believe, they would have left definite traces in the mythological record. The latter-day traditions of astrology, which apply the names of various gods to the planetary bodies, are unlikely to apply to earlier material as all of these deities – Ninurta, Marduk, Nergal, Erra, Ištar and Nabu – are all part of the Akkadian pantheon that came to prominence during the 3rd millennium BCE or, in the case of Marduk and Nabu, even later. Similarly the habit of assigning specific spheres of interest to each individual planet is also likely to be a later phenomenon, as the earliest texts treat the planets as an undifferentiated group designated by collective names like the Wild Sheep.

All this means that if the planets are to be found in earlier Sumerian mythology then they are probably going to be represented as a collective of archaic gods. This provisional description does match up very well with two sets of ancient beings known in Sumerian mythology. The first group are a collective of ancient and mysterious gods known as the Anunna. They have been popularised in recent years as being aliens from another world who visited the earth in ages long past to genetically modify the human race. There is a welter of books on this particular subject so it need not detain us any further here.[1] Instead we will explore the idea that the Anunna gods we know from Sumerian sources might constitute a late remembrance of a group of archaic planetary gods.

The Anunna Gods

The Anunna, whose name (**A-Nun-na**) can be understood as the 'Princely Offspring' or perhaps the 'Princely Seed', were born of An, the god of Heaven. Although various texts number them as 50, 60 or even 300, the oldest traditions count them as seven.[2] They are commonly described as setting the destinies of mankind and as acting as judges in heaven and the underworld. They are particularly associated with the Sacred Mound, the mythical locale where the sun rises every day and where the destinies of the land are determined by the gods.[3]

Even though they are frequently mentioned in mythical texts, very little is actually known about the Anunna gods; we don't even know what they were supposed to look like. This 'collective of undifferentiated but senior gods'[4] are widely portrayed as being present among the gods but they always take a secondary role, merely praising the high gods or confirming their decisions. The little snippets of symbolism that do occasionally get mentioned do point to an astral setting. Although these snippets are quite limited, when taken together I believe they paint a recognisable pattern of

[1] See the works of Zacharia Sichin and Joshua Free etc.
[2] Leick 1991, page 8. See also ETCSL: Inana's Descent to the Netherworld, lines 164-172.
[3] ETCSL: Lipit Eštar C, lines 11-18.
[4] Leick 1991, page 8.

Planetary Deities

planetary symbolism that draws together some of the varied ideas we met in the last chapter.

In hymns to the gods, the Anunna are said to 'shine forth radiantly',[5] and they are often described as 'standing by' when the moon god rises [6] – this naturally places them in the night-time skies and more specifically, it places them within the environs of the eastern and western horizons where all the celestial bodies rise and set. These are perfectly good attributes for planetary powers and the stress on their appearance alongside the newly risen moon shows that they are also closely associated with the astral bodies that traverse the starry skies. However, it is two pieces of descriptive symbolism that are of much greater interest for our present purposes.

In one myth concerning Ninurta, the Anunna are described as fleeing from the heavens. The story runs that a great adversary has arisen in the hinterlands who threatens to usurp the rule of the gods. He is the monstrous demon called Asag, and when news of his intentions reaches Ninurta, the god cries out in anguish and his cry, resounding through the whole of heaven, appears to scare the Anunna from their celestial abode. The terms in which their disappearance are rendered are full of significance as they 'disappeared over the horizon like sheep'.[7] This all too brief description is most intriguing. In the first place, the Anunna are likened to celestial sheep, which immediately recalls the title 'Wild Sheep' that is applied to the planets. But more importantly, they seem to be independent of the fixed stars as they alone disappear over the horizon. I don't believe that this is a loose poetic phrase. At the very least, it shows that the Anunna are being likened to the planets disappearing from the heavens just as the planetary sheep enter and exit their celestial pen.

The uncertainties inherent in this quote are mitigated by another passage from one of Inanna's hymns. This single line of text speaks volumes as it describes the Anunna not only alongside the celestial cow goddess, but also in terms of them being Wild Cattle, which I proposed was an older metaphor for the planetary powers.

In the hymn, Inanna praises herself as the cow goddess who rules all of heaven. She says: 'The Anunna gods butt each other, but I am the Wild Cow'.[8] By placing them alongside the cow goddess Inanna and by stating that they 'butt each other' the Anunna are evidently being identified as celestial cattle. The very term 'butt, push or thrust' conveys many allusions in Sumerian and Akkadian. It is written with the **Du₇**-sign (*right*),[9] which originally depicted two bulls' heads with their horns crashing together. The act of butting each other would then be a simple metaphor for a conjunction of the planets, when they come together in the same part of the skies. It can be no coincidence that the **Du₇**-sign was

The **Du₇**-sign

[5] ETCSL: Dumuzid-Inana Z, lines 10-19.
[6] ETCSL: Nanna O, lines 13-20. Išme-Dagan M, lines 23-30.
[7] ETCSL: Ninurta's Exploits, lines 70-95.
[8] ETCSL: Inana I, lines 23-34.
[9] PSD: DU [push] and CDA: *nakāpu*.

Planetary Deities

commonly used in later astrology texts to signify 'star, planet, constellation' [10] as an equivalent to the more usual **Mul**-sign made up from three radiant stars. This in itself is another independent confirmation that the stars could be likened to celestial cattle.

This is all that can be gleaned from surviving sources. Taking stock of what we have learnt we can see that the Anunna were at home in the heavens alongside the rising moon. Shining bright in the skies, they were characterised as celestial sheep and cattle that move independently of the fixed stars – the only class of celestial objects that fulfil these criteria are the planetary bodies.

The implications of this hypothesis are significant, especially in light of the fact that the Anunna are elsewhere described as the primordial gods of Mesopotamia who introduced farming and herding to the people at the dawn of time. That effectively says that they were regarded as being among the most ancient deities of the Near East.[11]

The evidence assembled here, although somewhat slender, is credible enough to show that the Anunna are potential candidates for being considered as archaic deities associated with the planets. Even so, by the time that these texts were committed to writing they seem to have lost any distinguishing characteristics. To get closer to the planetary powers of prehistoric times we will have to explore the nature of another group of archaic deities.

Beyond the Anunna, Sumerian sources provide us with another collective of mythical beings that could represent the planets. But before exploring this collective, we will take a closer look at one particular deity known as Šulpae, who was identified with Jupiter in later Babylonian astrology.

The God Šulpae

In later astrology texts, Jupiter was known by a number of different titles, among them the 'Bringer of Signs' (**Sagmegar**), the 'Lord of the Signs of Heaven' (**Engišgalanna**) and the 'Radiantly appearing Youth' (**Šulpae**).[12] The last name, although occasionally applied to Mercury as well, was most commonly used when Jupiter was close to the eastern horizon.[13] Like so many of the names for stars, planets and constellations, the name Šulpae can be traced to the earliest star-lists that date back to the Old Babylonian period (1950-1651 BCE). Beyond this time astrological sources dry up; however, the name Šulpae does occur in other text genres that predate this period.

In hymns and other literate sources, like the mid 3rd millennium lists of gods discovered at Fara, the name Šulpae can still be found. But in these texts Šulpae appears as a god-name. And that is the problem, as nobody knows if this god had any sort of planetary associations at this time.

[10] PSD: MUL [shine] #3.
[11] ETCSL: The Debate between Grain and Sheep, lines 26-36.
[12] Gossmann 1950, section 383 on pages 211-212; and Brown 2000 page 58; and Koch-Westenholz 1995, page 120.
[13] Brown 2000, page 58, section C.

Planetary Deities

Through mythical texts and the occasional incantation, we are fortunate to know enough about the Sumerian deity to create a character profile of him. One Sumerian hymn in particular, which is specifically dedicated to the god,[14] gives us a wealth of useful information.

Even at this early stage, Šulpae was a complex figure. It is therefore a good idea to list his attributes under a number of bullet-points:

- STORM; In one verse, Šulpae is likened to the flood-wave and the storm that 'flashes like lightning'.
- WAR In another verse he takes on war-like attributes, being called 'lordly in battle' and a 'battle-club that smashes enemies'.
- THE FERTILITY OF PLANTS AND ANIMALS; Šulpae was particularly associated with the fertility of the herds that roamed the high plains and the wild plants that these animals fed upon. His province also extended into the realm of the cultivated plants, since one passage in the hymn describes him as the 'lord of orchards and gardens, plantations and green reed-beds'.[15]
- ASSOCIATION WITH THE GODS; Šulpae has a strong association to the high gods; among his titles mentioned in the hymn he is the 'throne-bearer of An and Enlil', the 'fierce constable of the gods' and the 'table-steward of Enlil'.
- BIRD-DEMON; In contrast to his divine associations, another verse describes him in more primitive terms when he is known as a 'bird of grief' and a 'fate-demon' of the night that 'falls upon mankind'.

This combination of qualities shows how just how diverse a character Šulpae had acquired by the late Sumerian period. The hymn shows him to be a deity of the skies and storms, who governs the fertility of plants and animals. Like the Anunna, he has been assimilated into the cult of the high gods by being set as their attendant or officer. But what is most surprising is the last set of characteristics where he is called a fate-demon of the night. This, and being likened to a 'bird of grief', suggest that Šulpae may have been envisioned as one of the so-called 'demons' of Mesopotamian lore who typically bring disease and death in their train.

At last we have a clue as to how the god may have been depicted. The term 'demon' describes a mythical figure that is often winged and that is usually portrayed with an animal head attached to a human torso (*right*).

161 A winged demon [16]

[14] ETCSL: Hymn to Culpae A. See also Leick 1991, page 153.

[15] ETCSL: Hymn to Culpae A, lines 31-40.

[16] Stein 1993, detail of fig 495.

Planetary Deities

Having an idea of how Šulpae may have been envisioned is of great value. But does this, or any of his other traits, indicate that Šulpae was considered a planetary deity in this hymn, and thus in the late Sumerian period?

To answer this question we will first have to review the general nature of the planets in later astrological sources. In celestial divination, omens concerning the planets make predictions concerning all manner of things, from the fertility of the fields and the flocks, to uprisings and enemy attacks. They portend the coming of rain and storm and the strike of the thunder god's bolt. Like demons, the planets can also bring pestilence and disease to man and beast alike. But above all else, the stars and planets, in league with the high gods, decree the destinies of all the lands and nations.

As we can see, the nature of Šulpae, as described in this hymn, matches the general nature of the planets remarkably well. All the major attributes of this god are part and parcel of the powers typically attributed to the stars and planets in 2nd millennium astrology. And given the fact that it was An, the god of heaven, who placed these specific powers into Šulpae's hands [17] we have a decent case for arguing that Šulpae was indeed a planetary god in the Sumerian period. However, we have only shown that the description of Šulpae is consistent with the overall nature of the planets as known from later sources. We have not been able to prove that he was specifically associated with Jupiter. It is therefore expedient to compare the traits of Šulpae with the nature of Jupiter in modern astrology.

Unfortunately most of the powers and offices attributed to Šulpae are very general; only a single passage has sufficient detail to allow a comparison. The hymn states that Šulpae was given domain over 'orchards and gardens, plantations and green reed-beds'.

According to modern texts, Jupiter is closely affiliated with gardens, groves and places of prayer, and in general with the colour green with all its lush and verdant associations. Another modern source [18] also identifies Jupiter as the patron of large wild animals and, like Zeus, makes him the holder of the lightning bolt. According to the same author, Jupiter is also closely associated with palaces and temples, which may have a bearing on some of Šulpae's titles that associate him with the high gods. However, there is a little glitch: In modern astrology Saturn is specifically allocated the rulership of orchards and farms.[19]

Does this amount to a cogent argument that the Sumerian conception of Šulpae represents a recognisable match to the lore associated with Jupiter as known to modern astrology? Have these associations to the beasts of the steppes, the powers of the storm and the verdant plants survived the ages to form part of the bedrock of modern astrology?

Perhaps the reader should decide for themselves. For my own part, I am not convinced – partly due to the inconvenient fact that Saturn is associated with orchards

[17] ETCSL: Hymn to Culpae A, lines 31-40.
[18] Deb Houlding's article on 'Jupiter, the Lord of Plenty' on the Skyscript website.
[19] Thanks to Meredith from the Skyscript website for this information.

Planetary Deities

and farms, but more so due to the fact that all of these domains are affected by all the planets in later Babylonian astrology.

So although we cannot get a definitive answer to our question of whether Šulpae was an archaic version of Jupiter, we can certainly say that the description of his character matches the nature of the planets as a whole. The inherent uncertainty concerning his relation to Jupiter is perhaps due to us asking an over precise question. As we will see in the next section of this chapter, the overriding feature of the planetary powers is that they are formed as a collective.

The Sumerian Demons

Sumerian mythology provides us with another collective of primitive entities that are very good candidates for the planetary powers. This group of beings, nominally called 'demons', bear a great many similarities to Šulpae. A very detailed description of these beings is found in a long but rather fragmentary passage, right at the end of the Sumerian poem called *Lugalbanda & the Mountain Cave*.[20]

The background story of the poem is that Lugalbanda, a hero of Uruk who is commonly regarded as the father of Gilgamesh, fell ill among the mountains when on a military expedition. He retired to a cave thinking he was about to die, but after an ominous dream he made sacrifice to the astral trinity of the Sun, Moon and Venus, and directly following on from these events the demons are introduced.

The demons are presented under many symbolic images and with a multitude of functions. They have all of the well-attested qualities and attributes that were accorded to the planets of latter-day astrology and the demon-like deity Šulpae.

The demons rule the weather and the abundance of the land. They are bringers of the raging storm that destroys the rebel lands, and in a more benevolent role they also act as helpers to Iškur, the storm god, to bring an abundance of flax and barley to the land. Their fecund nature is further emphasised in the way that their arms are described as 'a string of figs dripping with lusciousness'.

At the highest level, they act alongside Enlil and the major astral gods – the Sun, Moon and Venus – to 'confirm with their power the destinies of the foreign lands'. This attribute is particularly interesting, as in later astrology nearly every star, constellation and planet had one or more geographical associations attributed to them. These correspondences formed part of the basis of State Astrology, in which court astrologers tried to predict the fate of nations.

There are several passages which describe the demons in terms of celestial symbolism. They are said to be 'favoured in the heart of Inanna' and like the Anunna gods who attend the rising moon, the demons 'stand by joyfully' as Inanna 'wears her crown under a clear sky'. The goddess' night-time crown is of course the crescent moon

[20] ETCSL: Lugalbanda and the Mountain Cave, lines 371 forward.

Planetary Deities

and I believe that the celestial nature of the demons is further expressed in an obscure passage that likens 'their foreheads and eyes' to a 'clear evening'.[21]

Alongside this celestial symbolism, the demons are further associated with the 'door' and 'door-bolt of the shining mountain', which again points to them being stellar bodies traversing the horizon. And the fact that they are also likened to 'torches of battle' further suggests that they are light-emitting bodies, as the fiery torch is commonly associated with Inanna and the gods of the sun.

While the foregoing passages certainly suggest that the demons are astral entities associated with heavenly Inanna, some of their symbolism is so close in nature to what we have learnt about the planets that their identification with these bodies becomes much more feasible. In direct parallel to the imagery of the Wild Sheep and Wild Cattle that roam the skies, this collective of demons are known as the 'Gazelles of the Moon god, running in flight', and akin to the notion of the aberrant planetary 'sheep', the demons are further likened to 'wild animals on the rampage'.

They are nocturnal beings as 'they lie up during all the long day' and only go out at night. Indeed, in one line that has proved impossible to translate, they are somehow associated with the constellation of the Chariot (our Auriga), which places them among the night-time stars and more specifically among the stars that lie along the path of the sun, moon and planets.[22]

Now we can ask our all-important question: Can this collective of demons be identified as the planetary powers? Given the scope and consistency of their attributes I believe that they can.

The foregoing discussion doesn't quite exhaust the information on the demons furnished by the Sumerian poem. As well as being involved with determining the fate of nations, the demons also interact with ordinary people. Just like Šulpae who was likened to a 'bird of grief' that fell upon mankind, Inanna's demons are said to fly like the sun god's swallows in the dead of night. Alighting in the towns and cities, they 'peer into street after street' and 'enter into house after house'. Stealing things and otherwise creating mischief in men's houses, they nestle up to the bedsides of men and women as they sleep to taint them with misfortune and to whisper secret words in their ears.

The speech of the demons is elaborated upon in one passage where the demons are described alongside the Sun, Moon and Venus as 'interpreters of spoken evil'. This title, despite the evil gloss, again places the demons in a celestial fate-determining context. In another fascinating passage the symbolism of their dialogue is taken further where it cryptically refers to the demons as 'talkers' and 'repliers to talkers', in which context they are said to seek 'words with a mother, replying to the great lady'.

This 'talk' of the demons and the participants involved in it are at the very crux of the matter. The 'great lady' that they reply to can be none other than Inanna, as the

[21] For the celestial symbolism of eyes and foreheads see *The Queen of Heaven*, pages 94-96.
[22] ETCSL: Lugalbanda and the Mountain Cave, line 497. Not translated into English but present in the Sumerian text as 'Mul Giš-Gigir'.

Planetary Deities

demons are explicitly called the 'favoured' companions of Inanna. Then the 'mother' spoken of must be the human mother on earth asleep in her bed. So it appears that the wind-like demons are visiting the earth to relay messages between the goddess in heaven and the mothers-to-be.

Here at last we have the pivotal link between the heavenly powers on the one hand and the mother with her child on the other. The concept of speech, and the information it conveys, is the all-important key as another hymn tells us that the divine word of the great lady fills the entirety of heaven.[23] Here, in the late Sumerian age, we appear to have the idea of the Logos, the divine word, formulated as a dialogue held between Inanna in heaven and the mother on earth, that is mediated through the archaic planetary powers. This matrix of sound connects the goddess of heaven with the human mother. In their own way, the ancients understood that both light and sound carried a creative force.

Later Greek philosophers developed the metaphor of a heavenly music made by the planetary spheres. They imagined that each of the planets were set upon a great sphere of transparent crystal, set together in perfect geometric ratios, that turned at different rates and that each produced one planetary note that, combined with all the others, sang out a harmony of the spheres. This heavenly music was amplified and repeated in wave-like rhythm by the resounding box of heaven's great dome.

What lies behind this arcane symbolism is the divine word of heaven and the music of the spheres. In later ages, the word of heaven became the irrevocable command of the sky god, but in earlier times the logos was feminine in nature. In the beginning, the divine word of the great lady filled the entirety of heaven. Her word is a choir made up from the voices of the celestial bodies who sing as they spin, each in their own tone and rhythm, on their way through the heavenly vault. This is the harmony of the planetary spheres that the demons relate to the expectant mother on earth. Their speech articulates the microcosmic child in the image of its great mother.

[23] Leick 1991, page 132.

The Animal Powers

In the last chapter, we saw how the planetary powers were imagined as a collective of demons who, flying with the winds, visited people's homes during the night. In this chapter we will explore the imagery of these much-maligned mythical creatures. Concentrating on designs from 1st and 2nd millennium BCE sources, we will see that the demons and monsters of ancient art are really archaic powers of the skies.

In modern works on the Near East, mythical beings are typically described by two main terms – demons and monsters. If they are purely animal composites with no human element like the *Bašmu*-serpent or *Anzu*-bird, they are called 'monsters'. But if they have animal features set upon a human torso they are called 'demons'. A third category, which fits rather uncomfortably between these two types, is composed of human-headed monsters like the sphinx and human-headed bull.

Different types of animalian being:
a storm griffin, a double-headed demon & a pair of sphinxes [1]

The basis upon which modern scholars categorise these beasts is a purely human one. From this perspective, there are human-headed monsters, human-bodied monsters (the demons) and monsters with no evident human parts. These three categories are very useful when describing the variegated beasts that inhabit the mythical world but they do have their limitations and can, at times, be very misleading.

This way of describing mythical creatures is prone to lead to confusion as even purely animalian figures like the *Anzu*-bird are very much involved with human reproduction. As I have argued before, creatures like the *Anzu*-bird are best understood as a variant form of the winged goddess. At the end of the day, the imagery of gods, demons and monsters is much more fluid than their designated names and categories, be they ancient or modern. Behind the convention of designated names, we actually have a spectrum of highly imaginative figures that combine the various parts of man and beast.

[1] Left, Boehmer 1965, Tafel XXXI, fig 367. Centre, Collon 1987, fig 868. Right, Collon 1987, fig 778. Details.

The Animal Powers

Before going further it will be wise to return to the word 'demon'. The term inevitably brings to mind all sorts of notions to do with hell and the underworld, with ideas of punishment and judgment, and the whole panoply of evil – the term is utterly loaded with negative and largely inappropriate associations. Accordingly, I will frequently use the more cumbersome terms 'animalian beings' or 'animal powers' in this chapter rather than the misleading 'demon'.

I said that the evil reputation of the demons was 'largely inappropriate' because it is only fair to say that in Mesopotamia the demonic hosts did conform to this pattern, but only in the 1st millennium BCE, which is a very late development from our perspective. This was a time when written texts described the underworld and its demonic powers in all their gory detail. The demons of this age were malign creatures of the winds, allied to the ghosts and ghouls, which brought disease, madness and mortal illness in their train.

Such demons are sometimes seen in the underworld, alongside Nergal, inflicting torment upon hapless sinners (*right*). These demons are tormentors, attackers, bringers of disease and death. This was the age when Lamaštu, the lion-headed demoness, stalked the nurseries and cruelly snatched away suckling babes from their mothers.

As I said before, the evil gloss applied to the demonic hosts is only true for the 1st millennium BCE when Near Eastern societies seemed to be obsessed with the underworld and its denizens.[3] Before this time almost identical beings were placed in a much more benevolent context. The demons of earlier ages are much more akin to the gods whom they act alongside in setting the decrees of heaven.

162 An underworld demon meting out punishment to a sinner [2]

Powers of the Storm

In the last chapter we saw how the planetary demons were allied with the Sumerian storm god, Iškur. Like Iškur they had a dual character, bringing the fertile rains and the devastating strike of the tempest. Accordingly, the poem cast them as benevolent beings whose rains brought an abundance of flax and barley to mankind, while their destructive wrath was vented on the rebel lands.

The nature and appearance of these wind-like beings are set out in our first design, which places a pair of demons standing in attendance to the storm god:

[2] Black & Green 1992, fig 55.
[3] Black & Green 1992, page 63.

The Animal Powers

163 The storm god with attendant demons [4]

Even though the storm god has unfortunately lost his head, he can still be recognised by the thunderbolt he wields and the storm griffin that he rides. The demons that stand either side of him are typical of this genre. Like all such demons, they are composed of a human torso and arms, with the head and appendages of various animals. One has the head of a crested bird and the other is adorned with the head of a roaring lion. With their wings and bird's feet, they are much more akin to the personified winds, but with their animal heads they have taken a further step towards a purely animal form.

By placing them as attendant spirits to the storm god, the basic layout of this design shows that they are regarded as being in a subordinate position. However, as the next set of images show, the demons could also be figured as independent powers of the storm:

164-166 A storm god & griffin, the North wind and a demon of the winds [5]

This set of designs shows that the demons could be treated as storm deities in their own right. While the storm god and the demon-like North Wind both hold their tridents aloft, the animalian creature on the right emits a two-pronged storm weapon from its mouth just like the storm god's griffin, as if to say it has a voice of thunder. Looking over these three images, it is easy to see just how the human and animal elements come together to form a spectrum of storm-bringing beings that blur the distinctions between the categories of gods, demons and animalian powers.

[4] Stein 1993, fig 305.
[5] Right, Stein 1993, fig 406. Centre, Stein 1993, fig 258. Right, Stein 1993, fig 659. Details.

The Animal Powers

Fertility Symbolism

Beyond their association with the storm god, the demons of ancient art are commonly found alongside all the familiar symbols of fertility that we have so far explored. The strange creature in fig 167 (*left*) is really a man with two lion heads; it is the first of several double-headed demons we will meet in this chapter.

The powers that this demon controls are indicated by the radiant star and rosette set around him. Both these symbols point to what I call 'the fertile skies' – the idea that all life originates in the sunlit skies. The same message is also conveyed by the astral disk and plant form set above its head.

167 A double-headed demon [6]

Our next image places the flower and star in a much more intelligible context:

168 The powers of the fertile horn [7]

Here the fertile powers of the horn are defined by the sun disk and the rosette set above the back of the goat. The symbol of the flower refers to the seed of all life that originates in the heavens. Even if we cannot be sure about the exact function of the kneeling demon who raises his hand to touch the beast's horn, we can be certain that he is associated with the life-bringing potency of the horn.

Human Fertility

Beyond controlling the fertility of plants and animals, the mythical monsters also have the power to deliver human life. There are several images that place human heads alongside various animalian beings; two of the clearest examples are seen overleaf:

[6] Stein 1993, detail from fig 760.
[7] Stein 1993, fig 399.

The Animal Powers

169 & 170 The animalian powers & human fertility [8]

If the symbol of the human head does indeed represent children or the power to create them, then the designs seen above certainly place the creation of the human child within the realm of the mythical monsters.

The first image (*left*) shows a man praying to the heavens in the form of a winged disk. The children he prays for are symbolised by the pair of human heads which are set upon the wing-tips of the sphinxes. This particular feature suggests that the children descend upon the winds which are referenced by the wings of the winged disk and the sphinxes that patiently stand in attendance. The second image (*right*) places a whole row of human heads in the midst of yet more mythical animals. In the lower register of the design we see another pair of bird-headed sphinxes before a tree and in the upper register, we find a pair of fish-men in attendance to a plant form with circular seeds. Once again the symbolism of seeds points to the creative potential that resides in the skies.

Carriers of the Child

While the imagery of human heads is not particularly common in these seal designs, there are many more examples that return to the well-known format of the 'carrier of the child'. In the two seal archives that I have drawn most of these designs from, the figure of the chick-carrier is much commoner than the carrier of the calf:

171 & 172 Double-headed demons act as carriers of chicks [9]

[8] Left, Stein 1993, fig 13. Right, Stein 1993, fig 706.
[9] Left, Stein 1993, fig 313. Right Stein 1993, fig 640.

The Animal Powers

Alongside these double-headed demons that carry the chick, we also find similar figures carrying a calf by its back legs (*below*).

173 Double-headed demons carry a calf [10]

These outlandish beings are part of the same group of sacred icons as the *Anzu*-bird and the double-headed panther seen in figure 127. Here in this design, the artist has given these strange creatures four completely different animal heads.

Even though these particular demons don't have wings, the next pair of designs (*below*) prove that the child-carrying demons are distinctly aerial and celestial in nature:

With a lunar crescent set above its head, the domain of this double-headed demon is obviously to be found among the skies and the celestial bodies that traverse the upper reaches of heaven.

The very same conclusion has to be drawn from the double-headed figure seen below, which is surmounted by the icon of the winged disk:

174 An astral demon with a lunar crescent [11]

175 A chick-carrying demon surmounted with a winged disk [12]

In light of the iconography of these two images, the 'demons' portrayed here have got to be considered as the life-bringing emissaries of the goddess of heaven. We will return to this point in the final section of this chapter.

[10] Stein 1993, fig 53.
[11] Stein 1993, fig 376.
[12] Stein 1993, fig 1.

The Animal Powers

Tree of Life

By now, the true nature of the animalian powers is becoming evident. Far from being creatures of evil associated with the underworld, they are creatures of the fertile skies that bring life to the earth. We have already seen how they are commonly portrayed alongside rosettes and seed-bearing plants. So now it will come as no surprise to see that they are also combined with other major fertility metaphors like the tree of life.

Our first illustration (*below*) shows a pair of demons standing before the sacred tree:

176 A pair of demons flank the sacred tree [13]

With a crescent moon and sun disk resting in its crown, this tree is evidently figured as the great tree of heaven. These particular demons are true composite beasts, decked out with a bull's head, a scorpion's tail and bird's feet, there is hardly enough room to attach their wings to their bodies.

Just as the demons sprinkled water upon the storm god (*fig 163*), they also appear to bless the sacred tree with their waters. In response, the tree appears to have initiated its seed-production – the three shoots rising from its crown each have a small circular bulge forming at their tips, representing the seeds of the tree forming in the heights of heaven.

The circular seeds of the tree are featured in our next pair of designs, which show the sacred tree attended by yet more animalian figures:

177 & 178 More animalian powers attend the sacred tree [14]

[13] Stein 1993, fig 450.
[14] Left, Stein 1993, fig 335. Right, Stein 1993, fig 14.

The Animal Powers

The astral setting of these scenes is again indicated by the stars and rosettes that appear in both designs, and by the crescent moon and winged disk that illuminate the skies in the right-hand example. The nature of the seeds that are forming upon their trees is finally revealed in our next design:

179 The seeds of the tree of life [15]

Under the auspices of the demons, the seeds set within the crown of this tree are thriving and forming. Beside the conventional circular seeds set at the end of each branch, one seed appears to be growing into a tiny calf. This tree is the creatrix of all living creatures; its sacred seed is nothing less than the seed of humanity.

Astral Associations

Many of the images we have already explored in this chapter show the animalian powers alongside winged disks, stars and rosettes. This almost constant feature shows that they are first and foremost powers of the skies and the celestial bodies that shine down from on high. The first image in this section (*below*) makes the same statement in the most unambiguous terms:

180 A bison-man holding astral standards [16]

[15] Stein 1993, fig 758.
[16] Stein 1993, fig 337.

The Animal Powers

Here a bison-man holds two symbolic standards that are topped by a sun-disk and lunar crescent. There can be no doubt that he wields the dual powers of heaven.

The storm griffin set beside him is also part of the same picture. The waters it spews from its mouth represents the rains falling to earth, and it is within this water that the heavenly seed of life resides.

Other designs, like our next example (*left*), develop the same idea in terms of the tree metaphor.

In the background we see the lunar tree surmounted with a crescent moon. The other tree, set between the pair of griffins, is topped by a winged disk, and can therefore be treated as the tree of the sun. I would further suggest that the metaphor of the descending seeds is also presented here under the guise of the row of circular forms that make up the trunk of this tree.

181 A pair of griffins with astral trees [17]

Our next image portrays a pair of demons standing in attendance before an unusual variant of the heavenly tree:

182 Demons with astral symbols [18]

Instead of the winged disk, this tree is crowned by what looks like a shrine with two disk-like objects upon it. The obvious conclusion to draw, in light of previous designs, is that these disks represent the sun and moon.

The incomplete disk (*on the left*) has sufficient traces to show that it was once decorated with a radiant star with small circles set between the rays – very much like the sun-disk held by the bison-man in fig 180. If that is the case then the second disk should represent the moon. But that would mean that the moon could be symbolised by a disk-

[17] Stein 1993, fig 457.
[18] Stein 1993, fig 724.

The Animal Powers

like object and that is unheard of in Near Eastern art, which always uses the crescent. However, if you look closely you can see that a crescent form is present in this disk as the lower part of the outer circle is rendered much thicker – so perhaps it is a lunar symbol after all.

The image of the double-headed demon in our next image (*left*) is even more intriguing, as it makes the connection between the demons and the skies even closer. The artist achieves this connection by portraying the winged-disk as growing directly out of the demon's body. Even though this bird-man is lacking wings, it really does embody the nature of the celestial powers.

183 Double-headed demon with winged disk [19]

The exalted nature of this demonic figure is further signified in the way that the bison-men raise their hands to petition it. In the language of these designs, this artifice makes the status of this astral demon akin to the gods.

For the final image in this section (*right*) we shall return to a seal design we first met in the chapter on the planets.

Given the decidedly astral nature of the demons and animalian powers, it may prove useful to ask again if the two-rayed star portrayed in this design is just an odd-looking star or whether it may represent a planet like Saturn as I previously suggested.

184 The animalian powers & the stars [20]

At the end of the day, it is still impossible to tell, but I hope that the possibility is now much more plausible.

The Sky Goddess & the Demons

As a goddess of the storms, Inanna was naturally associated with the tempestuous South Wind and the dust storms [21] that sometimes engulf the land of Iraq. This close relationship is borne out in various artworks that depict the goddess of the storm alongside the personified winds:

[19] Stein 1993, fig 422.
[20] Stein 1993, fig 413.
[21] ETCSL: Inana & Šukaletuda, lines 185-193.

The Animal Powers

185 The storm goddess and twin 'demons' of the West wind [22]

With her double-axe and lightning bolts, this goddess is obviously an embodiment of the storms. Next to her we see two scorpion-tailed demons, in the characteristic bent-over pose of the West Wind, receiving the sacred waters that fall from the skies.

In other ancient artworks, we see a winged goddess set alongside a motley group of demons and animalian figures:

186 A winged goddess with the animalian powers [23]

Among the strange creatures depicted in this design we see the unusual figure of a sphinx adorned with horns and another one of our double-headed demons crowned with a winged disk. To judge from these images alone, the demons are very much a part of the sky goddess' domain.

I previously suggested that some double-headed demons could be regarded as high-status entities akin to the gods in stature. The very same conclusion has to be drawn from our next image which depicts another such being riding upon an equally strange beast:

[22] Wiggermann 2007, fig 20.
[23] Stein 1993, fig 307.

The Animal Powers

187 A four winged demon [24]

Standing upon a wild goat that is decked out with bird's feet, this four-winged being is another creature of the skies, whose four wings probably allude to the four winds. In the same way that the storm god stands upon his elemental griffin, this double-headed demon is portrayed as a superior god-like power who controls the beast it rides.

The real nature of this figure, and all the double-headed demons we have encountered in this book, is finally revealed in the remarkable design seen below:

188 The powers of the winds & storms [25]

[24] Stein 1993, fig 296.
[25] Stein 1993, fig 659.

The Animal Powers

This wonderful design depicts all the powers of the storm and the skies. They are arrayed before the figure that I have called 'his Lordship' who stands on the upper left-hand side of the design. The powers he supplicates are dominated by the figure of the storm god astride his griffin, who looms large on the right-hand side. Scattered around the rest of the design, we have the other powers of the skies.

Surrounding the supplicant figure of the Lord, we see four demonic figures with outstretched wings – they are personifications of the four winds. And tucked away, underneath the storm god, we see another one of our double-headed demons next to a goddess who holds what is variously described as a mirror, musical instrument or ball-staff (*left*).

This goddess has been identified with the northern goddess known as Sauška, who was worshiped by the Hurrians and then the Hittites. She is well known in these parts as the consort of the storm god. What is important here is that modern scholars have been able to identify the double-headed demon as a form or 'hypostasis' of this goddess.[26]

Detail of fig 188

This composite figure with two bird heads should really be called a demoness. Like the *Anzu*-bird and the double-headed demons we have encountered in various parts of this book, she is another animalian form of the sky goddess. Behind the diverse, and at times monstrous, appearances of these beings we find the fertile goddess of heaven who brings all life to birth upon the earth.

We can now return to an image we first met in *The Queen of Heaven*. In figure 189 (*below*) we see another one of our template scenes where the Lama goddess prays to the heavens to bestow a child upon his Lordship:

189 A four-winged demon in a scene of human fertility [27]

[26] Wiggermann 2007, notes on fig 17, page 147.
[27] Collon 1987, fig 570.

The Animal Powers

This design is based around the oft-repeated metaphor of the heavenly flower and its sacred seed, which falls from the skies and manifests itself as the tiny child. Behind this familiar grouping we see another lion-headed demon who is set between a pair of stars and flowers. We can now identify this figure as an aspect of the sky goddess. With her four wings she is cast like a demon of the winds; but she is greater than this, as her realm stretches all the way to the shining stars.

In later ages, similar creatures were refashioned as the evil demoness Lamaštu, who delighted in killing newborn babies and children. But, as I hope I have shown in this chapter, the demonic figures of ancient art once had a much more benevolent and pivotal role in the creation of life rather than its wanton destruction.

The lion-headed demon seen in figure 189 helps to answer one final question. Why do the wind-like demons also embrace the nature of the sun, moon and stars? The problem at the heart of this question is founded on our modern notion of the winds. Contrary to our way of thinking, which relegates the winds to the lowest levels of the sky where the weather is created, in ancient cosmology the winds extended all the way to the very highest heavens where the celestial bodies revolved around the earth. In other words, the winds occupy the whole of heaven, and this makes them the perfect agent and connecting link between the goddess of the skies and humanity down below. It may even be the case that the winds were thought to move the sun, moon and wandering stars along their winding courses, as they do in some traditions of Vedic lore.

The Lady of Babylon

Since Akkadian times, the high gods of the Semitic tribes have waged a relentless war with the mythical creatures of the goddess. In artworks of the mid 3rd millennium BCE we see the capture and slaying of countless such beasts. Akkadian artists commonly portrayed the capture of such creatures as the Bison-man and *Anzu*-bird, but alongside these well-known mythical beings we also see the demise of more exotic monsters like dragons and serpents with multiple heads.

In previous chapters we encountered images of the *Bašmu*-serpent and the dragon, which both acted as the birth-serpent of the goddess. It is only one more step to create a fairy-tale monster with a multitude of heads. Just such creatures, adorned with seven heads, are seen in the art of the Akkadian period, where they are invariably killed by a warrior god:

190 & 191 Two Akkadian images of warrior gods attacking a seven-headed dragon [1]

In literate sources, we find a Seven-headed serpent (**Muš-Sag-7**) listed among the archaic gods and monsters called the Slain Heroes that were killed by Ninurta.[2] Even though we know nothing about this beast, except that it lived among the mountains,[3] we now know enough about similar creatures to conclude that such beings, slain by warrior gods, are almost certain to be part of the sky goddess' entourage.

Thousands of years later, the biblical prophets were still railing against the goddess and her menagerie of strange beasts. With their adamant belief in an all-powerful god in heaven, the philosophy and symbolism of the sky goddess were pure anathema to the monotheist religions.

The same vitriolic vein continued long into the Christian era. For John of Patmos, the Lady of Babylon was the epitome of all iniquity. Her figure looms large in the Book of Revelation, where she is cast as the great whore of Babylon riding the monstrous beast of the Apocalypse.

[1] Left, Amiet 1961, plate 105, fig 1394. For a photo see Finkel & Geller 1997, page 155, fig 13. Right, Boehmer 1965, Tafel XXV, fig 292. Amiet 1961, plate 112, fig 1492.
[2] Annus 2002, page 112. See also *Babylonian Star-lore* under the section on the 'Slain Heroes'.
[3] ETCSL: Ninurta's Exploits, lines 122-134.

The Lady of Babylon

Holding her 'cup of fornications' she rides upon the same seven-headed dragon slain so many of thousands of years before (*right*). According to the Christians, the beast's seven heads were meant to represent seven kings dedicated to Babylon's rule of Whoredom. Obviously these words are twisted with centuries of theological and moral hatred. But we are in the unfortunate position of only knowing about Babylon's seven-headed dragon through images of its destruction and the parodies of its enemies.

192 A Russian image of Babylon the Great [4]

Given these difficulties, we will take up the theme of Babylon's cup before exploring the nature of her great beast. To the Christian writers, her cup was a symbol of whoredom and fornications, a veritable abomination to their god on high. But as always, a very different picture emerges from the uncensored realms of ancient art.

To judge from surviving artwork, the cup is a significant ritual object in the cult of the goddess. A number of our seals featuring the birth goddess also include what looks like a drinking scene in the background (*right*). When I first came across this motif, I couldn't understand its role or significance; I thought it might be an incongruous element, but as I explored further, I found other designs that included similar drinking scenes. Evidently, the cup and the liquid it contains were an important part of the goddess' cult.

193 A drinking scene [5]

The design seen below, featuring the figure of the Hierodule, directly connects the goddess to the drinking scene as she clearly holds the same type of cup as the revellers:

194 The Hierodule & her cup [6]

[4] Russian engraving circa 1800 CE, from Wikipedia article 'Whore of Babylon'.
[5] Detail from Louvre collection AO 7296. See *The Queen of Heaven*, fig 52 for the complete image.
[6] Frankfort 1939, text fig 85.

The Lady of Babylon

The general birth context of this image can be deduced from the cow's head, the monkey and the tiny children scattered around the design. So what is the nature of the drink that the goddess offers to her mortal followers? There is actually a hint of the answer in the design itself, as the goddess has a tiny circlet set on her abdomen. I believe it is the symbol of the seed, the germ of a new life that has entered her womb.

Other designs, which focus on the drinking scenes, very helpfully incorporate some more familiar symbols:

195 & 196 Two drinking scenes with birds [7]

In both images we see the same human figures drinking their fill through what can only be described as drinking straws. But the presence of the divine bird in the midst of the revellers, along with the ankhs and the radiant star, should alert us to what is really going on – the drinking scenes are somehow part of the process of human conception.

Although there are many scenes of drinking and banqueting in ancient art,[8] our images are different in that all the drinkers in our designs appear to be female. This significant factor is made much clearer in our next design, which depicts a lone drinker amidst many more fertility symbols:

197 A drinking scene with animal symbols [9]

In this design the woman sits on her stool among what looks like a confusing mass of fertility symbols. However, various parts of this design do resolve themselves into well-known icons that start to make some sense of the overall scene.

The magical intent of this image is best conveyed by the group of symbols in the upper register of the design. Here we see the familiar icon of a pair of winged sphinxes set either side of a goat kid. I have previously argued that this icon shows the sphinxes acting as emissaries of the birth goddess by delivering the heaven-born kid to its mother on earth. I would further suggest that the scorpion is intended to implant the child-like kid into the womb of the drinking woman. This

[7] Left, Collon 1975, fig 77. Right, Amiet 1961, plate 89, fig 1170.
[8] See Amiet 1961, plates 88-93.
[9] Stein 1993, fig 131.

The Lady of Babylon

confirms our initial observation that the drinking scenes are part of the mysterious process of human conception. The same conclusion has to be drawn from our next design (*below*), which seats the drinking woman upon a rosette.

198 Another drinking scenes with a rosette [10]

Even though I have no idea about the meaning of most of the symbols set before her, the fact that she sits upon one of the goddess' flowers shows that she has assimilated the all-important seed and is now pregnant with her child.

The reason why I have included this difficult image is that one particular feature really stands out. This lady's drinking straw is portrayed in a very unusual manner, in that it has circular bulges depicted along its length. Like the circular seeds of the trees and flowers, I would suggest that these bulges on her straw refer to some kind of seed-like essence contained in the drink.

That some type of flowery or seed-like potency does indeed reside in the drink is further suggested by the golden drinking vessels discovered in one of the high-class graves at Ur (*left*). These tumblers were all decorated with a rosette on their bases which, in use, would only have been seen as the drinker finished off the beaker's contents.[12]

199 A tumbler with rosette on its base [11]

Now the outlines of a narrative are starting to take shape – the womenfolk are imbibing a magical essence from the drink, an essence that aids them in their quest to conceive a child.

In contrast to the highly symbolic images we have explored so far, our next set of designs gets much more explicit about the nature of the drink and the fertility rites associated with it.

[10] Stein 1993, fig 16.
[11] Internet source, 'Sumerian Shakespeare' under 'Sumerian images'.
[12] Cohen 2005, page 135.

The Lady of Babylon

This remarkable design leaves nothing to the imagination. In the first place, it confirms that the woman is the only partner to actually drink the brew. Ancient people knew that the vast majority of sexual unions do not result in pregnancy. They used all the magical means at their disposal to better their chances of conception – charms and amulets, incantations and herbal concoctions. Alcoholic or not, this drink must either be some kind of fertility aid for the woman or a ritualised intake of impregnating seed. In all likelihood it is probably a bit of both.

200 The fertility inducing brew [13]

The nature of the rosettes is the key to understanding the nature of the drink. Scholars have long debated what flower, if any, is actually intended. But one modern scholar, in his discussion of the drinking vessels found at Ur, has recently argued that it may be an early variety of cultivated apple.[15] From a symbolic perspective that would certainly be a very satisfying answer, and one that is extremely evocative, given the associations of the apple in biblical lore.

Regardless of its botanical nature, the rosette appears in many scenes of animal and human procreation. The odd-looking design in fig 201 (*right*) makes a point of setting the mating goats in a very human configuration. The same message is presented in much more realistic terms in our next design, which returns to the symbolism of the drinking festival:

201 The sexual nature of the rosette [14]

202 An orgy-like scene at the ancient drinking party [16]

[13] Sexualitat Article, fig 4 on page 422.
[14] Amiet 1961, plate 62, detail of fig 831.
[15] Cohen 2005, page 128. He also states that strings of apples were found in some of royal graves at Ur.

The Lady of Babylon

Set among the flasks and flagons of the drinking party, men and women make love under the sun and moon. On either side of the design, the symbols of the flower and the monkey point to the true intent of the rites.

In this orgy scene we may well see an enactment of Inanna's sacred rites at Uruk, her principal city. The nature of these rites is mentioned in a Sumerian text where Inanna was called 'the mistress, the Lady of the great powers who allows sexual intercourse in the open squares of Kullaba'.[17] Kullaba was an ancient district of Uruk where the ziggurat of heaven was constructed. The pleasures of the open squares around it are described in another Sumerian poem, where Dumuzi, the goddess' lover, is persuading his beloved to deceive her mother and join him in the bliss of love.

Dumuzi addresses the goddess: 'Let me teach you, Inanna. Let me teach you the lies of women: "My girlfriend was dancing with me in the square. She ran around playfully with me, banging the drum. She sang sweet songs for me. I passed the day there with her in pleasure and delight". Offer this as a lie to your mother. As for us – let me make love with you by moonlight. Let me loosen your hair-grip on the holy and luxuriant couch. May you pass a sweet day there with me in voluptuous pleasure'.[19] The scene is perfectly illustrated by the design seen in fig 203, which shows the lovers upon their couch amidst the revelers and the drinking vessels.

203 The luxuriant couch [18]

The holy couch, the drinking and music, and above all else the orgiastic nature of these rites are all part of the same night-time revelry. But when were they celebrated? There isn't the slightest hint of an answer in literate sources, but all the evidence we have gathered shows that they would have been celebrated at midsummer when the souls of mankind started their descent from the stars.[20]

Now we can see why the early Christians saw the cup of Babylon as her cup of fornication. Behind the derogatory slant, Babylon's cup is revealed to be a central part of her orgiastic rites. Its basic purpose, as far as we can tell, was to act as a fertility aid that helped the woman conceive, but even here we must still recognise that there may be a much more complex and informed symbolic conception behind the cup and its drink.

[16] Amiet 1961, plate 63, fig 850.
[17] ETCSL: Enki & the World Order, lines 358-367.
[18] Sezualitat A, fig 5 on page 422.
[19] ETCSL: A Tigi to Inana (Dumuzid-Inana H), lines 13-22.
[20] The sacred marriage ceremonies that we know from later periods were springtime rites, but their essential purpose was to legitimise and empower the king – their performance was part of the coronation ceremonies, which are typically springtime rites. See Lapinkivi 2004.

The Lady of Babylon

Beyond being a herbal remedy, the drinking rites were probably a ritual enactment of the woman imbibing the germ-like seed of her child. But above all else, the rites were founded on the recognition that the life-imparting seed originated in the goddess' rosette, her primary symbol of the fertile skies.

The symbolism of Babylon's cup naturally harkens back to the skies, where the cup or vase with its overflowing waters is one of the fundamental symbols of the heavens with its ever-flowing waters. These waters are the waters of the womb of heaven. Now we can see that the title 'the Whore of Babylon' is another mockery of the goddess as the great Hierodule of Heaven. Behind the scurrilous propaganda of the Christians, Babylon the Great is revealed as the celestial mother of all humanity.

And what of Babylon's great beast with its seven heads? Apart from being slain in some Akkadian designs and being mentioned in myths like the Slain Heroes, we know nothing more about the seven-headed dragon from Mesopotamian traditions. Given this lack of evidence, we are forced to widen the scope of our inquiry and look at the broader category of multiple-headed dragons and snakes.

Beyond the seven-headed dragons seen earlier, I have only found one such creature in Near Eastern sources, and consideration of its character opens up a new dimension in the symbol of the archaic serpent. This fascinating serpent-being is found within the cult of the sun god:

204 The sun god in his shrine [21]

[21] Ornan 2005, fig 65. Also Black & Green 1992 fig 73.

The Lady of Babylon

This illustration is drawn from a tablet commemorating the restoration of the ancient temple of the sun god in Sippar, one of his principal cities. On the left-hand side of the image, we see a priest leading the king into the presence of the sun god, who sits enthroned in his inner sanctum. What is so wonderful about this design is that the original tablet has three written captions added to it (not represented on my drawing). The first caption, which is set above the human figures, simply identifies the statue as 'an image of Šamaš, the great lord, resident of the White Temple, the one within Sippar'.

The second caption refers to the strange-looking canopy of the shrine. This arching construction, with two human bodies appended to it, is identified as a double-bodied serpent. The caption refers to it as 'a snake of two faces', which acts as 'the herald of Šamaš'. The third caption reveals the cosmic perspective of the shrine. Close to the sun god's head we see the symbols of the Sun, Moon and Venus; the caption describes them as being 'set upon the face of the Abyss, between the divine serpent and the support pole'.

Without these precious captions we couldn't even guess at the shrine's ingenious construction. Combined with the imagery of the design, they allow us to get to the heart of the cosmic serpent in Mesopotamia.

Ultimately, this image of the sun god's shrine is a depiction of the basic structure and mechanics of the solar heavens. The 'support pole' mentioned in the third caption has to be identified with the palm-like pillar that stands before the sun god. If his shrine is an image of the heavens, this support pole can only be the axial pole of the skies around which the visible heavens revolve. This sets the cosmological framework for the rest of the design.

The arching body of the serpent is therefore likely to be another great circle of the skies. My first thoughts centred on the idea that this serpent may represent the arch of heaven's dome, but the way that the astral disks are placed beneath its body suggests that the serpent is more specifically linked to the ecliptic and the celestial bodies that weave along its course. This scenario would then provide an explanation for why the divine serpent suspends the sun disk from a set of ropes.[22] By means of these ropes, the two human forms adjoined to the snake were probably thought to raise and lower the solar disk over the course of a year. By doing so, they created the ever-changing seasons with their characteristic variations in rainfall and temperature, and established the summer and winter solstices as the extreme limits of the sun's upward and downward movements.

Although we cannot be sure of its exact nature, the double-bodied snake-man seen in this design is certainly a fundamental part the superstructure of the heavens and appears to be closely associated with the sun, moon and planets that traverse the heavenly face of the Abyss.

[22] There are many references to cosmic ropes and harnesses in Babylonian astronomy. They appear to link together the spinning heavens to the fixed earth. See *Babylonian Star-lore* under 'The Ropes of Heaven'.

The Lady of Babylon

To get closer to these primal serpentine beings we will have to leave the environs of Mesopotamia and travel further east into the mythologies of China and India.

In Chinese mythology there are a famous pair of serpent-beings called Fu Xi and Nü Wa.[24] Fu Xi, the male serpent-being, is credited with being the first emperor of China and the inventor of the Eight Trigrams used in Chinese divination. Before his birth, mankind lived like the wild beasts, eating raw meat and cladding himself in animal skins. But Fu Xi, acting like a benevolent culture hero, brought civilised ways to mankind and taught him how to cook, hunt and make music.

His female consort, or sometimes sister, named Nü Wa has much more obscure origins. She was usually depicted as a beautiful woman with the lower body of a serpent, but she could also be depicted with horns and occasionally with an ox's head. The serpent-beings often appear together as a symmetric pair with their tails inter-twined, as in figure 205 (right).

According to Chinese legend, Nü Wa was a primordial being, present when heaven and earth were first separated. She appears to be at home in the skies, as one myth describes her repairing a hole in the heavens, which had been caused when one of the cosmic pillars that supported the dome of heaven was knocked askance. This cosmic catastrophe caused the four corners of the earth to tilt towards the south-east, which was the proximate cause of the Flood in Chinese tradition.[25] After repairing the hole in the firmament, Nü Wa restored the balance of the earth by cutting off the legs of the cosmic tortoise that supported the earth upon its back. These mythical events marked the end of the golden age, and the beginnings of a new era. In the more precise language of archaic astronomy, this story relates to the wrenching apart of two great circles of the sky – the ecliptic and the celestial equator. This is what gives us the seasons, the hot and the cold, the rains and droughts of summer and winter.

205 The serpent gods of ancient China [23]

The cosmological roles of the serpent-beings are indicated in their iconography. In fig 205 we see Fu Xi on the left, holding a carpenter's square, while Nü Wa on the right, holds a compass. With these implements, Fu Xi maps out the nine regions of the four-cornered earth and Nü Wa inscribes the great circles of the skies. Chinese myth does not accord the serpent-beings the status of being the creators of heaven and earth, rather they are regarded as setting the universe in order – this is the meaning of the compass and square they wield.

[23] Major 1993, fig 5.2 on page 267.
[24] Also known as Fu-hsi and Nü Kua. Walters 1995, page 67 & 129.
[25] Allen 1991, page 58.

The Lady of Babylon

The intimate relationship of these serpent-beings to the structure of the heavens is manifest in another Chinese design, which place them among the stars (*right*).

In this illustration we see the snake-beings in their proper context – set among the sun, moon and the stars. It is significant to note that most of the constellations appearing on this image are drawn from the Chinese lunar mansions.[27] This fact further supports the idea that the serpent-beings are associated with the ecliptic where the sun, moon and planets wander along their courses.

Like the human-bodied serpent of Šamaš, the Chinese serpents are also bound up with the superstructure of the skies. The serpent-beings of China are significant for this alone, but their deeds don't stop here. The mythic sources also tell us that Nü Wa created mankind. She did this by moulding his body from yellow clay. She laboriously moulded the first batch of men by hand, but then tiring of the task, she took a rope and dipped it in the yellow mud and cast the rope about. This flung masses of mud droplets around – the larger drops became the nobility and the tiny drops the commoners.[28]

206 The serpent gods among the stars [26]

The role of the Chinese serpent-beings in the creation of mankind finds a parallel in the function of the *Bašmu*-serpent and the dragons of birth that belonged to the Mesopotamian goddesses. Thus we can ascertain that the serpent-beings of archaic myth have a two-fold role in common – they represent a fundamental element in the structure of the heavens, most likely connected to the ecliptic, and they act as the creators of mankind. These diverse aspects can only be reconciled by understanding that mankind is born of the heavenly powers.

Moving away from China and on to India, we meet another mythical serpent under the name of Śeṣa, which was represented as a cobra with many heads (*below*). It is another cosmological beast, as it rests on the primal waters of creation that occupy the lower portions of the universe. In Indian mythology, Visnu sleeps upon it between successive manifestations and destructions of the universe. According to different texts, this snake has either 5, 7 or innumerable heads, and significantly each of them is associated with a particular planet. While the 5 and 7 headed versions of the serpent represent the visible planets plus the sun and moon, the innumerable-headed version references the many worlds theory of later Vedic thought, where the universe consisted of countless world-systems, each with their own set of planetary orbs.

[26] Xiaochun & Kistemaker 1997, between pages 112 & 113.
[27] Caption, Xiaochun & Kistemaker 1997, between pages 112 & 113.
[28] Waters 1995, page 129.

The Lady of Babylon

207 Visnu sleeps on Śeṣa, the cosmic serpent [29]

Although the Indian serpent doesn't appear to be involved in the creation of mankind, its cosmic status is again stressed by associating its multiple heads with the planets. In its own way, this Indian conception of the serpent is just as much a planetary collective as the planetary demons found in Sumerian lore.

At last we are in a position to make some informed inferences about the nature of Babylon's great beast. I would argue that the dragon's body represents the undulating path of the ecliptic around the heavens and that its seven heads represent the seven planetary powers known in the ancient world – the sun and moon, along with the five naked-eye planets. Its association to the Lady of Babylon would further indicate that her dragon would be another female monster akin to the goddess' *Bašmu*-serpents and dragons of birth. This, I believe, is the ultimate nature of Babylon's great beast and why it was so reviled by the Semitic gods.

208 Another 7-headed serpent is slain by a warrior god [30]

The occurrence of very similar serpent-beings in the early mythology and art of many nations points to their archaic origins. It is therefore something of a surprise to see

[29] Internet source, 'Ardesesha, the Cosmic Serpent'.
[30] Detail from Frankfort 1939, fig 27. Also Amiet 1961, plate 105, fig 1393.

The Lady of Babylon

that the very same conception turns up in Europe in renaissance times. The following illustration, from an Italian Renaissance manuscript, shows the great serpent of the skies in its all its cosmological glory:

209 A renaissance rendition of the planetary serpent [31]

This diagram of heaven and earth depicts the eternal realm of the gods at the very top of the world-order. Here Apollo sits enthroned beside the three Charities (or Graces). He is seen holding his lyre whose seven strings, being related to the planets,[32] produced the harmony of the spheres. Below the realm of the gods, the rest of the universe is set out as a series of concentric arcs that represent the seven planetary spheres contained within the dome of the fixed stars. Each of these spheres is associated with one of the Muses who are depicted on the right-hand side of the design. Right at the very bottom of the scheme we see the earth surrounded by the four elements.

[31] From Wikipedia article 'Musica Universalis'.
[32] Condos 1997, page133, see also page 136 concerning the variable number of strings on the lyre.

The Lady of Babylon

With its three heads upon the earth and its tail in the realm of the gods and the fixed stars, this serpent links the whole world-order together. When interpreted in the light of Macrobius' philosophy, this serpent can be seen to trace out the descending path of the soul through the planetary spheres. Only now do the two aspects of the serpent-beings come together in unity. This is the cosmic snake that creates mankind. This is the umbilical cord of heaven that creates and nurtures the sky-born child.

Even now the tally of cosmic serpents is not complete. In the Roman age, the same planetary serpent also appears on statues of the Mithraic deity called Aion. According to his name, Aion is a personification of Time; and many theories have been put forward to explain his unique iconography.[33]

I would argue that he is heir to the symbolism of the goddess and her animalian powers. With his lion-head and four wings he surely has his roots in the lion-headed demons of Mesopotamia (*below*). The fact that the Mithraic religion originated in Iran, where so many of our finest birth-related designs were created, lends even more weight to the argument.

Detail of fig 189

We can be sure that the square and rod that Aion holds and the image of the hammer and tongs by his feet show him to be the artificer of the worlds.

210 A statue of Aion [34]

In Gnostic philosophy these symbols mark him out as the demiurgos who created the cosmos to capture and bind men's immortal souls and cast them into the realm of dark matter. The metaphysical setting may be different, the religious narrative darker, but the basic philosophy of heavenly souls descending into material existence still endures.

The most remarkable feature of Aion's statues are the serpents that coil around him. Their context becomes clearer in another more famous image of Aion (*overleaf*) that is currently housed in the Vatican museum.

[33] There are useful summaries in the Wikipedia articles 'Aion' & 'Demiurgos'.

[34] Cumont 1896, page 238. Found in Ostia Antica, Italy.

The Lady of Babylon

This particular figure of Aion adds an extremely significant set of details – he has four zodiac signs placed upon his body. These four signs, undoubtedly meant to be placed on his arms and legs, are a direct parallel to the cross of the stars we explored earlier. But they are now updated to the new astrological era when Aries and Libra marked the two equinoxes and the solstices were marked by Cancer and Capricorn.

From this image we can deduce that Aion is a personification of heaven. His leonine head represents the sun and his body is equated to the ecliptic stars. The serpent, which has its head set above his crown and its tail resting upon the earth thus spans the whole of heaven. Winding around the skies, it can only trace out the descending levels of the planetary spheres. Here, in the figure of Aion, we do indeed have an image of the eternal heavens grinding out the cycles of time.

211 The Mithraic god Aion [35]

The planets on their whirling courses around the path of the sun are understood as a spiraling vortex. The same idea can perhaps be seen in the name of Nü Wa, which can be understood as 'Snail-lady', pointing to her spiraling shell.

Now we are better informed as to the nature of the serpent, we can return to some of our earlier Mesopotamian designs and see them in a new light. The twin serpents coiling around a series of rosettes (*left*) can now be understood as an icon of the seed of humanity descending through the planetary spheres towards their birth.

Likewise, the horned serpent found in the Assyrian image of the winged goddess (*right*) is the same planetary snake. This horned serpent has also stretched all the way into heaven and attained the seed of the heavenly flower. That seed, the germinal form of mankind, is equated to the stars of the firmament in Macrobius' philosophy. This is why the horned serpent delivers the soul of the child to its parents in the form of a radiant star.

[35] Redrawn from internet images of the statue at the Museo Profano, the Vatican.

The Lady of Babylon

There is also a possibility that the strange figure of the South Wind (*left*) is part of the same complex of ideas. Since first encountering these images, I have always wondered about their origin and meaning. The only clue that I have found to her mysterious form is the Akkadian name of the 'south wind' – *šūtu* – which is derived from a root meaning 'to circle around' like a flying bird.[37] It is certainly possible that her coiling legs relate to the spiraling form of the hurricane and tornado, which would be compatible with the south wind's tempestuous nature, but now we can also consider another potential meaning for her twisting legs. They may be related to the same planetary serpent that coils around the figure of Aion. Perhaps some day archaeologists will discover more images of this enigmatic goddess that will reveal her twisted legs to be serpents, but in the meantime the enigma remains.

212 The South & West Wind [36]

The role of the cosmic serpent can now be defined as bringing the stellar seed of mankind down from the sphere of the sun unto the earth – the great serpent can be nothing other than a symbol of the whirling vortex of the planetary spheres. These serpents are parallel in every sense to the other serpent beings we have met in this chapter. All these creatures span the skies and act as the creatrix to bring the seed of humanity to its birth. They capture stellar souls and bring them down through the spheres of limitation and deliver them into the realm of physical embodiment.

A fitting place to end this chapter is with the Greek star-map. The image of the Hydra (*right*), from an early edition of Hyginus' Poetic Astronomy, now takes on a whole new significance.

213 The Greek figures of Hydra, the Cup & Raven [38]

[36] Wiggermann 2007, right, fig 16c; middle, fig 31c; left, fig 9.

[37] Wiggermann 2007, page 127.

[38] Condos 1997 page 119.

The Ziggurat

As we saw in the last chapter, the great serpent of the skies traversed the whole span of heaven from the realm of the fixed stars unto the earth that sat at the very bottom of the world-order. More specifically, this coiling serpent represented the spinning spheres of the planets, through which the souls of mankind journeyed on their way to birth.

In Mesopotamia the same cosmic journey, to and from the stars, could be symbolised by the tower-temple or ziggurat. Biblical lore tells us of the Tower of Babel and how the misguided efforts of mankind to build this tower up into the heights of heaven led to their downfall and dispersal.[1] As always, there is a certain amount of truth in this tall tale. Through archaeology, we now know that the Tower of Babel was based on a historical reality, being the biblical name for the famous ziggurat of Babylon, which went by the official name 'the Foundation of Heaven and Earth'.

Nothing now remains of the great tower or the temple that once sat on its august peak. It was partially demolished in the Hellenistic era, and later robbed of all its baked brick, leaving nothing but a vast hole in the ground for modern archaeologists to discover thousands of years later.

Even though the classical multiple-layered ziggurats built of mud-brick are only known from the late 3rd millennium BCE onwards,[3] the basic idea of building a temple or shrine upon a raised platform dates back to the beginnings of Mesopotamian culture with the temples of Eridu, which were constructed in the 4th millennium BCE.[4] Given that the ziggurat is essentially a temple built on top of one or more platforms, it is difficult to say when the idea of the temple-tower really began.

214 Reconstruction of the ziggurat at Dur-Sharrukin [2]

Unlike the Tower of Babel, the remains of several other ziggurats have survived the ravages of time. From our perspective, the most interesting example is the painted ziggurat from the one-time Assyrian capital, Dur-Sharrukin (*left*). The bottom three layers of this massive spiralling staircase were preserved. From the ground upwards the three levels were painted white, black and red. The remaining structure is presumed to have

[1] Genesis II verses 1-9.
[2] Roaf 1996 page 105.
[3] There is some artistic evidence for their existence in the Akkadian period, see Fischer 2002, page 129.
[4] Black & Green 1992, page 174 under 'Temples and Tempe Architecture'.

The Ziggurat

included four more stages, which, according to the traditional colour scheme, would have been painted blue, orange, silver and gold.[5] The seven stages and their colour scheme identify the stages of the tower with the seven traditional planets (*below*). Unfortunately, the upper levels of every single ziggurat were eroded away thousands of years ago, leaving no trace of the temples that touched the skies.

| The Sacred Shrine |
| ☉ SUN - GOLD |
| ☽ MOON - SILVER |
| ☿ MERCURY - ORANGE |
| ♀ VENUS - BLUE-GREEN |
| ♂ MARS - RED |
| ♄ SATURN - BLACK |
| ♃ JUPITER - WHITE |

215 The planetary colour scheme of the seven-storied Ziggurat

A similar seven-fold model was reputedly used for the ziggurat of Babylon. According to the Greek historian Herodotus,[6] it was built of seven stages surmounted by a sacred shrine. The wholesale destruction of the tower means that nothing in Herodotus' description can be substantiated, and given that he or his sources were certainly given to exaggeration in declaring the size and extent of Babylon's walls, his account is often doubted. Nevertheless, I believe his account is well worth revisiting in light of what we have learnt.

Like other ziggurats, the temple-tower of Babylon had external staircases and walkways and it seems that quite a large number of people could climb it at once, as one of the middle levels had an area with seating so that people could have a rest on their ascent towards the heavens and take in the views. In later times, the towers were certainly used for observing the skies and some examples are helpfully orientated to the cardinal directions but no one knows if that was an essential part of their original purpose.[7]

The description furnished by Herodotus suggests an almost endless stream of people ascending the great tower just as latter-day penitents still climb holy mountains and hills today. From the top of the tower, the views over central Babylon must have been magnificent. Then as now, the mere act of looking down at the ongoing hubbub of daily life from a great height naturally instills a more spiritual perspective on one's life and personal circumstances. However, we can only speculate whether the climbers understood that they were making a ritual ascent to the stars via the planetary spheres

[5] Roaf 1966, page 105. The planetary colour scheme has one discrepancy as the lowest two levels attributed to Saturn and Jupiter have been reversed. This may be due to Jupiter (and Marduk) assuming sovereignty of the earth after the fall of the Golden Age. See Hamlet's Mill chapter 8. For a informative discussion of the planetary colour scheme see the enenuru website under 'Ziggurats, Colours & Planets' by Madness (Nov 17, 2010).

[6] Herodotus, The Histories, chapters 181-183.

[7] Black & Green 1992, page 188 under 'Ziggurats'.

The Ziggurat

associated with each of the seven stages. Nevertheless, Herodotus does give us some valuable clues as to the symbolic nature of the ziggurat and its role in the religious life of Babylon.

The Greek historian tells us that the top two levels of the tower were the business end of the monument where the sacerdotal rites were performed. A sacred shrine, at the very top of the tower, was where only the god and his anointed priestess could enter. Within this shrine there was nothing but a golden table and a luxuriant couch, and on certain nights of the year, the priestess would stay the night in this shrine and be visited by the god. Herodotus implies that a mystical union of priestess and god took place on these occasions.

This sacred union at the top of the tower sounds like a civilised and very symbolic version of what used to happen in Inanna's orgiastic cult. It is perhaps based on the same seasonal pattern that sees the sun and all nature reaching its sexual peak at the height of summer, but like Inanna's orgies in the open squares of Kullaba, we have no idea when the priestess and god joined in their sacred union.

Below the holy of holies, the penultimate level of the tower was as far as ordinary people could pass. Here there was another shrine with a golden statue of Marduk, the patron god of Babylon, and two altars, one apparently made of solid gold. We only know one more thing about these altars – upon one altar, only young animals could be sacrificed and upon the other, only mature animals.

This detail about the twin altars and their prescribed sacrifices gives us a potential key as to how the tower was thought to work as a cosmological structure. The first part of the equation, concerning the sacrifice of a young goat kid, has many parallels in our seal designs:

216 & 217 The sacrifice of a goat kid [8]

In both these examples, a man appears to offer a goat-kid to a god who holds a stylised tree. What is most significant about these two images is that they both indicate the nature of what the sacrificer is actually asking from the god. The answer, in both cases, lies beneath the tree where we see the familiar icons of a goat's head and a kneeling

[8] Left, Collon 1975, detail of fig 197. Right, Collon 1975, detail of fig 135.

The Ziggurat

youth. These two images therefore have to be understood as depicting the sacrificer asking the gods to bless him with a child.

These images show that the law of sacrifice is a life for a life. The sacrificed kid is transmuted into the child through the agency of the god and the tree. Through the sacrifice, life is interchanged between the worlds of heaven and earth. Taken together these designs suggest that the altar atop the ziggurat, where only young beasts could be offered, was associated with the mystical conception of the child and its descent from the heavens.

Needless to say, this interpretation only represents half the picture. To be a plausible theory we need to take account of the other sacrifice where only mature animals could be offered up to the gods. This requires us to go back to Macrobius again and explore the symbolism of midwinter.

One of the attractions of Macrobius' philosophy is the innate symmetry of its ideas. Opposite to the summer solstice gate through which children descend to earth is another gate, called the Gate of the Gods, through which the dead ascend to heaven. Macrobius tells us that at the end of their mortal spans the souls of the dead depart their earthly bodies and trace their steps back through the planetary spheres, shedding their corporeal limitations as they go. At last they break free from all earthly constraints and, regaining their god-like powers, they return to the shining stars of the Milky Way from which they originally came.

Macrobius located the Gate of the Gods in the region of Capricorn, which marked the month of the winter solstice in his era. In the previous aeon, however, the winter solstice was heralded by the rising of the constellation we know today as Aquarius. Only once does Macrobius hint at the older order when Leo and Aquarius ruled the solstice months. He states that as Aquarius was opposite to the Lion, where the first semblance of human nature was imparted to the soul, it is therefore considered to be a sign contrary and hostile to life. This is why the ancients celebrated the festival in honour of the dead when the sun was in the Water-bearer.[9]

The essential symbol of Aquarius is the overflowing vase; it is heaven conceived as a vast reservoir of water that falls to earth as the rain. This is one way to view the rainy skies of winter. Another way to symbolise the sky is as a great bull whose nature is of the storms and waters (*right*).

218 The sky bull & the waters [10]

[9] Stahl 1952, page 134.
[10] Black & Green 1992, detail of fig 153.

The Ziggurat

In ancient art, the waters of heaven are sometimes seen flowing between the horns of the sky-beast (*see fig ...*). But in truth, the body of the bull is heaven and the blood that courses through his veins represents the celestial waters that circulate through the skies. The spilling of his blood through sacrifice brings on the winter rains:

219 The bull sacrifice brings on the rains [11]

As the god plunges his sword into the 'slaughter spot' behind the bull's horns, Inanna and the storm god unleash the rains. However, the bull sacrifice is more than a simple act of sympathetic magic based on the similitude of its blood to rain. The act of sacrifice makes a transfer of life-force between the world of men and the realms of the gods. The sacrifice of the bull is also emblematic of death and the release of the soul. This is made much clearer in our next design (*right*).

Here the central motif is easy enough to identify as the sacrifice of the fertile sky beast. All around it, we see icons of new life and abundance; these are the gifts of the life-bringing rains.

Thus far, this image can be seen to be another sacrifice of the sky-beast which brings the fertile rains. However, one significant element remains – above the sacrificial scene, we see a flying bird carrying off the dead body of the sacrificed beast. This artistic convention can only represent the invisible reality of the heavenly bird carrying off the soul of the dead beast and returning it to the skies.

220 The sacrifice of the sky beast [12]

[11] Collon 1987, fig 780 on page 168; and Boehmer 1965, Tafel XXXI, fig 369.
[12] Collon 1987, fig 960.

The Ziggurat

The addition of the bird and its ghostly charge forces us to reconsider the nature of the horned beast – it is another symbol for humanity. The sacrifice of the adult horned beast refers to the death of man.[13]

While the icon of the bird and the dead beast it carries is rather indistinct in this design, another illustration of the sacrifice makes matters much clearer:

221 Two men sacrifice a mountain goat [14]

Here the bird alights upon the beast just as it is given the fatal blow. The connection between the animal's death and the flying bird is thereby established.

For obvious reasons, birds of death are not very common in artwork compared to the bird of life that descends from the skies. Nevertheless explicit depictions of the deathly bird do occur in Near Eastern art such as the image (*below*), which shows a number of *Anzu*-birds carrying off a group of men with their arms tied behind their backs.

222 A group of *Anzu*-birds carry off the dead [15]

Just like the Harpies of Greek myth who 'snatch' away a person's life, these lion-headed birds carry off the souls of the dead to their final destination in the skies.

[13] The motif occurs in *Inanna's Descent*. When the goddess visited the underworld she stated that her reason for visiting was to pay funeral honours to Gugalanna (the Great Bull of Heaven), the husband of Erishkigal. Leick 1991, page 92, also ETCSL: Inana's Descent to the Netherworld, lines 85-89.
[14] Stein 1993, fig 416.
[15] Collon 1987, fig 887.

The Ziggurat

The same idea probably lies behind the image of Etana flying into the heavens on the eagle's back (*right*). The Akkadian Epic naturally identifies this icon as the living king visiting Inanna in heaven to obtain the plant of conception. But the wider artistic tradition suggests this icon was originally based on the bird of death carrying off the soul of the deceased.

In the Near East, the fundamental idea of the bird of the dead can be traced back to the artwork of Catal Huyuk. This famous Neolithic village, discovered in Turkey in the 1960s, had several painted frescos. A number of them depict enormous vulture-like birds set among the headless corpses of men (*left*).

Detail of fig 115

These images hint at head cults and the practice of excarnation, in which dead bodies were exposed on a special platform for the birds to devour the flesh. After the flesh had been removed, the remaining bones were gathered together for some type of burial. Evidence from other houses in the village show that the bones were actually interred in the houses, under raised areas of floor.[17] Thus the great bird of the skies has a two-fold role – it is the bringer of life and its taker; it bears man's soul to and from the skies.

223 Two monstrous vultures of the dead[16]

Another set of painted frescos from Catal Huyuk allow us to complete the picture of the wintertime rites dedicated to the dead:

224 & 225 Two hunting frescos from Catal Huyuk [18]

[16] Detail from Roaf 1966, page 45.
[17] Roaf 1966 page 44.
[18] Left, Roaf 1966 page 154. Right, Mellaart 1975, fig 60.

The Ziggurat

Various creatures are selected as the quarry of the hunt – bulls, stags and wild boar – all of which are full-grown and distinctly male. In all these scenes, a multitude of tiny people, dressed in panther skins, race around excitedly, seemingly amazed at the size and vitality of the beasts.

If we are right in applying Macrobius' ideas about the winter solstice to these images, then the bird of the dead and the sacrifice of a mature animal are both related to the wintertime rites of the dead. The various frescos discovered at Catal Huyuk attest to the archaic roots of this cosmic philosophy.

Returning to the temple-tower of Babylon, we can now postulate that the two altars of sacrifice found at the penultimate stage of the ziggurat are dedicated to the dual rites of the solstices. These altars governed the two-way traffic in souls between heaven and earth. Through the offering of a calf, the souls of men descend from the heavens and children are begotten. Through the sacrifice of the mature animal, the doors of heaven are opened and the dead return to the skies. The pivotal times are the solstices when the massed ranks of souls travel to and from heaven on beams of solsticial light.

Origins and Ends

It is now time to draw our conclusions together and to map out the cosmic journey that mankind was believed to take before his birth and after his death. According to Macrobius, the story starts and ends among the stars of the Milky Way. Our galaxy, the Milky Way, is composed of a myriad of tightly-packed stars that trace out a rough and sometimes ragged circle around the celestial sphere. Roughly half of the galactic circle is low down in the skies, close to the horizon so it is not easy to observe, but the other half of the galaxy rises into the skies in the region of the Sagittarius, then arches across the vault of heaven before falling back toward the horizon again by the feet of Gemini (see the star-map in appendix ...).

In ancient art, the star-born origins of man can be expressed by the icon of the mother bird flying through the stars (*right*). She was probably thought to pluck stars from the firmament as the very first stage of the soul's descent towards the earth and its birth.

The souls of men then entered the realm of the sun through the Gates of Men, located at the summertime peak of the ecliptic and continued their descent through the spinning spheres of the planets.

226 The mother birds fly among the stars [1]

At each stage of their descent through the planetary spheres, the celestial orbs imparted specific qualities and attributes to man's immaterial soul. The progressive stages of their embodiment were likened to the development of seeds within the heavenly flower. This beautiful idea was sometimes expressed in ancient art by the simple yet elegant device of setting a rosette among the radiant stars:

227 A flower & seed set among the stars [2]

[1] Halaf period bowl, 5th millennium BCE. Goff 1963, detail from fig 80.
[2] Stein 1993, fig 654.

Origins and Ends

In this image, the three stars seem to descend through the skies towards the bottom of the design. By placing a rosette and what looks like a huge seed among them, the artist is surely identifying the seeds of the flower with the stars. However, neither of these designs is specific enough to point explicitly to the stars of the Milky Way as the starting point of mankind's cosmic journey, unless the dense star-fields through which the mother birds fly can be identified as the stars of the galaxy. The imagery of seal designs and painted pottery cannot provide us with the answer we are seeking, but another ancient artefact – the Babylonian star-map – can give us a definitive answer.

As our next illustration shows, the wintertime skies are traversed by the upper reaches of the Milky Way's arch:

228 A reconstruction of the wintertime stars

Right in the middle of the galaxy's arching pathway lie three very significant constellations labelled here as the Panther, the Eagle and Dead Man. The image of the Eagle immediately stands out. Carrying the corpse-like constellation of the Dead Man in its talons, it is a direct parallel to our wintertime bird of death carrying off the soul of the dead (*see fig ...*). Here we undoubtedly see the very end of man's cosmic journey among the stars of the Milky Way. His beginnings are bound up with the constellation called the Panther.

According to its Sumerian name, the Panther is actually a 'storm demon with a gaping mouth'.[3] It is a relatively new constellation that is located among the stars of the Greek constellation known as Cygnus, the Swan. Before the Panther graced the night-

[3] See *Babylonian Star-lore* under the 'Panther'.

174

Origins and Ends

time skies, I believe these stars constituted the archaic constellation of the *Anzu*-bird.[4] Indeed, the Greek constellation with its outstretched wings and trailing feet (*see below*) bears an uncanny resemblance to the ancient bird-form of *Anzu*. I do not believe this is coincidental.

229 & 230 The Anzu-bird from a Mesopotamian seal. The Greek figure of Cygnus [5]

To make a rough and ready restoration of the archaic constellations, including the image of the *Anzu*-bird, it is a simple matter of removing the image of the Panther and replacing it with the Greek form of Cygnus (*below*). The resultant image is so similar to the icon of the heavenly bird carrying a pair of horned beasts down from the skies that a Mesopotamian origin for Cygnus is well worth considering.

If we accept the idea that the *Anzu*-bird was originally located within the stars of the Milky Way, then its precise role in the grander scheme of things would be to carry the souls of those to be born upon earth from their home among the galactic stars. Its function is therefore the exact opposite of the Eagle that is placed beside it.

231 A restoration of the archaic constellations

The presence of the archaic *Anzu*-bird alongside the Eagle and the Dead Man in adjacent parts of the Milky Way shows that the souls of mankind did have their true home among the immortal stars of the galaxy. This, according to the star-map and Macrobius, is where the great journey of embodiment begins and ends.

[4] In *Babylonian Star-lore* I made two suggestions for the location of the archaic *Anzu*-bird. I originally thought that it was located among the stars of Pegasus and was later replaced by the constellation of the Horse (**Anše-kurra**). This was largely due to the similarity of their names. However, I later came to revise this idea after recognising that the similarity in form between the Greek Cygnus and *Anzu* suggested that *Anzu* was once placed among the stars of Cygnus (see the section on the 'Slain Heroes').
[5] Left, Amiet 1961, plate 113, detail of fig 1499. Right, Wellesz 1965, fig 5.

Origins and Ends

Before trying to look at the bigger picture of mankind's origins and ends, we need to return to the symbolism of the Gate of Men and the planetary spheres. In the previous chapter, we saw that the seven-stage ziggurat of Babylon correlated to the seven spheres of the planetary powers (*fig 215*). Consequently, the ziggurat, as a whole, embodies a complete map of the archaic skies with all the planets set out in orderly tiers. I would argue that the very same information is also encoded into the zodiac constellations that follow on from the Gate of Men. Back in the archaic era, the summer solstice and the Gate of Men would have been marked by the constellation of Leo. This is where the star-born souls of mankind joined the path of the sun and started their descent through the planetary spheres towards the earth.

As any astrologer knows, Leo is regarded as the special domain of the sun; in astrological parlance, Leo is regarded as the 'rulership' of the sun. And just as Leo is allotted to the sun, all the other planets are similarly associated with the other signs of the zodiac. Even today, the Rulerships are regarded as the most fundamental planetary scheme, even if nothing is known of their origins. The whole set of Rulerships is laid out in the diagram below:

232 The Rulerships of the Zodiac

As can be seen from the diagram, the whole system is set out in a very neat and orderly fashion, with the planets arranged in two near-symmetrical sets that closely follow the same descending pattern we saw earlier in the seven-stage ziggurat.

To integrate the seven traditional planets with twelve zodiac signs took a little ingenuity. The solution was to allocate the sun and moon to Leo and Cancer at the very top of the planetary order; then either side of them, the five remaining planets were allocated two zodiac signs each. The whole structure is divided in the vertical plane by the ancient positions of the two solstices.

Origins and Ends

The process of the soul's descent through the skies can now be more fully described as a simultaneous descent along the path of the sun and the planetary spheres. From the station of the summer solstice guarded by Leo, the souls descend month by month through the planetary rulerships of the zodiac until they reach the winter solstice station at the bottom of the diagram.

The process of involution is summarised in the following diagram:

233 Diagram of the soul's descent down the planetary spheres

This, I believe, represents the fundamental layout of the Mesopotamian scheme. Even though it is not entirely consistent with the colour-coded ziggurats – in the order of the sun and moon, and the order of Saturn and Jupiter – it is self-evidently based on the same underlying system.

What I find most interesting about this scheme is the way that the soul's evolutionary descent is completed by the time of the winter solstice – some three months before its springtime birth. Here at the start of the Third Trimester, the formation of the child is complete; it is fully formed and all its life-systems are viable. During the third and final Trimester, the foetus does not develop further, but only grows in size.

However the Mesopotamian scheme was not adopted in the West. By Macrobius' era, the traditional order of planets had changed. Instead Macrobius bases his philosophy on the planetary sequence seen in the western traditions and the Qabalah –

177

Origins and Ends

Saturn, Jupiter, Mars, Sun, Venus, Mercury and finally the Moon.[6] According to this formulation, the capacities and functions imparted to the soul at each planetary sphere are listed as follows:

Macrobius' planetary associations [7]	
Saturn	Reason & understanding
Jupiter	The power to act
Mars	A bold spirit
Sun	Sense-perception & imagination
Venus	The impulse of passion
Mercury	The ability to speak & interpret
Moon	The function of moulding & increasing bodies

Personally, I have always found this set of attributions a bit disjointed and, in places, difficult to understand. This is especially true in regard to the function of the moon which is said to mould and shape bodies. Logically speaking, this function should occur much earlier in the embodiment process.

Largely for the purposes of my own understanding, I have constructed another table of planetary influences, that takes some of the bare essentials of Macrobius' scheme and some of the traditional associations of the planets from modern traditions, and reorders them according to the Babylonian scheme of the Rulerships:

Hypothetical Babylonian scheme of planetary associations	
Sun	The living soul as centre of a person's being
Moon	The unconscious mind and basic life support systems of the embryo
Mercury	Formation of the intellect & reason
Venus	The emotions
Mars	The dynamic will of the individual
Jupiter	The power to act and assimilate sense-perceptions
Saturn	Binding together of the immaterial soul with the bodily form

I'm sure a great many readers are better placed to improve this set of attributions. I have merely sketched out the bare essentials of the scheme as best as I am able. This hypothetical framework, much more compatible with modern spiritual traditions, describes the process of embodiment in terms of progressively greater limitation and individuation. From the spiritual realms of the sun with its undifferentiated light of awareness, it traces out the defining stages of the soul's descent into the realm of material existence.

It now remains to trace out the great ascent of the soul that occurs after death.

[6] Macrobius actually discusses two variant forms of this planetary scheme, see Stahl 1952, pages 17-18.
[7] Stahl 1952, pages 136-7.

Origins and Ends

The Ascent of the Soul

The souls of those who die linger in the environs of the earth until midwinter, at which time they enter through the Gate of the Gods and start their return journey through the skies. Now the souls rise up on the great ladder of the planetary spheres and entering upon the path of the sun in the region of Aquarius, they go through the same planetary spheres in reverse order. After 6 months they reach the top of the solar path once more and under the governance of the sun and moon, they leave the realm of the planetary spheres and make their way back to the galactic stars.

This metaphysical journey is mapped out in the following diagram, which should be approached from the bottom upward:

234 Diagram of the soul's ascent up the planetary spheres

According to Macrobius, the soul progressively loses its limitations as it rises through the spheres of the planets. As they rise, they become more and more godlike in nature until, finally rejoining the stars of the fixed sphere, they assume their stations as immortal stars blazing from the firmament.

Now it is time to try and pull all this information together and map out the bigger picture of mankind's origins and ends. We have two main components in the mix. Firstly, we have the ultimate starting and ending point of man's journey among the stars of the Milky Way, which were marked out by the constellations of the *Anzu*-bird and Eagle. And secondly, we have the soul's ascent and descent around the zodiac

Origins and Ends

constellations and their associated planetary stations. However, integrating this information into unitary scheme is not as simple as it seems, as significant uncertainties still remain, especially concerning how the journeying souls are meant to move from the great circle of the Milky Way to the circle of the zodiac and vice versa.

At this point, it will prove very useful to consider one final piece of astral lore concerning the dual nature of the goddess. The lore in question is a pair of Venus omens concerning life and death. In the following rendition from a modern translation, the first line comprises an astrological dictum that describes the human side of one of Venus' by-names. The second line (*in italics*) is an equally condensed commentary upon it, which adds extra information and associations.

> 'The Star of Men is for death, fall in battle.
> *Venus (Ištar) is seen in the west, she is male.*
> The Star of Women is for taking a wife …. for giving birth to males.
> *Venus (Ištar) is seen in the east, she is female*'.[8]

The omens are based around the dual symbolism of Ištar. Her masculine warlike aspect rules the western station of heaven and relates to Venus' role as Evening Star. In Near Eastern lore, the west and evening are both associated with death, as can be seen in the Ugaritic saying 'to go to the sunset' [9] meaning that the person has died – they have left the light of day and descended into the dark sleep of death. In contrast to this, the feminine and fertile aspects of Venus are reflected in the Morning Star, the east and the dawn, where Venus is concerned with marriage and the birth of children.

The overtly Venusian qualities of this pair of omens give the impression that they are exclusively based on Ištar's symbolism. Contrary to this overt gloss, I believe some of Inanna's qualities can still be detected, especially in the eastern omen concerning the birth of children, which is not, properly speaking, within the sphere of Ištar's influence.

Due to the way that the cuneiform writing system works, some of the terms used in this pair of omens have alternative meanings and associations. Principally, the terms 'east' and 'west' are very limiting translations as they equally signify the closely related concepts of 'sunrise' and 'sunset'.[10]

This factor suggests an alternative scenario that is more relevant to our purposes. Removing the bisexual nature of the Akkadian goddess, the lore within these omens could be reworked within the milieu of heavenly Inanna as follows: 'Inanna of sunset is for death' and 'Inanna of sunrise is for the birth of children'.

[8] BPO2, Text IV, lines 6-7a. The editors translate the term NAM-BAD as 'pestilence'; however, the lexicon gives 'death, & epidemic' as other possible meanings. NAM has an 'abstractive' function, while BAD has a very broad range of meanings. Here its death-like connotations are more applicable than epidemic or pestilence. Additionally, the modern editors do not translate the last part of the first line: ME3 ŠUB-BA – 'fall in battle'.

[9] Ugaritic Texts, page 37.

[10] PSD: UTU'E [Sunrise] & UTUŠUŠ [Sunset]. See chapter 1 of the present book for the written forms of 'sunrise' and 'sunset'.

Origins and Ends

Regardless of the specific translation of these terms, this pair of omens informs us that the 'station' of death lies in the west, diametrically opposed to the eastern 'station' of birth. With this additional information and the all-important principle of symmetry, I believe we can now make a plausible reconstruction of the cosmic journey that mankind takes before his birth and after his death.

In the following pair of diagrams I have simplified the star-map to concentrate on the two great circles of the skies – the galaxy and the zodiac. The first diagram depicts the journey of the soul's involution:

235 The journey of the soul's involution towards birth

Starting from the constellation of the *Anzu*-bird (A), amidst the stars of the Milky Way, the stellar souls travel round the path of the galactic stars till they reach the summertime colure below Leo and Cancer (B). Then they arise on the solsticial colure and enter the circle of the zodiac through the Gates of Men (C). Then travelling with the sun through the planetary spheres they reach the stage where the soul is fully embodied (D), and following on from that they finally emerge into the world in the springtime season of birth (E).

181

Origins and Ends

Our final diagram traces out the path that the dead follow back to the stars:

236 The process of the soul's ascent to the stars

Starting at the western station of death (V), the soul separates from the body at the midwinter Gate of the Gods (W) and starts its ascent through the planetary spheres. At the end of its ascent, it is back at the Gate of Men (X) through which it now returns to the stars of the Milky Way (Y). Completing its circuit of the Milky Way, it finally returns to its starting point under the guardianship of the Eagle (Z).

These diagrams stress the central role of Macrobius' two gates in the grand scheme of mankind's cosmic journey. The summertime Gate of Men is in many respects more important, as this portal acts as the junction between the sphere of the fixed stars, which includes the Milky Way, and the planetary spheres under the jurisdiction of the sun.

Origins and Ends

The wintertime Gate of the Gods is rather different in nature. For the descending soul it marks the completion of the involution process when the foetus is complete and capable of independent life, that is when body and soul are formally united. Conversely, in the death process, it marks the separation of body and soul and the start of the soul's ascent through the skies.

Now that we can appreciate the bigger picture, we see that the soul travels graceful spirals through the star-filled skies. The beauty of the scheme is reflected in its symmetry and the cosmic conception of man's nature, as defined by his origins and ends. For the ancients, every man and woman was truly a shining star.

The Lion of Death

Throughout this book we have concentrated on the imagery of life and the process of its creation. Ancient artists did exactly the same, as they and their audience naturally focussed on the life-engendering aspects of their traditional symbolism. Nevertheless, the symmetry of ideas inherent in Macrobius' philosophy places an equal emphasis on death and the process of the soul's return to the skies. Even though images of death are much rarer in our corpus of designs, they do still occur, and it is the purpose of this, the last chapter of the book, to examine the imagery of death.

The fundamental tenet of the archaic belief system we have been exploring is that the human soul originates and ends in the heavenly realms. As such, the goddess of heaven is accorded a dual role that encompasses the process of life's creation and its cessation. We have already seen that this dual nature is particularly manifest in the symbolism of the *Anzu*-bird, which not only carries the newborn baby down from the skies, but also transports the dead back to their heavenly abode.

In ancient art, the lion of the goddess has the same two-fold role. As well as being a symbol of the sunlit skies that brings all life to birth, the lion also appears as a creature of death, which deals the fatal blow that initiates the soul's return to heaven. Set within the metaphors commonly used by ancient artists, this lion of death is most often portrayed in the act of attacking the herds:

237 A lion attacks the herds [1]

This image is founded upon the lion's innate nature as a ferocious carnivore that ravages the precious herds. Even the heroic efforts of two shepherds cannot counter its devastating attack.

The way that one shepherd attacks the lion with a spear is a significant and very useful key that helps us identify the lion as a creature inimical to life. Such a weapon, either held by a shepherd or set in isolation, is a surprisingly common feature occurring in many illustrations, where it is used as a magical device to counter the baleful influence

[1] Boehmer 1965, Tafel XXIII, fig 260.

The Lion of Death

of death (*see also fig 131*). The same motif of the shepherd wielding his spear against a lion occurs in our next design, which shares much in common with our previous example:

238 A shepherd protects his flocks [2]

Even in these two deathly encounters there are signs of life present. In our first image a thriving tree is set behind the cow and in this design, as well as adding a calf head to the background, the artist has also depicted the cow in the process of giving birth to a tiny calf. This places death in its proper context. Upon the earth, life and abundance necessarily hold sway, the cattle breed and new generations replace the old. Even though death will inevitably come to all, the herds continue to prosper.

The form and function of the lions of life and death are clarified in our next design, where the two aspects are set side by side:

239 The lions of life & death [3]

We have already met with the lion of life in the form of the double-headed demon seen on the left-hand side of this design. Opposed to this life-bringing creature we find a pair of deathly lions over on the right-hand side. Here two rampant lions confront each other over the lifeless corpse of a gazelle or antelope. The destructive nature of these lions is again stressed by the figure of a shepherd who tries in vain to fight them off with his weapon.

This rather ungraceful design is informed by a majestic philosophy. The image shows the whole cycle of a human life, or stated in archaic terms, it depicts the descent of the soul from the skies and its return to the heavens after death. As much as anything

[2] Amiet 1961, plate 39, fig 602, also Goff 1963, fig 271 (photo).
[3] Collon 1975, fig 218.

The Lion of Death

else, the message is conveyed by the postural language of the gazelles, which are seen rising and falling through the skies. From this perspective, even the deadly lions have to be thought of as guiding the soul back to the heavenly realms,[4] represented here by the winged disk set above them.

Given the dual nature of the lion, it would be useful to have some visual clues as to which is which. Apart from making deductions from the overall content and context of the design, I think there may be such clues here. I believe that the way that all these deadly lions attack their prey from the front is such a characteristic – all three images seen above are laid out in this fashion, which is in marked contrast to the lions of fertility that typically grasp the calves by their back legs.

240 The lion of death [5]

The lion of death also appears as the central character in many more designs, such as the 4th millennium BCE seal seen in fig 240 (*left*).

This image again shows the lion attacking the head of its unfortunate victim. This detail is drawn from real life as lions typically kill their prey through suffocation – either clamping the windpipe of their victim with their jaws or as here smothering its muzzle. This carnivore appears to suck the very life out of its prey.

If we work on the assumption that the lion represents the realm of heaven, then this image takes on a cosmic significance. It depicts the soul of man being reabsorbed into the potent heavens that gave it birth. I don't believe this is a far-fetched idea, as an alternative form of this icon replaces the lion with a bird-headed sphinx (*right*).

Here the addition of bird-like elements to the basic lion-form of the sphinx references the soul's flight into the heavens. The fabulous nature of the sphinx only emphasises the fact that we are dealing with spiritual principles rather than the earthly act of a carnivore killing its prey.

241 A sphinx kills a deer [6]

[4] Note the Vedic parallel in the twin dogs of Yama, who are said to guide the dead to the heavenly afterlife. O'Flaherty 1981, page 44. (Rig Veda 10.14, verses 10-12 & notes 12 & 13 on page 46).

[5] A 4th millennium seal from Iran. Amiet 1961, plate 4, fig 97; and Root 2005, fig 5.44.

[6] Amiet 1961, plate 25, fig 417.

The Lion of Death

So far the unfortunate victims of our lions have been portrayed in the form of different horned beasts – domesticated cows, wild goats and deer. Our next illustration dispenses with this convention to reveal that the real prey of the lion, behind the façade of symbolic imagery, is ultimately mankind:

242 The sphinx as the killer of men [7]

Even with the change of imagery, these hawk-headed sphinxes still attack the head of their victims. Tramping down their quarry, these relentless and remorseless beasts cut the mystical cord that unites body and soul. These men have breathed their last. And with a fateful sigh, their final breath merges with the winds, never to return.

The same metaphysical reality informs our penultimate design, which shows another sphinx trampling down its prey:

243 A sphinx kills a horned beast before renditions of the winds [8]

This wonderful image tells us so much. Over on the right-hand side we see another sphinx finishing off a defenseless beast. The way that the sphinx aims it death-dealing blow to the animal's throat is very curious. I believe that this is a very specific sign that is intended to suggest the Akkadian word *napištu*. This term has the physical meaning of

[7] Metropolitan Museum, Roger's Fund 1961, Accession number 61.197.8.
[8] Stein 1993, fig 258.

The Lion of Death

'throat' and the less material meaning of 'breath'. And dependent on this latter meaning, *napištu* can also refer to the 'essence of life', the 'living being' and even 'the self'. It is used in this sense in the Akkadian phrase *napišti šakānu*, which is translated 'to give up the ghost'.[9]

This design is really saying that the living essence of man and beast is akin to the breath and the winds. This explains why the North Wind with his thunder-weapon and the animalian South Wind are incorporated into the design. The aerial soul is returning to the winds and the skies that originally bore it. This is how the ancients conceived of their death – a going forth into the expanse of the skies and ultimately a return to the immortal stars.

In light of the cosmic functions of Inanna's lions we have to redefine them as two forms of the goddess herself. One bears the celestial soul down from the skies, the other returns the essence of man to the heavenly realms. There is no real place for 'death' in this scheme, only the celestial journeying of the soul.

The contrasting roles of Inanna's sacred lions are the subject of our final design, which sums up the origin and end of man's mortal span:

244 *Anzu*, the life-bringing lion of the skies & the twin lions of death [10]

[9] CDA: *napištu*.
[10] Internet source, 'Sumerian Shakespeare', under the 'Enmetena vase'.

Appendices, Bibliography & Indexes

Appendix □

As the star-maps of Babylon and Greece are central to our enquiry I have included renditions of them in this appendix.

The Babylonian Star-map

245 Reconstruction of the Babylonian Star-map [1]

[1] Original – Gavin White. Reproduced from Babylonian Star-lore, see Appendix 1 for the sources used in this reconstruction.

Appendix

The Greek Star-map

246 The Greek star-map as envisioned by medieval Arabic astronomers [2]

[2] Original – Gavin White; reconstructed from the illustrations in As-Sufi 1954, except for the figure of Taurus which was missing from this edition, thus Taurus is redrawn from Wellesz 1965, fig 15.

Bibliography

Allen 1991. The Shape of the Turtle: Myth, Art and Cosmos in Early China. State University of New York Press.
Amiet 1961. La Glyptique Mesopotamienne Archaique. Centre National de la Recherche Scientifique.
Annus 2002. The God Ninurta. Neo-Assyrian Text Corpus Project.
As-Sufi 1954. Uranometry or Suwaru'l-Kawakib. Osmania Oriental Publications.
Ayatollahi 2002. The Book of Iran. The History of Iranian Art. Centre for International Studies.
Babylonian Star-lore. Gavin White. Solaria Publications 2008.
Black & Green 1992. Gods, Demons & Symbols of Ancient Mesopotamia. British Museum Press.
Boehmer 1965. Die Entwicklung der Glyptik Wahrend der Akkad-Zeit. Walter de Gruyter & Co.
BPO2 – Babylonian Planetary Omens vol 2. Reiner & Pingree 1981. Undena.
BPO3 – Babylonian Planetary Omens vol 3. Reiner & Pingree. 1998. Styx.
Brown 2000. Mesopotamian Planetary Astronomy-Astrology. Styx.
Bunson 1995. A Dictionary of Ancient Egypt. Oxford University Press.
CAD – Chicago Assyrian Dictionary – online
Carey 2001. Painting the Stars in a century of Change. PhD Thesis. British Library Or 5323.
CDA – Concise Dictionary of Akkadian. Black, George & Postgate. Harrassowitz Verlag 2000.
Cohen (Andrew) 2005. Death Rituals, Ideology & the Development of Early Mesopotamian Kingship. Brill-Styx.
Cohen (Mark) 1993.Cult Calendars of the Ancient Near East. CDL Press.
Collon 1975. The Seal Impressions from Tell Atchana/Alalakh. AOAT Band 27.
Collon 1987. First Impressions. British Museum Press.
Condos 1997. Star Myths of the Greeks & Romans, A Sourcebook. Phanes Press.
Cumont 1896. Textes et monuments, figures relatifs aux mysteres des Mithra.
Cunningham 1997. Deliver Me from Evil. Editrice Pontificio Istituto Biblico.
Dalley 1989. Myths from Mesopotamia. Oxford University Press.
Van Dijk & Hussey 1985. Early Mesopotamian Incantations & Rituals. Yale University Press.
Enenuru website – online resource on Mesopotamian studies.
ETCSL – Electronic Text Corpus of Sumeria Literature – online.
Falkenstein 1936. Archaische Text aus Uruk I. Online at the CDLI website.
Fischer 2002. Twilight of the Sun God Pages 125-133 of Iraq, volume 64.
Frankfort 1939. Cylinder Seals. Macmillan.
George 1999. The Epic of Gilgamesh. Penguin.
Glassner 2003. The Invention of Cuneiform. Johns Hopkins.
Goddard 1965. The Art of Iran. George Allen & Unwin Ltd.

Bibliography

Goff 1963. Symbols of Prehistoric Mesopotamia. Yale University Press.
Goody 1962. Death, Property & the Ancestors. Stanford University Press.
Gossmann 1950. Planetarium Babyloniacum. Sumerian Lexicon part IV/2 of Deimal. Photostat.
Graves 1992. The Greek Myths, the Complete Edition. Penguin
Grimal 1990. Penguin Dictionary of Classical Mythology. Penguin.
Hamlet's Mill. De Santillana & von Dechend 1977. Godine.
Harcourt-Smith 1928. Babylonian Art. Frederick Stokes.
Harrison 1962. Prolegomena to the Study of Greek Religion. Merlin
Huot 2004. Une archeologie des peoples du Proche-Orient. Tome II.
Kawami 1992. Ancient Iranian Ceramics. Arthur M Sackler Foundtion.
Koch-Westenholz 1995. Mesopotamian Astrology. Carsten Niebuhr Institute of Near Eastern Studies.
Labat 1988. Manuel D'Epigraphie Akkadienne. Geuthner.
Lapinkivi 2004. The Sumerian Sacred Marriage. State Archives of Assyria Studies, vol XV. Neo-Assyian Text Corpus Project.
Leick 1991. A Dictionary of Ancient Near Eastern Mythology. Routledge.
Lloyd 1978. The Archaeology of Mesopotamia. Thames & Hudson.
Louvre collection – online resource.
Major 1993. Heaven & Earth in Early Han Thought. State University of New York Press.
Mallowan 1965. Early Mesopotamia & Iran. Thames & Hudson.
Mallowan 1978. the Nimrud Ivories. British Museum Publications.
Maquet 1972. Civilisations of Black Africa. Oxford University Press.
Mellaart 1965. Earliest Civilisations of the Near East. Thames & Hudson.
Mellaart 1975. The Neolithic of the Near East. Thames & Hudson.
Metropolitan Museum – online resource.
Moortgat 1969. The Art of Ancient Mesopotamia. Phaidon.
Oates 1986. Babylon, Ancient Peoples & Places. Thames & Hudson.
O'Flaherty 1981. The Rig Veda, An Anthology. Penguin.
Ornan 2005. The Triumph of the Symbol. Academic Press Fribourg/Vandenhoeck & Ruprecht.
Parrot 1960. Sumer. Thames & Hudson.
Porada 1965. Ancient Iran. The Art of Pre-Islamic Times. Methuen.
PSD – Pennsylvania Sumerian Dictionary – online.
The Queen of Heaven. Gavin White. Solaria Publications 2013.
Reiner 1995. Astral Magic in Babylonia. Transactions of the American Philosophical Society, volume 85, part 4.
Roaf 1966. Cultural Atlas of Mesopotamia & the Ancient Near East. Facts on File Inc.
Root 2005. This Fertile Land. Signs & Symbols in the early arts of Iran & Iraq. Kelsey Museum Publication 3.

Bibliography

SAA8 – State Archives of Assyria vol 8. Hunger 1992. Astrological Reports to Assyrian Kings. University of Helsinki Press.

De Santillana & von Dechend 1977. Hamlet's Mill. Godine.

Sexualitat Article – Wiggermann's article available online from the Academia.edu website.

Slanski 2003. Babylonian Entitlement Narus. American Schools of Oriental Research.

Stein 1993. Das Archiv des Šilwa-Teššup. Harrassowitz Verlag.

Stahl 1952. Commentary on the Dream of Scipio by Macrobius. Columbia University Press.

Stol 2000. Birth in Babylonia & the Bible. Styx.

Sumerian Gods & their Representations 1997. Ed: Finkel & Geller. Styx.

Tigay 1971. Literary-critical studies in the Gilgamesh Epic, An Assyriological contribution to biblical literary criticism. Imprint.

Ugaritic Texts … Pardee 2012 British Academy by Oxford University Press.

Veldhuis 1991. A Cow of Sin. Styx.

Walter's Art Museum – online resource.

Walters 1992. Chinese Mythology. Diamond Books.

Weidner 1967. Eine Beschribung des Sternhimmels aus assur. Archiv fur Orientforschung 4, pages 73-85.

Wellesz 1965. An Islamic Book of Constellations. Bodleian Library.

White 2008. Babylonian Star-lore. Solaria Publications.

White 2013. The Queen of Heaven. Solaria Publications.

Wiggermann 1992. Mesopotamian Protective Spirits, The Ritual texts. Styx & PP.

Wiggermann 1997. Transtigridian Snake Gods. Pages 33-55 of Sumerian Gods & their Representations, edited by Finkel & Geller. Styx.

Wiggermann 2007. The Four Winds and the Origins of Pazuzu. Available online at the Academia.edu website.

Wilkinson 2003. The complete Gods & Goddesses of Ancient Egypt. Thames & Hudson.

Winter 1987. Frau und Gottin. OBO series 53. Heidelberg-Brill.

Xiaochun & Kistemaker 1997. The Chinese Sky during the Han. Brill.

Symbol Index

Like my previous book, I have elected to include a visual index of all the main symbols found in the illustrations. By using this index, the reader will be able to reference all the designs which contain a particular icon, and will thus be able to explore any particular theme in much more detail.

The listings of this index are set out in the following categories:
HUMANS – CELESTIAL – DEITIES – MYTHICAL BEINGS – ANIMALS – PLANTS – GEOGRAPHIC - GEOMETRIC & CULTIC

Humans

	Lord, (*left*) the central figure in many designs, often appears alongside the **Lama** goddess who prays on his behalf. Figs: 9, 10, 19, 60, 66, 112, 124, 140, 169, 173, 180, 188, 189, 194, 204, **Nobleman**, (*right*) sometimes prays for the **Lord**. Fig: 9,
	Child, usually seen kneeling down on one knee or walking. In later times, he could be closely related to the **Virile Man**. Figs: 9, 30, 60, 103, 117, 131, 134, 189, 217, **Children**, in groups of identical siblings. Figs: 65, 104, 124, 194,
	Descending Child He is about to be born & is closely related to the **Descending Calf**. Figs: 64, 123, 149,
	Child's Head, an abbreviation for the child, which depicts a baby's wrinkled face. It can be identified as the Head of Humbaba. Figs: 10, 138, 169, 170, 198,
	Girl or Daughter, very similar to figures of the **Naked Goddess**. Figs: 9, 103, 112, 124,
	Virile Man represents the male potency within the waters & ordinary men who have attained the power to father children. Closely related to the concept of ancestral lineage. Figs: 31, 81, 96, 97, 125, 131, 218, 220,

Symbol Index

	Ancestors, represent the forefathers of the kin group. Figs: 100,
	Shepherd, feeds the herds & protects them from predators. Figs: 137, 237, 238, 239,
	Water-pourers & Purifiers, make offerings to the gods. Purifiers use a bucket & sprinkler to bless gods & sacred objects. Water-pourers, Figs: 106, 145, Purifiers, Figs: 81, 163, 176,
	Sex scenes are often set alongside animal symbols of fertility. Figs: 75, 76 77, 86, 87, 149, 200, 202, 203,
	Pregnant Woman, a pose of a mother giving birth & an impregnated woman. Figs: 44, 78,
	Drinking Festival & Ritual Drinking, women drink an impregnating brew. See also **Vase**. Figs: 76, 193, 194, 195, 196, 197, 198, 200, 202, 203,
	Dead Man, carried off to the land of the dead by a bird. Figs: 222, 223, 242,

Celestial Orbs

	Winged Disk, the solar disk with a set of wings, representing the heavens, the winds and weather. Figs: 12, 23, 66, 80, 114, 158, 159, 163, 169, 171, 175, 178, 181, 183, 184, 185, 186, 227, 239,
	Radiant Stars, a common way of representing the sun and stars. Figs: 3, 5, 12, 17, 36, 37, 46, 50, 51, 53, 64, 65, 79, 80, 94, 95, 102, 109, 114, 129, 131, 146, 149, 153, 155, 156, 159, 164, 167, 168, 170, 172, 173, 175, 176, 177, 178, 179, 181, 187, 189, 191, 196, 213, 219, 226, 227, 240,

Symbol Index

	Solar disk, usually portrayed with four outflows of water. Otherwise depicted as a simple circle or floral circle. Figs: 1, 2, 5, 11, 109, 167, 180, 202, 204,
	Lunar Crescent, a narrow crescent with upward pointing horns. Figs: 12, 17, 32, 50, 51, 53, 63, 64, 76, 79, 102, 113, 114, 146, 147, 153, 154, 156, 157, 173, 174, 178, 180, 181, 202, 204, 219, 229,
	Sun & Moon, combining both celestial symbols into a single glyph. Figs: 10, 64, 124, 176, 189,
	Celestial objects, representing stars & possibly planets; often seen with the sun & moon. Figs: 154, 155, 156, 157, 158, 159, 182, 206,
	Pleiades, the only recognisable constellation in ancient art. Figs: 12, 17, 50, 51, 153, 173 (?), 175,

Deities

	Winged Goddess, often seen carrying calves, kids & children down from the skies. Figs: 119, 139, 149, 186,
	Courtesan or **Hierodule**, *(left)* closely related to the sexual aspects of Inanna. Figs: 194, **Naked Goddess**, *(right)* a granter of fertility to mankind. Figs: 23, 65, 132, 140, 188,
	Mother Goddess with her child. Figs: 132,
	Storm Goddess, with her storm-griffin. Figs: 185, 219,
	Solar-Sky Goddess, with rays of radiant light or the sun-disk. Often seen holding a **Circlet**. Figs: 16, 109, 110, 114, 145, 147, 192,

Symbol Index

	Farming Goddess, usually seen holding an ear of barley. Figs: 72, 73, 144,
	Water Goddess, with an overflowing vase. See also **Water God**. Figs: 59, 61, 62, 63, 64,
	Eye Deities, emphasising the solar eyes of the sky goddess. Figs: 44, 45,
	Lama-goddesses, tutelary deities that pray on behalf of the **Lord**, or introduce him into the presence of the gods. Figs: 9, 10, 19, 60, 65, 112, 124, 140, 204,
	Sun god, known as Utu & Šamaš, often seen rising into the heavens. Figs: 204,
	Water God known as Enki or Ea, with his fertile waters. See also **Water Goddess**. Figs: 58, 59, 176, 187,
	Storm God, (*left*) known as Iškur or Adad, rides in a chariot or on a storm beast. Figs: 163, 164, 188, 219, **Syrian Thunder God,** (*right*) a distinct form of the **Storm God** seen in northern seals. Usually seen striding over the mountains. Figs: 124, 194,
	Battle between sacred powers, a warrior god or king fights against the mythic monsters. Figs: 16, 17, 102, 117, 147, 190, 191, 208,

Symbol Index

Mythical Beings

	Anzu, symbol of the sky goddess, often seen carrying calves in its long legs. Figs: 107, 118, 154, 222, 244,
	Man-headed bird, male equivalent to Anzu. Figs: 104
	Storm Griffin, unleashing the storm-waters from its mouth. Figs: 163, 164, 180, 181, 188,
	Sphinx, combine elements of lion, human & bird. Figs: 30, 133, 134, 135, 136, 137, 138, 139, 140, 141, 142, 159, 169, 170, 175, 178, 186, 187, 197, 221, 227, 241, 242, 243,
	Winged Bull, usually male, a symbol of the fertile heavens. Figs: 12, 14, 15, 16, 17,
	Bison-man, symbol of the fertile fathers. Figs: 71, 98, 99, 155, 180, 183, 204,
	Fish Sage, with ritual bucket & sprinkler, the fish-form of the Seven Sages. Figs: 81,
	Goat-fish, usually a symbol of the human foetus. Figs: 63, 64, 81, 211,
	Fish-man, symbol of the celestial waters. Figs: 60, 149, 170,
	Scorpion-man, symbol of the impregnating male. Figs: 80, 81, 185, For a scorpion-tailed demon see fig176,

Symbol Index

	Horned Man, a symbol of the potent man. Figs: 94, 95
	Snake-men, perhaps a symbol of the foetal child with its umbilical cord. Figs: 83, 84, 85, 100, 204, 205, 206,
	Multiple-headed Dragons & Snakes, archaic monsters often killed by the **Warrior God**. Figs: 190, 191, 192, 204, 207, 208, 209,
	Dragon, Bašmu, creatures often associated with the birth goddess. Figs: 102, 103, 105, 106, 107, 108, 124, 146, 147, 148, 149,
	Demons, animal-human composites often with a lion head. Figs: 161 162, 163 167, 168, 171, 172, 174, 176, 177, 178, 179, 182, 189,
	Double-headed Demon, an animalian form of the sky goddess. Figs: 126, 127, 167, 171, 172, 173, 174, 175, 183, 186, 187, 188, 239,
	Aion, a Mithraic deity of Time. Figs: 210, 211,
	South Wind, with her twisted legs. Figs: 128, 212 See also fig 127 for a panther-demon with twisted legs.
	Personified Winds, human and animalian forms, with wings. Figs: 165, 166, 185, 188, 212, 243,

Symbol Index

Animals

	Lion, symbol of heavenly light, creature of the birth goddess. Figs: 30, 71, 109, 110, 111, 112, 114, 115, 116, 120, 121, 123, 124, 125, 131, 133, 134, 145, 146, 148, 156, 157, 170, 173, 197, 198, 221, 237, 238, 239, 240, 243 244,
	Panther, an equivalent to the lion in archaic art. Figs: 122, 129, 130, 131, 132,
	Dog, symbol of the birth goddess Gula. Figs: 115, 145,
	Flying bird, symbol of the sky goddess, carries the child-calf down from heaven; broadly equivalent to **Anzu**. Figs: 15, 30, 47, 48, 71, 113, 115, 131, 136, 140, 145, 150, 155, 194, 195, 196, 198, 220, 221, 223, 226, 229,
	Chick, symbol of the child. Figs: 23, 42, 130, 145, 148 (?), 171, 172, 175, 177, 182, 187, 213 (?),
	Cow, a symbol of the great mother goddess. Figs: 2, 3, 4, 5, 7, 8, 11, 42, 52, 53, 123, 130, 237, 238,
	Bull, a symbol of the fertile skies. Figs: 13, 32, 50, 145, 153, 218, 224,
	Breeding Cattle, often used as a metaphor for human reproduction. Figs: 50, 52, 88, 89, 201
	Cow & Calf, symbol of mother goddess & her calf-child. Figs: 6, 50, 51, 55, 56, 93, 220,
	Mother Beast & Star, symbol of a pregnant mother. Figs: 46,

Symbol Index

	Descending Calf, symbol of the child descending from heaven, usually carried by a **Winged Goddess** or a **Flying Bird**. Figs: 15, 47, 108, 118, 119, 122, 124, 126, 127, 128, 131, 173, 174, 239,
	Calf, symbol of the foetal child. Figs: 18, 20, 24, 32, 41, 42, 48, 50, 52, 77, 115, 116, 120, 121, 123, 133, 134, 135, 136, 137, 158, 179, 180, 197, 220, 221, 244,
	Bull head abbreviation for parental cattle. This category also includes the heads of goats and wild rams. Figs: 24, 33, 34, 37, 40, 194, 220,
	Calf head, symbol of the child, equivalent to the **Child's Head**. Figs: 10, 19, 179, 217, 238,
	Sheep, a less common equivalent to the cattle symbol. Figs: 160, For an image of Aries see fig 211,
	Standing Goat, the potent male, often seen eating from a tree.. Figs: 19, 138, 140,
	Stags, Wild Goats & Bison, usually a symbol of the parent. Figs: 18, 20, 21, 22, 23, 24, 25, 26, 27, 28, 30, 31, 35, 36, 38, 39, 46, 90, 91, 120, 121, 135, 136, 137, 140, 150, 156, 157, 168, 198, 225,
	Dead Beast, a metaphor for the death of man. Figs: 220, 221, 239, 240, 241, 243,
	Bull Sacrifice, brings on the winter rains. Figs: 16, 17, 219, 220, 221,
	Kid Sacrifice, offered to the gods to gain a child. Figs: 216 217,
	Pig or **Boar**, an occasional symbol used as a sacrificial beast. Figs: 225,

Symbol Index

	Scorpion, symbol of impregnation & the union of male & female parents. Figs: 9, 23, 24, 30, 53, 71, 75, 76, 77, 78, 79, 82, 83, 144, 145, 146, 152, 157, 158, 197,
	Serpent, symbol of sexual potency & ancestral inheritance. Figs: 15, 24, 82, 86, 87, 88, 89, 90, 91, 92, 94, 95, 96, 97, 98, 99, 101, 103, 150, 151, 210, 211, 213, 240,
	Fish, symbol of the early stages of the foetal child. Figs: 35, 53, 60, 62, 65, 77, 179, 198,
	Frog, symbol of the foetal child in the celestial waters. Figs: 29, 64,
	Monkey, symbol of the later stages of the human foetus. Figs: 81, 194, 202,

Plants

	Tree, their seed is a metaphor for the seed of mankind & they are the source of potency for man & beast. Figs: 14, 18, 21, 23, 31, 39, 42, 44, 58, 115, 116, 117, 121, 135, 136, 138, 140, 158, 170, 171, 176, 177 178, 179, 181, 182, 213, 216, 217, 221, 227, 237,
	Plant of Life, contains a fertile power. Figs: 6, 15, 17, 20, 22, 32, 56, 62, 90, 91, 92, 120, 134, 167, 170,
	Palm Frond, occasionally held in the hands of various goddesses and fertility figures. Fig: 110,
	Falling Seeds, symbol of procreation & the birth of offspring. Figs: 15, 31, 78, 80, 136, 140, 189, 194, 227,

Symbol Index

	Flowers, the seed producing flower, symbol of the fertility goddesses. The clusters of circles are identical to the Date Cluster. Figs: 7, 8, 9, 14, 15, 23, 24, 31, 32, 36, 38, 44, 45, 58, 61, 109, 110, 136, 137, 139, 142, 149, 150, 151, 152, 158, 159, 163, 167, 168, 174, 176, 177, 178, 179, 181, 189, 198, 199, 201, 202, 220, 227,
	Barley Head, the fertile plant within the farming metaphor. Figs: 13, 27, 28, 67, 68, 69, 72, 73, 144, 147, 153,

Geographic

	Mountain, often with trees upon its summit. Figs: 18, 39, 58, 121, 124, 194,
	Field system, the seeded field. Figs: 25, 26, 27, 28,
	Water, often with **Fish**. Also rain falling from the skies. See also the symbol of the **Vase**. Figs: 26, 32, 33, 34, 58, 59, 60, 62, 185, 204,

Geometric & Cultic

	Cross, a solar symbol representing the annual fertility cycle of animals. Figs: 2, 18, 20, 53, 120, 157,
	Rotating Cross or **Swastika**, a dynamic version of the **Cross**. Figs: 111, 130,
	Circlet, sacred symbol of the sky goddess. Figs: 109, 114, 147,
	Ankh, Egyptian symbol meaning 'eternal life' and 'physical life'. Commonly used as a symbol of the child. Figs: 123, 195,
	Spirals & Interlace, perhaps related to the idea of seed. Figs: 133, 134, 136, 139, 140, 156, 181, 183, 186, 194, 221,

Symbol Index

◇	**Lozenge** another symbol of womb that gives birth. Figs: 50, 53, 102, 147,	
▽	**Triangle**, an occasional symbol perhaps a womb. Figs: 44, 149,	
	Vase, usuly overflowing with water. A symbol of the celestial waters and the sexual potencies of human beings. Figs: 58, 59, 60, 61, 62, 64, 66, 163, 176, 187, 192, 194, 199, 200, 202, 203, 213, 218,	
	Gatepost & Ring-posts, symbols of the goddess Inanna commonly seen on the **Cattle-pen**, & used in writing her name. Figs: 4, 5, 45, 160, 219,	
	Tom's Stick, of uncertain derivation but may be related to the drinking straws seen in **Drinking Scenes**. Figs: 180, 182, 198,	
	Dagger-Spear, often used by a shepherd against a predator. Figs: 24, 131, 237 238, 239,	
	Plough, symbol of implanting seed within the furrow Figs: 71, 144, 145, 146, 153,	
	Bed-Couch, seen in scenes of sex & birth. Figs: 76, 77, 79, 87, 203,	
	House or **Temple** or **Shrine**, Figs: 44, 45, 46,	
	Cattle-pen, symbol of the herd's fertility & on a more abstract level a symbol of the fertile heavens. Figs: 41, 42, 43, 48, 52, 160,	

Sumerian Signs

Many of the written signs of the cuneiform script are very helpful when trying to establish the meanings of various symbols used in ancient art. Indeed it is fair to say that some of the signs with multiple meanings function as symbols in their own right. There is every reason to suppose that the inventors of the cuneiform script drew extensively upon the older artistic traditions when creating the signs of the world's first writing system (*see pages 112-113*).

SIGN	MEANING	PAGE
	Sumerian A; Akkadian *mû*. The sign depicts the banks of a river or the wave-like motion of flowing water. 'Water, semen, human progeny'. The Akkadian term refers to 'body fluids' in general and 'amniotic fluids'.	65, 70,
	Sumerian AB₂; Akkadian *arhu, littu*. The face of a cow with its down-turned ears. 'Cow, Wild Cow'.	43,
	Sumerian AM₂; Akkadian *rīmu*. The face of a bull (**GUD**) with the sign for 'mountains' (**KUR**) added to its face. 'Wild Bull'.	127,
	Sumerian AMA; Akkadian *ummu*. The sign is a container enclosing a star. Read as **DAĜAL** this sign means '(to be) wide, width, breadth'. See also **ENGUR**. 'Mother'.	66,
	Sumerian AMAR; Akkadian *būru*. The sign depicts the face of a calf. 'Calf, young, youngster, chick, son, descendant'.	19,
	Sumerian AMAŠ; Akkadian *supūru*. This sign shows several sheep-signs (**UDU**) entering or leaving a pen. 'Sheepfold'.	126,
	Sumerian AN; Akkadian *šamû*. Usually described as a star, this sign is probably a glyph of the sunlit heavens. 'Sky, heaven, upper, crown (of a tree).' Also refers to An, the god of Heaven, and is used a classifier written before the name of 'divine beings'.	15, 38, 46, 65,
	Sumerian DU; Akkadian *alāku*. Depiction of a human foot but instead of referring to feet it is used to signify the verb 'to go'.	46,
	Sumerian DU₇; Akkadian *nakāpu*. This sign depicts two bull's heads (**GUD**) with horns clashing together. 'To push, thrust, gore'.	129,

Sumerian Signs

Sign	Description	Pages
	Sumerian ENGUR; Akkadian *engurru*. A star within a box. Read as **ZIKUM** this sign means 'the heavens'. See also **AMA**. '(cosmic) underground waters'.	65,
	Sumerian GANA or GAN₂; Akkadian *eqlu*. A rectangular field surrounded by irrigation canals. 'Field, area'.	69,
	Sumerian GUD; Akkadian *alpu*. Depicts the face of a horned bull. 'Bull, ox, cattle, calf'	
	Sumerian IDIM; Akkadian *ekdu*. Unknown origin. This sign has many different readings and meanings. 'Wild, furious'.	125,
	Sumerian MUL; Akkadian *kakkabu*. Three stars. 'Star, constellation, planet, comets and meteors'.	16, 33, 122, 125,
	Sumerian MUNUS; Akkadian *sinništu*. Female genitals. 'Woman or Female'. Read as **GALA** it refers to the 'vulva or female genitals'.	
	Sumerian MUŠ; Akkadian *ṣēru*. A horned serpent. Its meaning cover all types of snake and reptile. The sign also extends to mythical serpents and dragons. See also **UŠUM** 'Snake'.	87,
	Sumerian MUŠ₃. A reed-built column or pillar, used as a divine standard. Prefixed with the sign for 'god' this sign is used in the name of Inanna. By itself, the sign means 'flat space, holy area'.	34,
	Sumerian NIN; Akkadian *bēltu*. The sign for 'woman' (**MUNUS**) set upon the sign for 'noble' (**NAM**). 'Lady or queen, mistress, owner, lord'.	38, 46,
	Sumerian NINDA₂; Akkadian *ittū*. Part of the seed-plough. A tube which deposits seed in the furrow, called the 'seed funnel'. Also used to write 'breed bull'.	71,
	Sumerian NUMUN; Akkadian *zēru*. Presumably depicts a sprouting seed. 'Seed' of plants and cereals.; in Akkadian it also means 'sown land, human semen, offspring & descendants'	71,
	Sumerian SAĜ; Akkadian *rēšu*. A human head & neck. 'Head, person, capital'.	46,

Sumerian Signs

	Sumerian ŠAG₄; Akkadian *libbu*. A person's belly. 'Inner body, heart, inside, in'.	39, 46, 70, 71,	
	Sumerian ŠE; Akkadian *uṭṭatu*. An ear of barley. 'Barley, grain'.	67,	
	Sumerian SI; Akkadian *qarnu*. An animal's horn. 'Horn, finger, fret'.	33, 34,	
	Sumerian SIG; Akkadian *enšu*. An upside down sun-sign (**UD**). '(To be) weak, thin'	15	
	Sumerian ŠILAM; Akkadian *littû*. The sign for cattle-pen, with a woman-sign (**MUNUS**) within it. 'Cow, bovine'.	39, 51, 127,	
	Sumerian TUD; Akkadian *alādu*. A cattle-pen (**TUR₃**) with the standard bent over. Read as **UTUD** it means 'to give birth (to) to bear a child'.	38, 51,	
	Sumerian TUR₃; Akkadian *tarbaṣu*. A cattle-pen with divine standard on top. 'Cattle-pen, animal stall'.	37, 39, 51,	
	Sumerian UD; Akkadian *ūmu*. Depicts the sun rising between two mountains. 'Day & sun, heat, fever & summer'.	43,	
	Sumerian UDU; Akkadian *immeru*. A crossed circle, later a crossed square. 'Sheep'.	125, 126,	
	Sumerian UŠUM; Akkadian *bašmu*. Unknown origin. The chief term for 'dragon' and mythical serpent. '(Mythical poisonous) snake'.	87	

Word Index

If the reader wants to access all the designs where certain symbols appear, please use the 'Symbol Index' presented earlier. Because I have taken this primarily visual approach to indexing, the following word index is largely limited to referencing the principal discussions of the symbols and various proper names.

Abyss (**Abzu**) 60, 64-65, 66, 157,
Adad 65, 127,
Aesclepius 79,
Ages, Three 20, 21, 23, 61, 62,
Aion 162-163, 164,
Altars of sacrifice 167-168, 172,
Amniotic waters 59, 62, 64,
An (god of heaven) 14, 131, 132,
Ancestral figurines 37,
Anunna gods 128-130,
Anzu-bird 96, 174-175, 181, 183,
Apple 154,
Apollo 161,
Aquarius 47, 59, 60, 63, 92, 168,
Aries 57, 163,
Aruru 88,
Asag 129,
Assurbanipal 127,

Babylon, City of 165, 166-167,
Babylon, Lady of 150-151, 156, 160,
Balih 94,
Barley 21-22, 29, 67,
Bašmu-serpent (see also Serpent) 86, 87, 89, 113-115,
Bird of death 169-171, 172,
Bison 34,
Bison-man 68,
Breath of life 187-188,
Bull of Heaven 20, 23,
Bulls of skies 14, 20-24, 31, 71,

Calf as symbol of the child 19, 58,
Cancer 50, 91, 163,
Capricorn 91, 161, 168,
Catal Huyuk 101, 103, 171, 172,
Cattle-pen 36 ff, 44 ff, 51-52, 125-126,
Ceres 79,
Chariot (constellation) 134,

Charites 161,
Compass 158,
Constellation figures 47 ff, 72, 122,
Couch (see also Marriage bed) 155, 167,
Cow & calf 16-17, 58,
Cow of skies 13 ff,
 as rain clouds 14,
 as rays of sunlight 14,
Cross 54,
Cross, Rotating 92,
Cup symbol (see also Vases) 151-156,
Cygnus (constellation) 174-175,

Daughters of Heaven 58,
Dead Man (constellation) 174, 175,
Dead, Rites of 92, 168,
Death 184 ff, 188,
Demons 100, 101, 131, 133-135, 136 ff,
 astral associations 143-145,
 as carriers of the child 140-141,
 Double-headed 139, 140-141, 147-148,
 and fertility 139,
 and human fertility 139-140,
 and storms 137-138,
 and the Tree of Life 142-143,
 and the Sky goddess 145-148,
 and the winds 149,
Descending child symbol 63,
Dragon 86, 87-88, 89-90, 150-151,
Drinking scenes 151-156,
Dumuzi 155,
Dur-Sharrukin, City of 165,

Eagle (constellation) 174, 175, 182,
Elysian mysteries 72,
Enki-Ea 60, 65, 66, 88,
Enkidu 24,
Enlil 14, 69-70, 88, 131, 133,
Enmerkar 19, 42,

209

Word Index

Entitlement stones 63,
Eridu, City of 165,
Erra 123, 128,
Etana 93-95, 171,
Excarnation 171,

Fara 130,
Farming (see also Seed symbolism) 64-65, 67 ff, 110 ff,
Farming metaphor 28-29, 68, 69 ff, 109,
Fathers 84-85,
Field – see Farming metaphor
Fish-men 77,
Fish symbol 59, 60, 61, 62, 64,
Flood (Chinese) 158,
Flower – see Rosette
Flying bird 41-42,
Fox star 45,
Fu Xi 158-159,

Gate of the Gods 168, 179, 182, 183,
Gate of Men 50, 91-92, 109, 173, 176, 181, 182,
Geme-Sin (name of cow) 50, 51,
Gemini 124,
Gilgamesh 19, 23-24, 133,
Goddess
 Birth goddesses 70,
 Farming goddess 69, 110,
 Sky goddess 145-148,
 Water goddess 62-63,
Golden Calf 57,
Great Beast of Babylon 150-151, 160,
Griffin 144,
Gula, the Great One – see Aquarius

Haloes (of celestial bodies) 51-52,
Harpies 170,
Hathor 13-14, 15, 16,
Heracles 33, 79,
Herodotus 166-167,
Hind of Ceryneia 33,
Hittites 148,
Hoe 67, 68, 69-70,
Horned man 82-83,
Horns 25 ff, 77, 139,

Horse (Vedic) 33,
Horus 13,
Hurrians 148,
Hyginus 164,

Inanna
 as cow 14, 15, 129,
 as dragon 88,
 as light 34, 88,
 as lion 91, 103,
 as mother 39, 94,
 name of Inanna 46,
 as sex goddess 155,
 as sky goddess 41, 88, 133, 134-135, 180,
 as warrior goddess 87,
Išhara 74, 75,
Iškur 133, 137,
Ištar 34, 75, 93-94, 123, 128, 180,

Jesus 43,
Juno 48-49,
Jupiter 123, 125, 130, 132-133,

Kiš, City of 93,
Kullaba, District of Uruk 155, 167,

Lamaštu 137, 149,
Leo 47, 48, 50, 52, 91-92, 168, 176,
Libra 163,
Lion symbol 91 ff, 104, 184 ff,
Logos 135,
Lugalbanda 133,
Lunar Mansions (Chinese) 159,
Lyre of Apollo 161,

Macrobius 50, 91-92, 109, 168, 177-178,
Mankind, Creation of 69-70, 159,
Marduk 99, 123, 127, 128, 167,
Marriage bed 74-75,
Mars (Planet) 123, 125,
Mars (Roman god) 48,
Mercury 123, 130,
Midwives 48, 51, 75-76, 88-89,
Milk 36,

210

Word Index

Milky Way 50, 173, 174, 175, 179-180, 181, 182,
Moon 119, 129, 144-145,
 omens of the moon 51, 52,
Moon god 50, 58, 88, 127, 133, 134,
Mouflon 31,
Muses 161,
Music of the spheres 135,

Nabu 99, 123, 127, 128,
Nammu 65-66,
Nergal 87, 123, 127, 128, 137,
Nigin₃-garra shrine 88-89,
Ninhursag 88,
Ninisina 88-89,
Ninsun 19,
Nintu 38-39, 88, 94, 103,
Ninurta 87, 123, 126, 127, 128, 129, 150,
North Wind 138, 188,
Nü Wa 158-159, 163,

Ophiuchus (constellation) 79, 80,

Panther 98, 101-103,
Panther (constellation) 124, 174-175,
Paths of Enlil, Anu & Ea, 44,
Phorbas 79,
Planets 119 ff, 132, 159, 176, 178,
Pleiades 21, 53, 119,
Plough 67, 68, 110-111,
Pregnancy 48-49,

Re' 13,
Revelation, Book of 150,
Ring posts 39, 41,
Rosette 17-18, 40, 62, 106, 113-114, 149, 153, 154, 173-174,
Rulerships 176, 177,

Sacred Mound 128,
Sacrifice of kid 167-168, 172,
Sacrifice of mature animal 168-170, 172,
Šakkan 44-45, 125, 126, 127,
Šala 69,
Šamaš 156-157,

Šassurum 38,
Saturn 121-122, 123, 125, 132-133, 145,
Sauška 148,
Scorpion 27-28, 73 ff, 110, 114, 152,
Scorpion (constellation) 47, 52, 73,
Scorpion-man 76-78,
Seed symbolism 71, 106-107, 110, 113-114, 142, 143, 152, 153,
Seed funnel 71, 111,
Serpent (see also *Bašmu*-serpent) 80 ff, 109, 113-114, 162-164, 165,
Serpent-men 79-80, 84-85, 90, 157 ff,
 Chinese serpent-beings 158-159,
Serpents, Multiple-headed 150-151, 156-157,
Serpent, Seven-headed 150-151, 156,
Šeṣa (Indian serpent) 159-160,
Shaman 82-83,
Shepherds 184-185,
Sippar, City of 157,
Sitting Gods (constellation) 73, 79,
Sky Father 21, 43,
Slain Heroes 126-127, 150,
South Wind 101, 164, 188,
Sphinx 104 ff, 152, 186-187,
Square 158,
Stag 31, 33,
Storm 131, 133, 137-138,
Šulgi 42-43,
Šulpae 123, 130-133,
Sumerian peoples 41,
Sun god – see Utu
Sun symbolism 58, 144, 156-157,
Sun-disk 13, 15, 16, 119, 157,
Sunrise 15,
Sunset 15,
Support pole (of heaven) 157,
Susa City of 63,
Swastika – see Cross, Rotating

Taurus 20-21, 47, 48, 53, 57,
Textiles 36,
Tower of Babel 165,
Tree symbolism 25-27, 95, 105, 142-143,
Trigrams 158,
Trimesters 49,

211

Word Index

First Trimester 110,
Second Trimester 73, 110,
Third Trimester 59, 177,

Umbilical cord 39, 58, 59, 89, 162,
Underworld 24, 137,
Ur, City of 42,
Uruk City of 19, 23, 155,
Utu 32, 34, 127, 133,
 gaze of sun god 41,

Vases (see also Cup) 60, 168,
Vedic quotes, Cattle of skies 14, 21,
 Solar Horse 33,
Venus 123, 133,
Venus omens 123-124, 180-181,
Virgo 69, 112,
Visnu 159,

West Wind 146,
Wild Cattle (planetary name) 126-127, 129,
 130, 134,
Wild Sheep (planetary name) 124 ff, 128, 129,
 130, 134,
Winds, Nature of (see also South, North &
 West Winds) 148, 149,
Winged Disk 21, 145, 186,
Womb 39, 86,

Ziggurat 155, 165 ff,
 colours of ziggurat 165-166,
Zodiac 45,

Chronological Tables

The following tables map out the principal periods of Mesopotamian history. The first table concentrates on the prehistoric periods and the second table on the historic Era.

Prehistoric Eras

DATE BCE	SOUTH IRAQ	NORTH IRAQ	PERIODS	MY AGES
7000			NEOLITHIC [rainfall farming, livestock domestication & villages]	FIRST AGE
		PROTO HASSUNA		
6000		HASSUNA SAMARRA		
	EARLY UBAID	HALAF	CHALCOLITHIC PERIOD [irrigation farming] [stamp seals]	
5000				
	LATE UBAID	NORTHERN UBAID		
4000	EARLY URUK		[first large cities] [cylinder seals]	
	LATE URUK	URUK	[invention of notation writing]	SECOND AGE
3000	JEMDET NASR	NINEVITE 5		
	EARLY DYNASTIC [Gilgamesh]		EARLY BRONZE AGE [palaces, city-states & full writing]	
	AKKADIAN	AKKADIAN		THIRD AGE
	NEO-SUMERIAN			
2000	UR III	UR III		

214

Historic Eras

DATE BCE	SOUTH IRAQ	NORTH IRAQ	PERIODS	MY AGES
3000	JEMDET NASR	NINEVITE 5		SECOND AGE
	EARLY DYNASTIC		EARLY BRONZE AGE	
	AKKADIAN	AKKADIAN		THIRD AGE
	NEO-SUMERIAN			
2000	UR III	UR III	MIDDLE BRONZE AGE	
	OLD BABYLONIAN	OLD ASSYRIAN		
1500	KASSITE OR MIDDLE BABYLONIAN	MITANNIAN	LATE BRONZE AGE	
		MIDDLE ASSYRIAN		
			EARLY IRON AGE	
	Period of disruption			
1000		Period of disruption		
	ASSYRIAN DOMINANCE	NEO-ASSYRIAN EMPIRE		
	NEO-BABYLONIAN			
500	PERSIAN EMPIRE		MIDDLE IRON AGE	
	Alexander 331-323 BCE			
	HELLENISTIC			
	PARTHIAN			
000				
	SASANIAN		LATE IRON AGE	
500 CE				
			MIDDLE AGES	
	Advent of Islam 636 CE			

CPSIA information can be obtained
at www.ICGtesting.com
Printed in the USA
BVHW060931191022
649813BV00004B/186

9 780955 903731